# Classic Portrait Painting in Oils

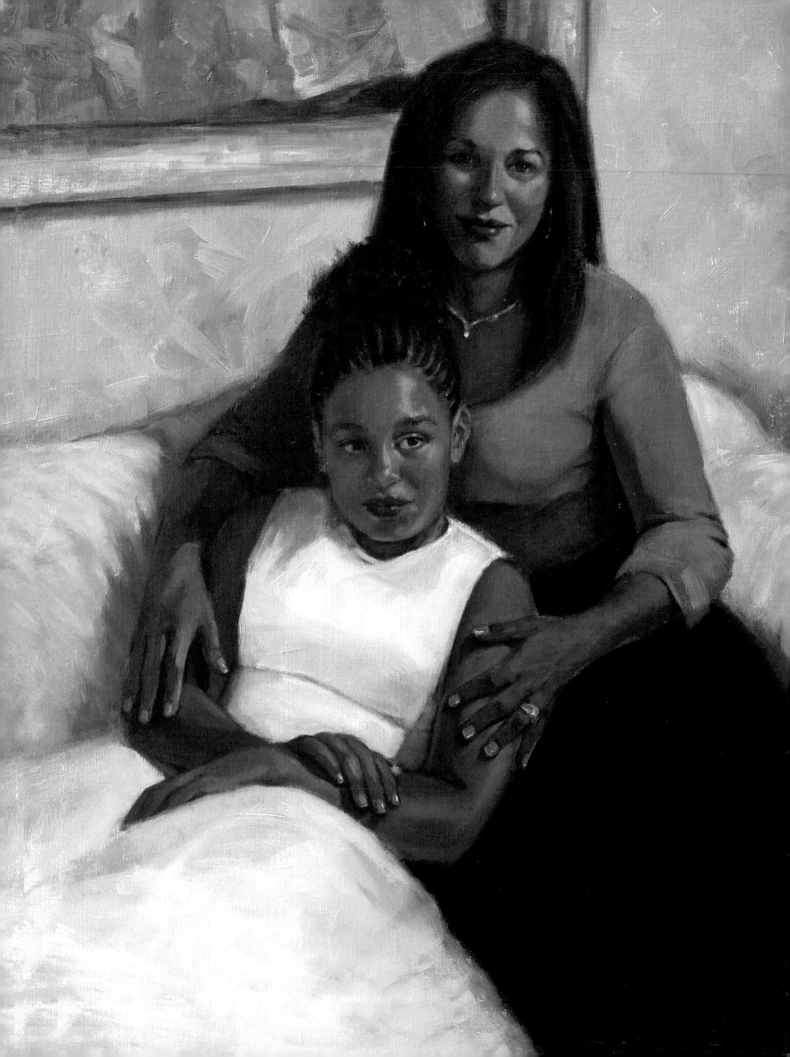

# Classic
# PORTRAIT PAINTING
## in Oils

## KEYS TO MASTERING
## DIVERSE SKIN TONES

Chris Saper

**NORTH LIGHT BOOKS**
CINCINNATI, OHIO
artistsnetwork.com

# Contents

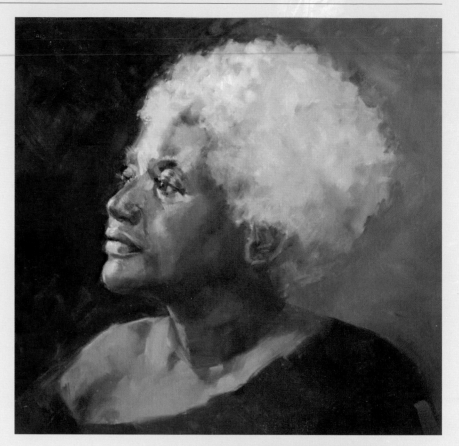

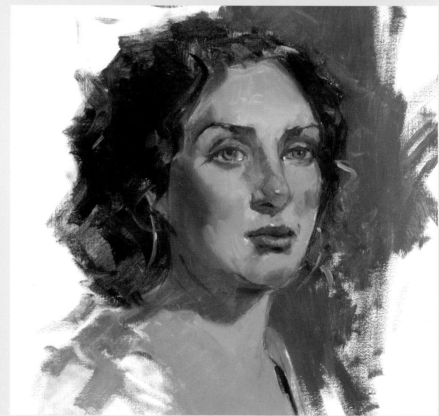

## WHAT YOU NEED

### SURFACES

- Artist's choice—author uses oil-primed linen canvas (occasionally clear acrylic-primed) in demos

### OIL PAINTS

- Alizarin Crimson Permanent
- Asphaltum
- Brilliant Yellow Light
- Burnt Sienna
- Burnt Umber
- Cadmium Orange
- Cadmium Red Light (or Cadmium Scarlet)
- Cadmium Yellow Medium
- Caput Mortuum Violet
- Cerulean Blue
- Flake White
- Flesh
- Foundation Greenish
- Indian Yellow
- Indigo
- Ivory Black
- Monochrome Tint Warm
- Naples Yellow
- Permanent Rose
- Phthalo Green
- Portland Gray Medium
- Radiant Blue
- Radiant Magenta
- Raw Sienna
- Raw Umber
- Titanium White
- Transparent Earth Red
- Ultramarine Blue
- Vermilion
- Yellow Ochre

### BRUSHES

- A variety of synthetic, sable and bristle options in small, medium and large sizes (from 1/16 inch [2mm] to 1 inch [25mm] or bigger) in the following types: cat's tongue, comb or rake, fan, filbert, flat, and mini pointed round

### OTHER TOOLS

- Binder or photo clips
- Camera
- Easel
- Mahlstick
- Medium of choice—author uses Oleogel and Maroger* in demos
- Odorless mineral spirits
- Palette (preferably handheld, midvalue and neutral-colored)
- Palette knife
- Photos (for reference)
- Pushpins
- Source light (natural and/or artificial)
- Straightedge

\* Product contains lead and carries a powerful smell, so use in a well-ventilated area and handle with care according to the manufacturer's instructions, or choose a suitable substitute.

## RECOMMENDED READING FOR PORTRAIT PAINTERS

*Face to Face With Greatness: The Adventure of Portrait Painting* by John Howard Sanden (The Portrait Institute Press, 2009)

*Portraits from Life in 29 Steps* by John Howard Sanden with Elizabeth Sanden (North Light Books, 1999)

*Harley Brown's Eternal Truths for Every Artist* by Harley Brown with Lewis Barrett Lehrman (International Artist Publishing, 2004)

*Painting Beautiful Skin Tones With Color & Light* by Chris Saper (North Light Books, 2001)

*On Becoming a Painter* by Robert A. Johnson (Sunflower Publishing, 2001)

*Painting the Visual Impression* by Richard Whitney (The Studios at Crescent Pond, 2005)

*Photo-Imaging for Painters: An Artist's Guide to Photoshop* by Johnnie Liliedahl (Liliedahl Publications, 2005)

*Color Choices: Making Color Sense out of Color Theory* by Stephen Quiller (Watson-Guptill Publications, 2002)

*Alla Prima: Everything I Know About Painting* by Richard Schmid (Stove Prairie Press, 1999)

# Introduction

Since writing *Painting Beautiful Skin Tones With Color & Light* more than ten years ago, I've had the opportunity to teach hundreds of students and to review and critique more work and portfolios than I can count. Within that context, several things stand out as predictable obstacles to artists progressing in the quality of their work. My goal in this book is to help painters overcome these obstacles and to embark on a path of growth and excellence in their work.

The most significant of these obstacles is not working often enough from life. Without regular practice painting the live model, even the most accomplished artists' skills will become rusty. There is simply no way to paint fresh and accurate color, thoughtfully executed edges and convincing form without study and practice from life. Period. There is no shortcut, no book or DVD that can give a painter the observational skills and insights to be gained from real life interactions with real subjects. Teachers routinely stress the importance of practice. They aren't just talking about repetitive acts; they are talking about the concept of "perfect practice."

In math or chemistry, perfect practice means systematically and accurately showing the steps involved in getting an answer. In vocal training, it means performing vocal exercises and scales that incorporate proper breathing, posture, mouth and tongue positioning—not merely hitting the notes in a song.

In portraiture, perfect practice means working with proper tools and under conditions that enable growth, including good lighting, good rest and good materials.

Another obstacle to better portrait painting involves using inferior references. Portrait artists who fail to insist on excellent photographic references cannot reasonably expect to have excellent results. Without honing our observational skills by studying the live subject (including still-life and landscape subjects) there is no way for us to effectively interpret photographic references or to understand the significant limitations they impose upon the portrait painter.

Through a series of paired step-by-step demonstrations—where each subject is painted once from life and again from photos—you will learn techniques that painters in any medium can use to understand and record accurate color and to retain that accuracy when using photographic references. Fundamental concepts such as drawing and value are discussed within the larger context of the demonstrations; however, much greater emphasis is given to seeing and mixing color in skin tones and successful portrait design and execution.

It is not my intent to repeat basic information on materials or the color wheel—such dialogue is available in virtually every published art instruction book on the market. Rather, I have selected seven different subjects representing a variety of skin tones and have chosen to show how and what I learn in color studies from life, and how that knowledge can be applied to a more finished portrait. In most cases I have had no more than three hours in the life study to get down basic visual information. I don't paint fast enough to complete a finished portrait in a life session, but with excellent photo references, I can take as much time as necessary to produce a finished work.

Nothing you read in this book is the one and only truth. In painting (or in any creative endeavor) there are many truths, all of which are valid. My suggestion in reading this book is the same suggestion I would make in taking any workshop (even mine), or watching any DVD: if you find something that can help you, by all means seize it. Let the rest go.

It is my goal, and I believe yours as well, to continue to grow as a painter. I want to convey more energy and more understanding of my subject, and to say something about the way I see that individual's beauty and character.

*Chris Saper*

Chris Saper

**Payne in Profile**
Oil on linen
20" × 16" (51cm × 41cm)

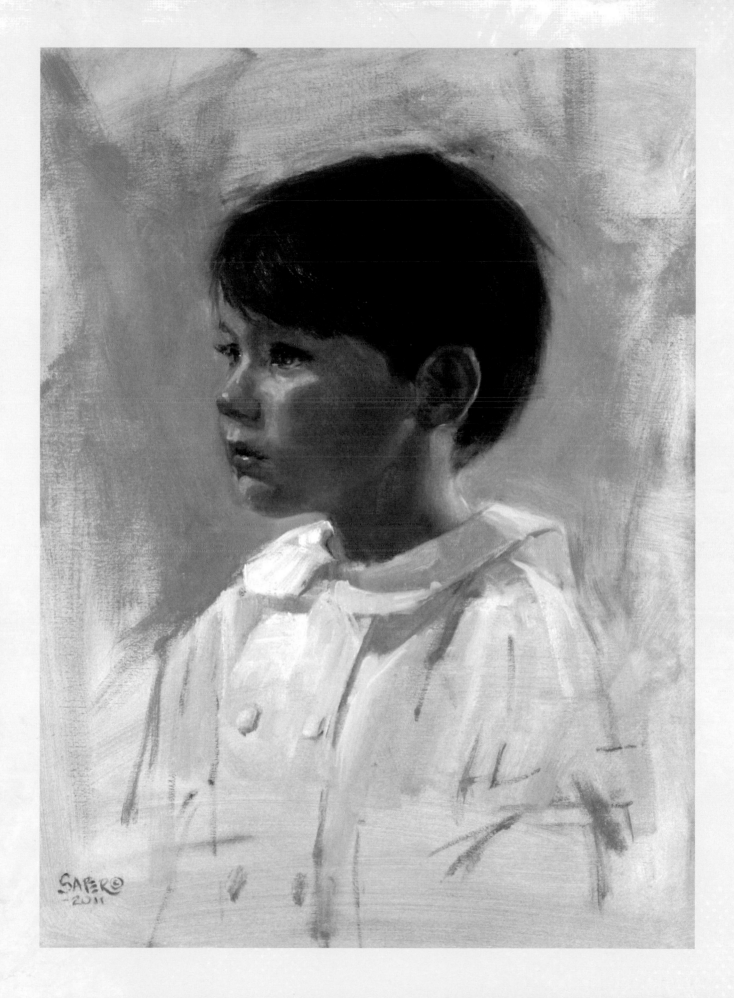

# Tools & Materials

The set of tools and materials you select as an artist is generally straightforward. The selection of materials within each category is, however, very personalized.

All you need to get started is a sturdy, solid easel, paint, brushes, a mixing surface, a painting surface and a way to clean your brushes. The important thing is that you buy the best materials and supplies you can afford.

Beyond the basics, and for each of the types of materials, you can get as carried away as a kid in a candy store, and so can your budget! Many of the tools you'll buy will last for years or even a lifetime. As you gain experience and study with other artists, you're likely to become introduced to supplies like paint colors and brushes that you may want to try out for yourself. These are generally low-priced additions, so start with a good set of basics and add to it over time.

# Setting Up Your Palette

Over time, every painter finds a standard working palette. Developing an intimate and regular familiarity with the same group of colors will allow you to become both proficient and efficient in color mixing.

Give your colors a fair chance to see how well you like them. If you find that you put out a color every day, and it's untouched when you clean your palette, drop it from your standard set of colors. Conversely, don't be afraid to try new colors to add to your usual palette.

## KEEP YOUR PALETTE CONSISTENT

The order in which you place your colors on your palette doesn't really matter, only that you place them the same way every time. This helps you quickly and efficiently reach for the color you want each time.

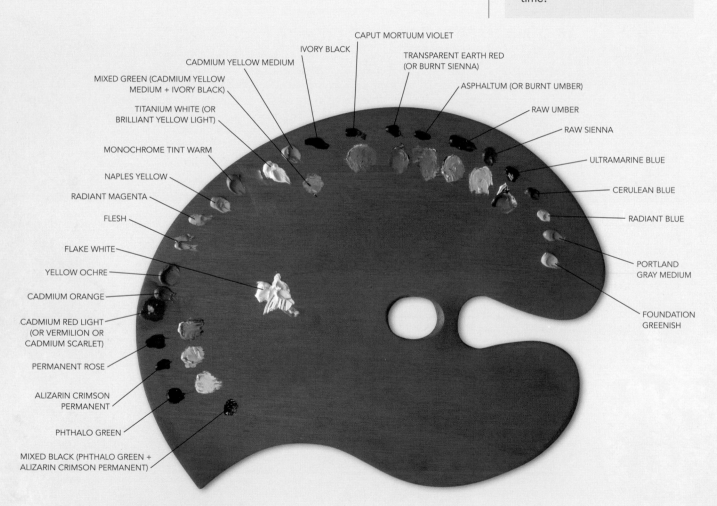

Labels (clockwise from top center):
CAPUT MORTUUM VIOLET
IVORY BLACK
TRANSPARENT EARTH RED (OR BURNT SIENNA)
CADMIUM YELLOW MEDIUM
ASPHALTUM (OR BURNT UMBER)
MIXED GREEN (CADMIUM YELLOW MEDIUM + IVORY BLACK)
RAW UMBER
TITANIUM WHITE (OR BRILLIANT YELLOW LIGHT)
RAW SIENNA
MONOCHROME TINT WARM
ULTRAMARINE BLUE
NAPLES YELLOW
CERULEAN BLUE
RADIANT MAGENTA
RADIANT BLUE
FLESH
FLAKE WHITE
PORTLAND GRAY MEDIUM
YELLOW OCHRE
CADMIUM ORANGE
FOUNDATION GREENISH
CADMIUM RED LIGHT (OR VERMILION OR CADMIUM SCARLET)
PERMANENT ROSE
ALIZARIN CRIMSON PERMANENT
PHTHALO GREEN
MIXED BLACK (PHTHALO GREEN + ALIZARIN CRIMSON PERMANENT)

## Set Up Your Standard Palette Every Day

This is my daily palette. All of the demonstrations in this book were created using this palette (plus a few specialty colors when applicable). It's important to put out your standard palette every day, even if you are working on only one part of your painting that seems unlikely to need every color. Areas of the portrait painted with isolated colors may create a disconnect with the color harmony of the overall canvas.

Sometimes you'll need to put out a color that can't be mixed, particularly if you are painting brightly colored fabric with quinacridones or phthalos. Indigo is a great color to use when painting someone with blue eyes; Indian Yellow is useful when painting blondes.

# Working With Oil Paint

To paint portraits successfully, you need a medium that lets you make changes and modifications throughout the painting. Oil, pastel and charcoal are the most forgiving. Acrylic and watercolor are more difficult to adjust once dry.

For me, oil on linen is truly the gold standard when it comes to portraits. Oil paint lets you work as loosely or a precisely as you'd like. There are so many choices in linen weaves and surfaces that you can select the surface that best suits your intent and painting style. The nature of the medium itself allows for subtlety in color and value transitions that I have found unparalleled. Oil is equally suited to the direct alla prima painter as to a classical approach using underpainting and glazing. If you're interested in commission work, you'll find that the highest demand for portraits is in oils.

## CONTROL YOUR DRYING TIME WITH MEDIUMS

Mediums are excellent for speeding up or slowing down the drying time of paint. Paints mixed in walnut oil dry more slowly than paints mixed in linseed oil. Mediums such as Maroger and a number of others speed drying. A tiny drop of clove oil will keep your paints "open," or wet, for many days.

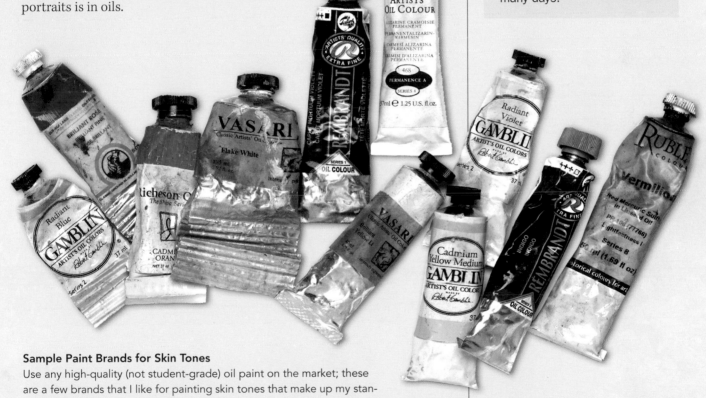

**Sample Paint Brands for Skin Tones**
Use any high-quality (not student-grade) oil paint on the market; these are a few brands that I like for painting skin tones that make up my standard palette.

## KEEP YOUR COLORS FRESH

Working with old colors is penny-wise but pound-foolish.

When you run out of a color, stop and replenish it.

Put out fresh paint as soon as a color begins to stiffen. Earth colors and colors mixed with Flake White or accelerated drying mediums will become stiff much faster than cadmiums or colors mixed with Titanium White.

# Brushes

Finding the brushes that work best for you is as personal as choosing a pair of shoes. Try synthetics, sables and bristles. Collect a variety of flats, cat's tongues, fans and filberts that vary in width between 1 inch (25mm)—or larger, depending on your painting style and scale—and ¹⁄₁₆ inch (2mm). Other brush types including the rake, comb and mini pointed round will also come in handy when painting portraits.

Don't accept any teacher's recommendation as the ultimate truth. You won't know what brushes you like until you use them for a bit. Think about those fabulous dress shoes you just saw in the store. They might look great in the shop. Your best friend might love them. They might be on sale. But if they aren't right for your feet, you'll regret it every time you put them on.

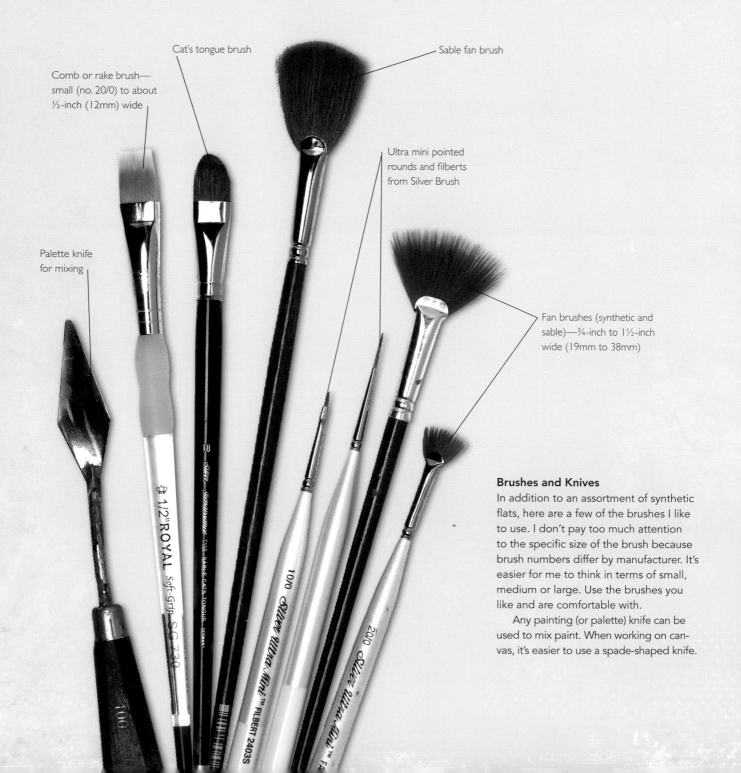

Cat's tongue brush

Sable fan brush

Comb or rake brush—small (no. 20/0) to about ½-inch (12mm) wide

Ultra mini pointed rounds and filberts from Silver Brush

Palette knife for mixing

Fan brushes (synthetic and sable)—¾-inch to 1½-inch wide (19mm to 38mm)

**Brushes and Knives**

In addition to an assortment of synthetic flats, here are a few of the brushes I like to use. I don't pay too much attention to the specific size of the brush because brush numbers differ by manufacturer. It's easier for me to think in terms of small, medium or large. Use the brushes you like and are comfortable with.

Any painting (or palette) knife can be used to mix paint. When working on canvas, it's easier to use a spade-shaped knife.

# Mediums and Other Tools

To get an idea of the enormous array of art gadgets available, page through any art instruction magazine. Many unique and useful tools have been developed by professional artists to make different aspects of painting easier.

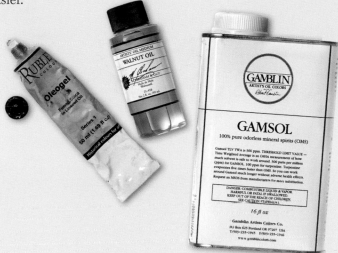

### Mediums and Mineral Spirits

Portraits in this book have been painted with Oleogel or Maroger medium. Oleogel, which is nontoxic and has no scent, can make your paints appear thinner or more transparent. Maroger will do the same—plus speed the drying time—but it should be handled carefully and used in a well-ventilated area, as it contains lead and has a very powerful smell. Pure walnut oil is a safe, nontoxic alternative, especially if you like your paints to dry more slowly. Walnut oil and Oleogel can be packed safely in checked luggage, should you need to fly with your supplies. It is not necessary, however, to use any medium at all when you paint.

I use odorless mineral spirits to clean my brushes and palette between uses.

### Mahlstick

Use a mahlstick to steady your hand when painting to prevent smudging. My mahlstick even came with an extension for painting very large works.

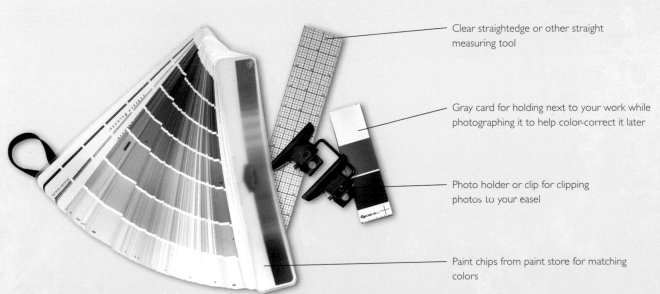

Clear straightedge or other straight measuring tool

Gray card for holding next to your work while photographing it to help color-correct it later

Photo holder or clip for clipping photos to your easel

Paint chips from paint store for matching colors

### Miscellaneous

Here are a few miscellaneous tools I use as a portrait painter. Gray cards are essential when photographing your work to ensure color accuracy in the event it's reproduced.

# Palettes and Supports

## Palette Considerations

If you haven't used a handheld palette, try it! There are enormous advantages to being able to mix colors right up against the model or right up against the canvas. It helps you avoid the mental delay that happens while moving back and forth from your easel to your mixing station.

The eye judges every color that you mix in comparison to the mixing surface. Regardless of what type of palette you choose or where you place it, be sure to use one that is a middle-value, neutral color. Middle value surfaces allow you to better gauge the value of a mixed color; neutral color surfaces let you better judge its hue, temperature and saturation. If you use a glass palette, place a piece of midvalue gray paper underneath, or try a wood palette in a neutral color.

After value and color, comfort and weight are most important in selecting a handheld palette. Sometimes the thumbhole needs to be sanded or reshaped so that it is more comfortable for your hand. If your palette drops forward when you hold it, glue some small weights under the front peninsula to balance it.

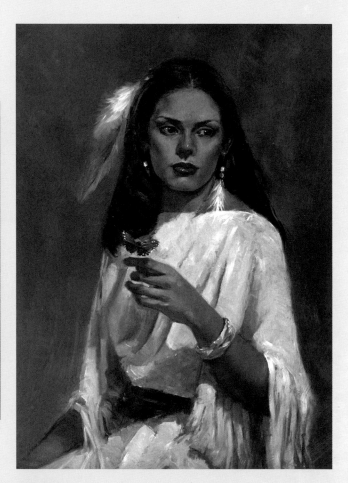

**Claessens C-13 Double Oil-Primed Linen**

Oil-primed Belgian linen is one of my favorites—it has beautiful texture and a variety of weaves available. The painted surface feels like soft leather. Claessens offers a C-13 fine weave suitable for portraits, though other oil-primed linens produce excellent results as well.

**Tee**
Oil on linen
12" × 12" (30cm × 30cm)
Private collection

**ABS Plastic**

ABS plastic is used to make everything from car dashboards to folding tables and will probably outlast the next ice age. Prepare the sheet of plastic to accept paint by sanding the surface to create tooth. Even when sanded, the surface remains extremely smooth, so be patient in getting the first layer of paint to stick. It's easier to work after letting your underpainting dry.

**Monarch**
Oil on ABS plastic
20" × 16" (51cm × 41cm)
Private collection

## Painting and Supports

A tremendous variety of canvases are available from fine art manufacturers. I prefer linen to cotton and oil-primed linen to acrylic-primed linen. Double oil-primed canvas has a beautiful, leatherlike feel, although it can be a bit difficult to stretch. Canvas textures range from a smooth, fine weave to a coarse weave closely resembling burlap. In general, relatively finer weaves work best for most portraits, assuming you are working in a life-size or smaller scale. Try several different textures, and you'll see how personal a canvas choice can be. The smoother the surface, the finer the detail you'll be able to get. On the other hand, a surface with a rougher weave can have a beauty all its own. Also experiment with stretched canvas and canvas mounted on a rigid surface to see which you prefer.

I've worked on surfaces with no texture, or tooth, including ABS plastic, as well as the tiny-toothed Wallis sanded pastel paper, which is a unique surface for oil as well as pastel. Be sure to use synthetic brushes if you're experimenting with sanded paper, since the surface will eat up your natural-hair brushes. The clear acrylic-primed linen canvases are a nice alternative for vignettes.

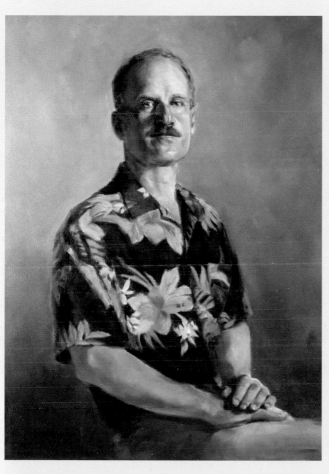

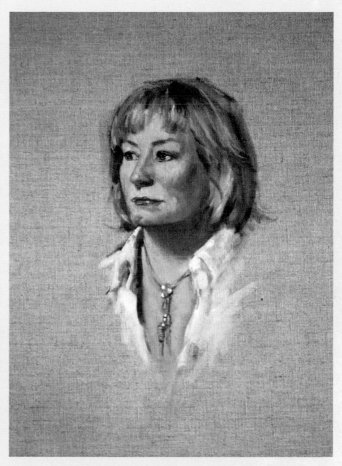

### Sanded Pastel Paper

Well known to pastelists, the Wallis sanded paper is rugged, heavy and versatile. Try mounting the paper to a rigid surface like Masonite. The fine gritty surface of the sanded paper allows you to explore a huge range of surface effects from dragging the pigment across the surface (much as one would apply pastel), to working very subtle, fine color and value transitions.

**Richard**
Oil on Wallis sanded pastel paper
20" × 16" (51cm × 41cm)
Private collection

### Clear Acrylic-Primed Linen

Several manufacturers offer clear acrylic-primed linen, which preserves the beauty of raw linen. The weaves tend to be a bit coarser than the portrait weave linen, but easy to adjust to. Given my penchant for oil-primed linen, I reserve the clear primed linen for vignettes where the color of the surface is an integral part of the painting.

**Colleen**
Oil on clear acrylic-primed linen
20" × 16" (51cm × 41cm)
Private collection

# The Basics of Painting a Portrait

This is an abbreviated example of how to paint a portrait. Here, I began the first two steps at a workshop, then finished at home in the studio. Refer to the quick reference guide often as you paint your portraits.

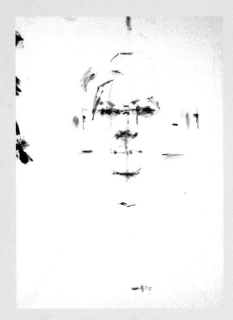

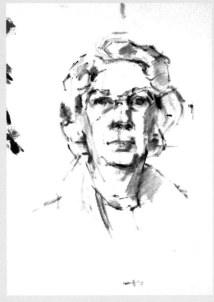

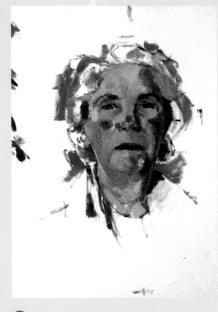

**1** **Establish the Measuring Marks and Color Notes**
After you've determined the lighting and the sizing and placement of the head, mark the vertical and horizontal measurements and the general angles using thinned Raw Umber and a small cat's tongue brush.

**2** **Separate Light From Shadow**
Once you have the basic layout and shape placement established, divide the painting into light and shadow areas. Don't worry about any middle values yet. Simply review the design pattern of your canvas and make sure you like the distribution of shadows and that the painting isn't equally divided between light and shadow.

**3** **Place the Background and Initial Skin Tones**
Place your background color immediately, right up against areas of your subject's hair, skin and clothing. Procrastinating on the background leads to difficulties in color and value judgment later on. Lay in general skin tones and hair color in a three-value pattern (dark, middle and light).

---

**QUICK REFERENCE:
PORTRAIT-PAINTING STEPS**

YOU CAN USE THE SAME METHOD TO PAINT PORTRAITS FROM LIFE AND FROM PHOTOGRAPHS. POST THESE STEPS IN YOUR WORKSPACE AND REFER TO THEM OFTEN.

1. Determine the color and type of source light
2. Pose and light the model (or choose the most appropriate photo)
3. Record your color notes
4. Place the subject on your canvas
5. Size the head
6. Establish vertical relationships
7. Establish horizontal relationships and angles
8. Separate light from shadow
9. Commit to the background
10. Paint the darks as a value layer
11. Paint the lights and middle values
12. Refine details and establish edges

Watch a free video lesson by Chris Saper at artistsnetwork.com/portrait-painting

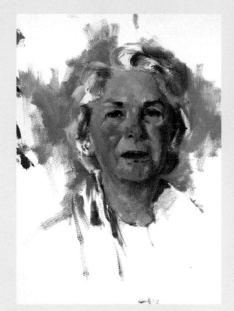

### 4 Refine the Colors and Value Transitions

Take as much time as you need to refine the skin tones and to model the forms of the head by attending to value. Each stroke is an opportunity to improve the drawing and the likeness of your subject. Set up the features to accept final details.

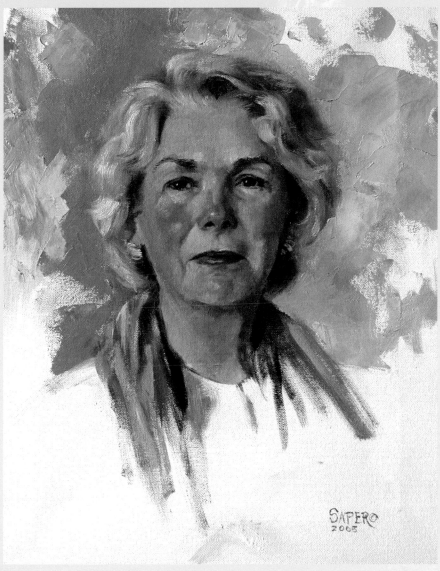

### 5 Fine-Tune the Details and Finish the Edges and Background

Complete the details in the features and hair. Consider how to finalize the edges, whether they may need to be softened or sharpened. For the vignette, work the background color and scarf into the surface so the vignette is integrated.

**Barbro**
Oil on linen
16" × 12" (41cm × 30cm)

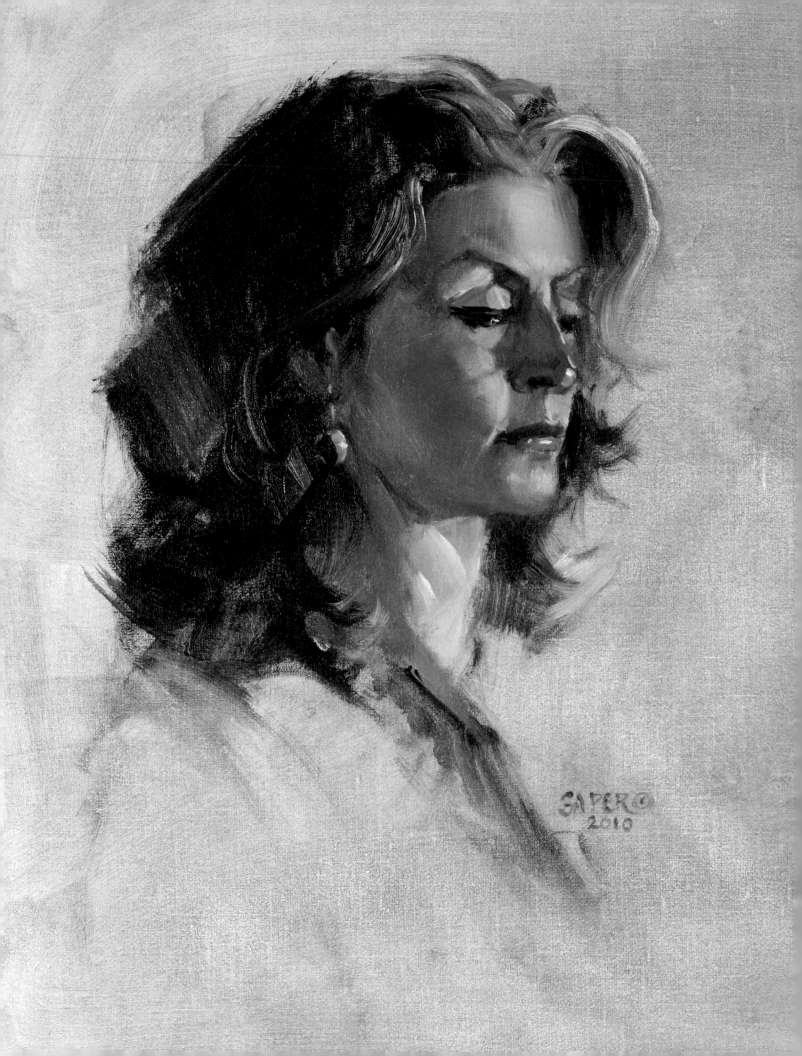

# Painting From Life

In this section you'll find information and tips on lighting and posing your subject, making compositional decisions about your painting, and applying the basic principles of seeing and mixing color. Although the discussion focuses on oil painting, the principles are universal and apply to any medium you choose to employ. We discuss ways to effectively light your subjects using both artificial and natural light sources. If you don't have artificial lights available, you can learn how to use natural light to your advantage. After all, portraits were painted for hundreds of years before electricity was invented, so think of light bulbs as just one of a number of modern-day conveniences.

**Silver Wolfe, Life Study**
Oil on linen
16" × 12" (41cm × 30cm)

# The Color of Light

All light has color, and that color is measured on the Kelvin (K) temperature scale, which for the artists' needs, generally runs between 2500K (candlelight, or daylight at sunrise and sunset) and 6000K+ (natural north daylight or color-calibrated fluorescent light bulbs). Like color, visible light can be warm or cool, depending on its source. Warm lights produce cool shadows and cool lights produce warm shadows.

The numbering system for Kelvin temperatures works opposite to what seems logical to us as painters: warmer colors have lower temperatures, while cooler colors have higher temperatures. It's probably most helpful to think of the Kelvin temperature scale as similar to a metal rod placed into a fire. When the rod begins to heat, it takes on a red glow. As the rod gets hotter, its glow moves from red to yellow to white and then finally to blue-white.

**CHOOSING YOUR LIGHT BULBS**

In selecting artificial bulbs, there are three main elements to consider:

1. Strength (watts)
2. Color (Kelvin temperature)
3. CRI or color rendering index*

*The index number rates (on a scale where 100 is perfect, natural daylight) how fully and accurately color is rendered under the bulb, so look for high CRI numbers.

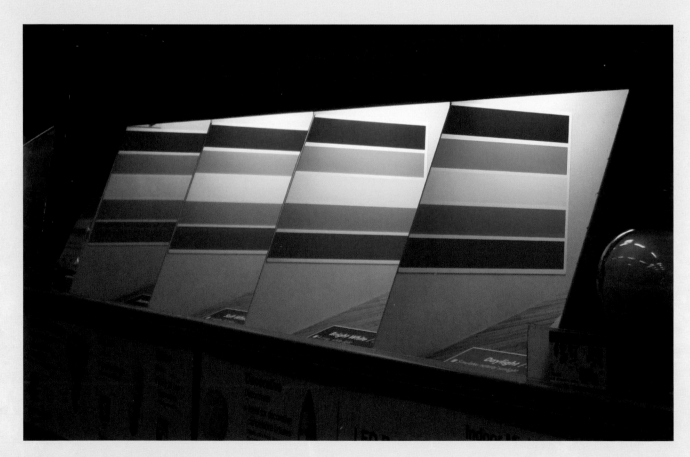

**Color Differences in Light Bulbs**
Displays like this in stores that have large or specialized lighting departments show how dramatically Kelvin temperatures impact color. On the left is indoor lighting; to the far right is bright daylight.

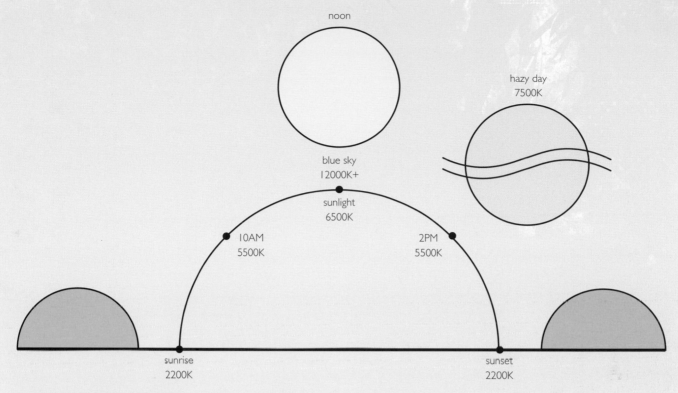

## The Changing Color of Daylight
Reddest at sunrise and sunset (about 2200K), the color of natural light becomes more neutral midmorning and midafternoon (about 5500K), and slightly cooler at noon. The warmer (redder) the color of the light, the cooler (bluer) the shadows will appear.

## Common Artificial Lights and Their Kelvin Temperatures
This diagram shows several common artificial lights and their color temperatures. Kelvin bulbs are currently available from 2700K to 6500K. However, the Energy Independence and Security Act will eventually eliminate incandescent bulbs in the United States, so there's been an explosion in new lighting technology. When you're buying bulbs, be sure to look into the newer options.

# Artificial Light

Artificial lights include incandescent (household bulbs), fluorescent, halogen and tungsten bulbs. Incandescents are similar in color to the natural light at sunset, creating a warm, orange cast on the skin and clothing touched in light, and cool temperatures on the areas in shadow. Fluorescent lights, often found in office and commercial settings, cast warm shadows and cool blue-green shadows on the skin and clothing. At full brightness, halogen light is yellow-orange, becoming more orange then red-orange as it dims. Tungsten lights are manufactured to exactly match 3200 tungsten film. While used extensively in color-controlled photography, they're impractical for lighting models because they are hot, delicate and expensive, and emit accurate color for only a limited number of hours.

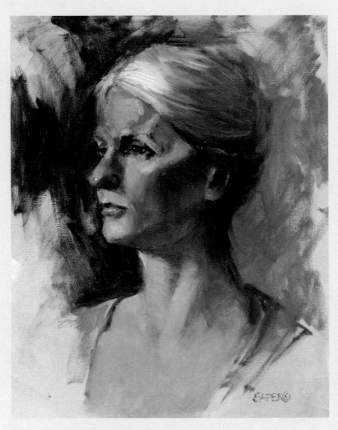

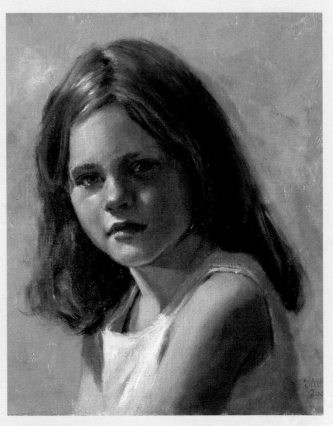

**Warm Artificial Light**
A standard household incandescent light (about 3000K) established strong, warm colors on the lit areas of Teresa. Cooler neutrals and desaturated greens in the shadows helped underscore the powerful, warm light source.

**Teresa, Life Study**
Oil on linen
16" × 12" (41cm × 30cm)

**Cool Artificial Light**
Mary was lit by a cool (6500K) compact fluorescent light, creating soft cool notes in the lit areas of her face, and relatively warmer tones in the shadowed areas.

**Mary in Blue (detail)**
Oil on linen
12" × 12" (30cm × 30cm)
Private collection

# Natural Light

The color temperature of natural sunlight changes throughout the day and with different weather conditions. Direct sunlight is very warm in color, influencing the reds and oranges in skin tones, and creates crisp shadows. Portrait painting from life in direct sunlight is unsuitable for any but the fastest of painters because light changes so rapidly, but can be excellent for quicker life studies and color observation. Natural indirect light remains constant for many hours.

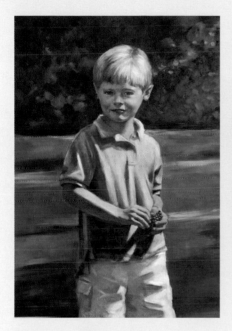

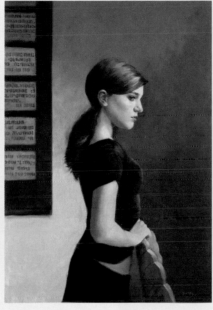

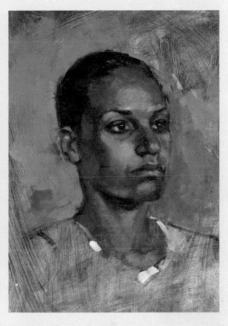

**Warm Direct Sunlight**
You can use strong direct sunlight to create dramatic lighting and exciting designs. When you photograph your subject in direct sunlight, angle his face so that you have back or rim lighting, or less than half the face in light. Otherwise, you'll get shadows under the eyes.

**William**
Oil on linen
30" × 24" (76cm × 61cm)
Private collection

**Cool Natural Daylight**
When you place your subject near a large picture window, you'll get soft, diffuse light that illuminates the figure directly and evenly from the side.

**East Light**
Oil on linen
36" × 24" (91cm × 61cm)

**Natural Indirect Light**
If your ceilings are high enough, you can use natural indirect light from above and to one side, as in this life study, by blocking off the light that would otherwise directly face your model.

**Irish, Life Study**
Oil on linen
20" × 16" (51cm × 41cm)

# Posing a Model in North Light

The Old Masters painted from life and frequently employed beautiful north light settings where the window light source was above the model and about 45 degrees to either the right or left. Light that rakes across the form provides light and shadow patterns that enable painters to use value to successfully model form. If you become skilled in setting up just two light and shadow pattern options, you'll be able to accommodate many, if not most situations. You can mimic north light with a 6500K artificial bulb.

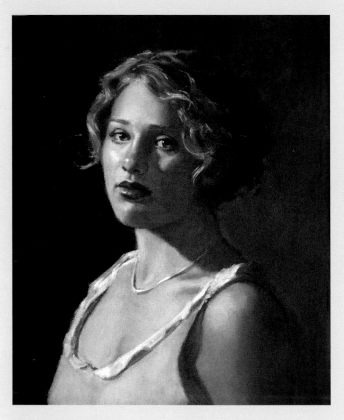

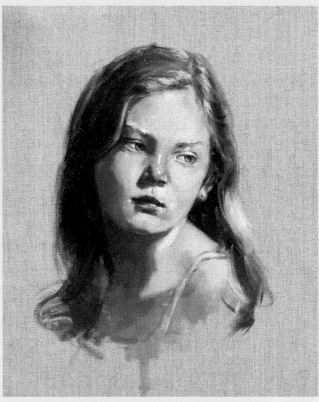

**The Rembrandt Option**
Lighting your model's face from above and about 45 degrees to her right creates a design that provides for an unequal but balanced division of light and shadow. Like Rembrandt's self-portrait, the shadowed side of the face shows a triangle of light on the cheek.

**Seventeen**
Oil on linen
18" × 14" (46cm × 36cm)
Private collection

**"Girl With a Pearl Earring" Option**
By rotating your subject just slightly more toward the light, you can find the same light and shadow pattern Jan Vermeer used in his exquisite painting.

**Kenzie**
Oil on clear acrylic-primed linen
20" × 16" (51cm × 41cm)
Private collection

# Convey Mood With Creative Lighting

Experiment with different lighting options in the way you direct light toward your subject. You can even combine two different temperatures in your light sources. Many artists utilize two light sources coming from different directions. Sometimes you'll want to introduce some fill light, just enough to keep the shadows out of extreme darkness. You can also use light sources of different or same temperatures. As long as they're not equally strong and the second source doesn't obliterate good light and shadow patterns in the face, you're OK.

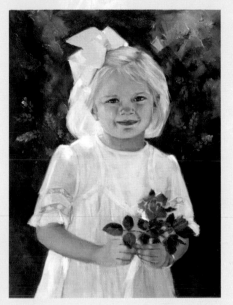

**Pull Your Subject Forward With Back Lighting**
Lighting your subject from above and behind creates strong edges and separates the figure from the background.

**Parker in Pink**
Oil on linen
20" × 16" (51cm × 41cm)

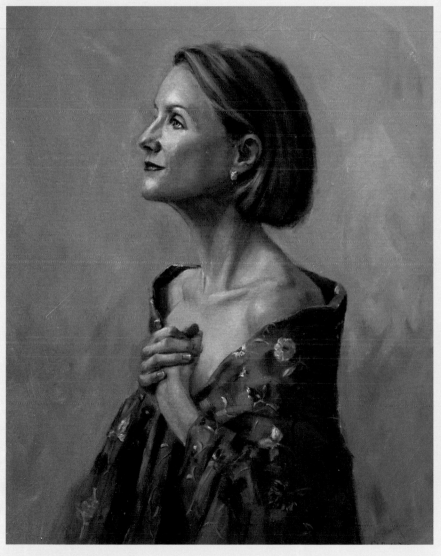

**Light a Profile Directly**
Profiles can work well when the subject's face is directly lit from the upper left and when it doesn't overwhelm the painting.

**Alison**
Oil on linen
24" × 18" (61cm × 46cm)
Private collection

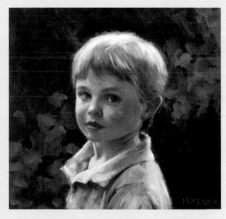

**Use Rim Lighting to Suggest Sunlight**
Rotate your subject slightly into the light to emphasize the profile and hair, leaving about two-thirds of the face in shadow.

**Brandt**
Oil on linen
12" × 12" (30cm × 30cm)
Private collection

Visit artistsnetwork.com/portrait-painting for a free demonstration on painting a vignette

# Keys to Working From Life

### It's All About the Clock

Most of the work I've done from life has been in open studio or classroom settings. Sessions typically last three hours, including model breaks. To make easel time most valuable in the live sitting, committing to the principle of perfect practice is truly worthwhile.

Consider the time you have available, and what you can best accomplish during that session. If you decide that you want to work on values, you might decide to paint or draw in monochrome. If you decide to work on color during a session, spend your time really observing, mixing and recording color accurately. You may even decide not to paint the head at all and instead concentrate on painting hands!

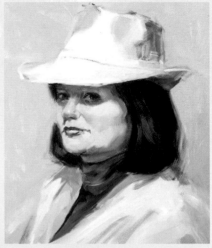

**Two-Hour Study: Practice Values and Drawing**
If you have only a couple of hours available, you can spend your time exploring value transitions in a monochrome medium.

**White Fedora, Life Study (detail)**
Black, white and gray oil on canvas
24" × 12" (61cm × 30cm)

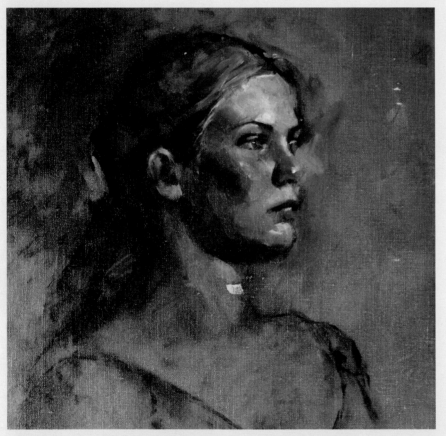

**Eight-Hour Study: Intensive Light and Color**
In much longer workshops, you have more time to work on subtleties and to notice problems and resolve them, achieving a greater overall likeness.

**Catherine, Life Study (detail)**
Oil on linen
20" × 16" (51cm × 41cm)

**Three-Hour Study: Focus on Color**
You might find your model wearing an exciting article of clothing that gives you the chance to study reflected color during your three-hour session and not to worry so much about likeness.

**Lavender Lady, Life Study**
Oil on linen
18" × 14" (46cm × 36cm)

# Tips for Painting Children

When you decide to paint a portrait of a very young child, often the greatest challenge is getting suitable photo references.

Infants and children who are not old enough to sit up on their own are usually better photographed being held by an older sibling or adult. A sleeping infant is just as charming a subject as one who is awake. Children between the ages of 6 to 18 months are generally easy to charm and cajole. But after about 2 years of age—well, that's when the fun really starts.

For the photo sitting, allow twice as much time as the maximum you think you'll need. You need to work around the child's naps, snacks, play and attitude. Let the parents know before you begin that you may need them to leave the room when you begin painting. Have a cue, such as asking for a glass of water, so Mom knows when it's time to leave the child and artist on their own.

Get everything (and I mean *everything*) set up and ready to go before you invite the child to sit. Absolutely use a tripod, and assume that you'll need to combine photo resources, even in an outdoor setting. Keep your viewing angle constant to enable you to combine images later.

**Use a Real Color Swatch of Fabric**
Sometimes the color of a dress or article of clothing is significant, especially if the garment is an heirloom or has been made by hand for the child. If the parent approves, use tiny manicure scissors to snip a bit of fabric from inside a seam. Of course, this works for clothing for any subjects, not just children.

**Use a Video Camera During the Photo Sitting**
Use a high-definition video camera to supplement your digital camera. Many videos produce excellent, printable single-frame images, perfect for catching the expression between the two silly-faced images you got with the still camera. To maximize your options, set both cameras on tripods right next to each other and at the same height. Turn on the video camera and let it run while you go about your photo sitting, directing your subject on where to look, how to sit and so on.

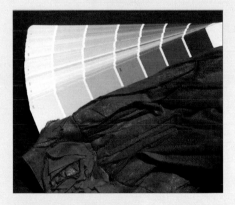

**Color References**
With children, you can mix your color notes for them while they play with toys or look at books. Alternatively, you can engage children. If they're old enough, play a color game where you and the child figure out the color that matches—skin, clothing, etc.—using a book of paint chips available through a variety of wall paint manufacturers. Pantone color books work well, too.

# Placing the Subject

In painting a head-and-shoulders subject, you must consider two things: head size and canvas size.

Is the head size you intend to paint consistent with your personal comfort zone? While my comfort zone ranges from about 50 to 90 percent of life-size, I've seen painters paint spectacular portraits with a head that's only 2 inches (5cm) high! With time and practice, you'll naturally gravitate to a size range that works for you.

The second consideration is the canvas size. Be sure you have enough room at the bottom to create a pleasing composition. You do not want to be forced to truncate the painting because you've run out of room.

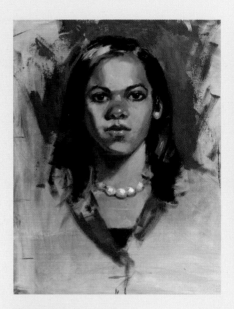

**Good Vertical Placement**
In a life study of this lovely young woman, the head is sized and placed so there is enough room at the bottom to include the beads and jacket closure, thereby creating a visual path that returns the viewer to the face.

**Elizabeth, Life Study**
Oil on linen
20" × 16" (51cm × 41xcm)

**Poor Vertical Placement**
There is so much extra room at the top of the canvas that my subject looks like he's slipping right out of the frame! Fortunately, I could re-stretch this canvas to a suitable composition.

**Boy in the Blue Vest**
Oil on linen
16" × 16" (41cm × 41cm)

**Canvas vs. Subject Placement**
Place your canvas so you can view both the canvas and your subject at the same time. Raise the easel tray so you're looking right at the canvas from your viewing position and your eye level is roughly at the model's eye level.

# Balancing the Subject

In a head-and-shoulders composition, the "lollipop on a stick" problem is significant. How can you make your painting interesting and dynamic, rather than static and boring?

A good portrait painting should contain a healthy amount of negative space around the subject. When deciding on the final placement, consider how far to the right or left of center you'll place the figure. In other words, on which side will you leave the breathing room? Strive for the "balanced but unequal" principles of composition—aim for slightly different amounts and shapes of negative space on either side of your subject.

Also, consider the following three elements to create a balanced composition:

1. The direction from which the light falls
2. The direction the model is facing
3. The direction of the model's gaze

Sometimes, when all three elements are in sync, deciding where to place the subject is easy. Make your decision based on the overall silhouette, including the hair, neck and shoulders, and sometimes the clothing. When only two of the three elements are in sync, you'll decide whether the strength of the third element is powerful enough to override the other two.

**Gaze Only**
In this case, both the direction of the face and the light source are to our right. Yet the strength of the gaze to our left is powerful enough to affect the head placement, leaving breathing room to our left.

**Hibiscus**
Oil on linen
12" × 16" (30cm × 41cm)

**Direction of the Light Source, Eyes and Face Agree**
When all three variables agree, it usually makes sense to leave breathing room on the side supporting the variables, in this example, on the right.

**Mallory**
Oil on linen
30" × 24" (76cm × 61cm)
Private collection

# Painting the Head in Profile

Many of my students tend to keep the edge of their subject's profile too close to the center line of the canvas. This will invariably result in too little room at the back of the head to include the hair, skull or collar without running off the canvas.

### Controlling Head Size

Although I frequently see students allow the size of the painted head to grow throughout the process, I can't recall ever seeing a head become smaller. This may be because it's perceived as easier or faster to change the size of adjacent features or elements to accommodate something that may already be painted well, but is the wrong size or in the wrong place. For this reason, I insist that students stay with a head size that reflects their initial sizing decisions. Sometimes just keeping the measuring marks of several key landmarks will be enough, but other times it's helpful for the painter to place a piece of tape along the top of the silhouette. I'll hear, "But it's only a head and shoulders! What does it matter?" Well, the fact is it might not matter for this particular painting. But establishing the discipline does matter; it's part of perfect practice, which leads to successful paintings. Consider the significance of painting head sizes arbitrarily when there is more than one subject in the composition, or when the accuracy of the scale of other pictorial elements in a larger composition is required to make the painting convincing.

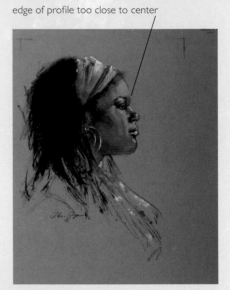

edge of profile too close to center

**Subject Too Close to Edge of Paper**
In this life study, I jumped the gun to get started and placed the edge of the profile too close to the center of the paper, crowding my space on our left. Paper works may be cropped more easily than canvas, so that is an option here.

**Rush**
Charcoal on Canson Mi-Tientes
24" × 18" (61cm × 46cm)

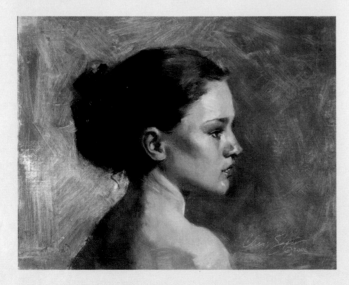

**Well-Balanced Negative Space**
Differently shaped and sized negative spaces let the head sit comfortably on the canvas.

**Beauty**
Oil on linen
8" × 10" (20cm × 25cm)

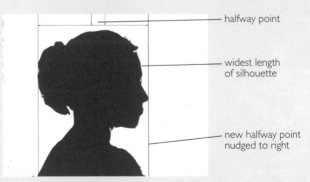

halfway point

widest length of silhouette

new halfway point nudged to right

**Place the Silhouette**
Consider the widest part of the silhouette, including the hair, then locate the "landmark" or halfway point across the widest part of the shape. Then nudge the silhouette's center point slightly to the left or right of the center point of the canvas, depending on where you decide you need more negative space. Here, I want some extra space to the right, so I nudge the new center line in that direction to balance the canvas.

# Seeing and Evaluating Skin Tones

You can use the same approach to evaluate every color you see—whether your subject is still life, a landscape or a portrait—by asking yourself three questions:

1. What is the local color, which is the color of an object unaffected by light and shadow? For example, red is the local color of an apple, although it may appear as a warm red (contains orange), a cool red (contains blue) or somewhere in between, depending on the way light reflects off it.
2. What is the value of the color (how light or dark)?
3. How saturated (pure) is the color?

Evaluating skin tone is no different than an apple, except that living skin contains elements of red and yellow, that is to say, orange. When you look at your subject, consider whether the skin tone leans toward red, toward yellow, or whether it falls in the middle. Then you are ready to make a judgment about its value, and finally its saturation.

## Evaluating Skin Tones

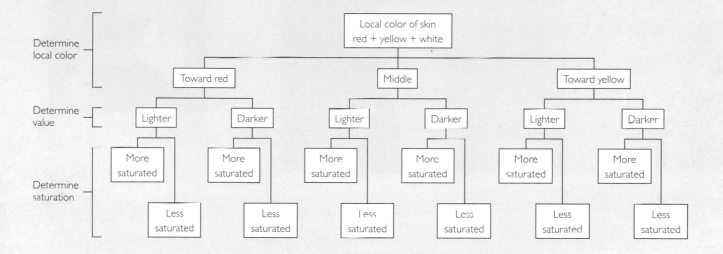

# Mixing Skin Tones

For middle to lighter skin tones, try starting with Flesh (or a mixture of Cadmium Scarlet + Yellow Ochre + Flake White), adjusting the proportions for both value and color. For middle to dark skin tones, start with a mixture of Cadmium Scarlet + Yellow Ochre, then adjust the value with Asphaltum and/or Transparent Earth Red depending upon the color and saturation of the darker skin tone.

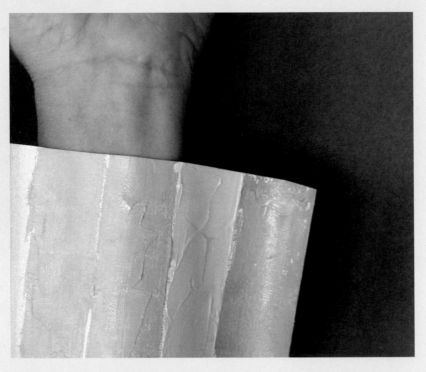

### Paint Your Own Skin Tone

Look at the skin on the inside of your wrist and think of it as a shape of color. Mix a general skin tone that roughly represents your basic skin color—in my case, Flesh + Radiant Magenta. Next, I adjusted the value of the basic color by adding Flake White. (Naples Yellow would also have worked, but Flake White helped cool and lighten it, instead of just lightening it.) Finally, I adjusted the saturation of the color mixture by adding a mixture of Raw Umber + Foundation Greenish, mixed to match the value of the color mixture. Sometimes you need to make a final correction. Here, I added a little more Radiant Magenta to pink up the color. Either of the two color swatches on the left can be used to paint the wrist color.

After you've done this exercise, turn your hand over and paint the skin tone on top of your forearm.

# Creating Color Notes

Take the time early in your life session to make up the color notes of the main elements of the painting. These will be essential for reference both during the life session and later when you work on the painting in the studio with your reference photographs.

## An Octave of Color Notes

I mix my color notes on a small scrap of canvas or the border of my painting. I record the main colors of my subject in eight squares, leaving some space around the grid where I can write the exact color mixture in pen or pencil. I mix the base colors for the skin, hair, clothes and background each in light and shadow and place on the canvas grid, creating a beautiful octave of color notes for reference as I paint the portrait. Written notes also help you remix at a later date.

**Step Forward to Check Your Color Mixtures**

Often your canvas will not be lit in the same way as your model, especially the farther away you are. It's helpful to evaluate your color mixtures by taking your palette knife and handheld palette right up to the model. Hold the knife against the skin color you're mixing, against the background, and then against the clothing. In more complex compositions, you may want to mix two background colors. One mixture is fine if the background is fairly evenly colored.

| | |
|---|---|
| Background in light | Background in shadow |
| Skin in light | Skin in shadow |
| Hair in light | Hair in shadow |
| Clothing in light | Clothing in shadow |

**An Octave of Color Notes**

# Painting From Photographs

**M**ost portrait painters paint from photographs—some rarely, some often. The entire premise of this book, of course, is that to paint successfully from photographs you need to do two things: first, paint regularly from life. Second, insist on excellent photographic reference—and I mean excellent. You can't count on other people to hand you the right material, so it makes sense to learn how to properly take (or select) the photos yourself.

Too often, I see students whose work is doomed before they begin simply because of poor reference. John Singer Sargent couldn't have done anything with my fourth-grade class picture, nor would he have even tried. Even when, and maybe especially if, you're just practicing, make the practice count toward your own growth, embracing the idea of perfect practice.

**Mary Sue (detail)**
Oil on linen
20" × 16" (51cm × 41cm)
Private collection

# The Photographic Sitting

The photographic sitting is fairly straightforward, as long as you take the time to set up your camera properly. When painting an adult, I start with this request: "Can you tell me the two things you like best about your face and the two things you like least?" The answers are invaluable in helping select the best angle, lighting and side of the face to emphasize.

With children, the process of setting up the photographs is often up to you. Parents love their children and love the way they look, and usually children haven't yet learned to develop aesthetic preferences (likes or dislikes) about their appearance.

Because your subjects need to stay still only for a fraction of a second, feel free to take as many photos as you like and in interesting positions that could never be held in real life—sometimes by the subject and sometimes by you! You can vary your point of view and the nature of your light.

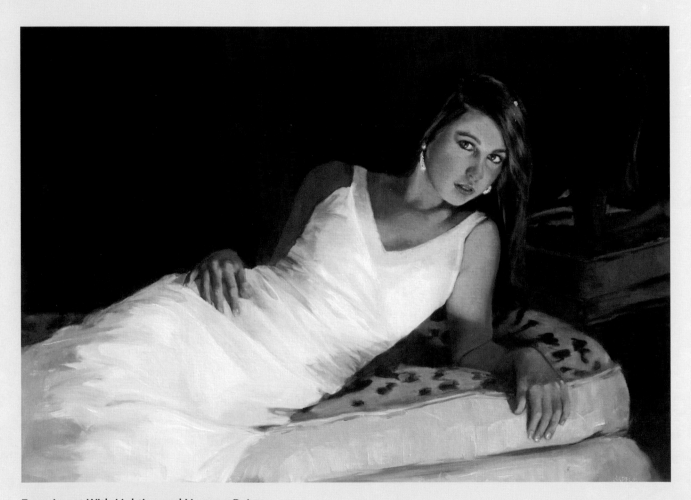

**Experiment With Lighting and Vantage Points**
Have fun experimenting with different lighting situations and vantage points when you photograph your model. By lighting Mary from below and situating her in a diagonal position, I was able to establish a dramatic mood. My camera was only about 30 inches (76cm) from the floor—quite unsuitable for canvas placement!

**Mary in Saffron**
Oil on linen
30" × 40" (76cm × 102cm)
Private collection

# The Life vs. Photograph Debate

The debate about whether it is better to paint from life or from photos will go on as long as there are painters. I love to do both and for different reasons. I'll happily give up a tight likeness and precision for the sheer joy of painting in the moment and the fresh results. Yet, with photo reference, I enjoy spending as much time as I like to work on subtleties in color and value, seeking the accuracy I want in likeness, design and surface quality. Keep in mind, however, that only working regularly from life is what will give you the skills you need to paint successfully from photographs.

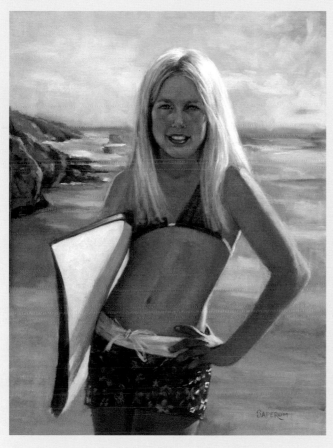

**Paint a Fleeting Moment With the Help of Photos**
Certainly no one could ever hold a surfboard long enough for me to do a painting from life or even a quick study. The same is true for a smile.

**Kim**
Oil on linen
24" × 18" (61cm × 46cm)
Private collection

**Create a Background From Photo Reference**
Knowing that Kim was going to be painted in a beach setting, I hunted down some of my old vacation photos from the coast (making sure that the sun's direction agreed with that in the photos of Kim) and painted her in the chosen location. In reality, I took Kim's reference photos in an Arizona desert backyard; here, you can just barely see the edge of her surfboard.

# Taking Photo Reference

Do you need to be a good photographer to be a good portrait painter? If you plan to paint from photos, then yes, or you need a good photographer who will work with you. You can learn the basics of photography easily enough, and you'll only get better with practice. You don't need to produce Pulitzer Prize-winning photographs, just images suitable enough to help you in your painting.

You can also use someone else's photo as reference, as long as you have the permission of the photographer. Sometimes you won't have the choice, as with a posthumous portrait. It is uncommon for the typical client to have a photo with the right composition, light and shadow patterns suitable for the portrait painter. It's better to take your own photos unless you have no other option.

Do you need a fancy, expensive camera? No. A digital SLR is nice, but good quality, lower-priced digital cameras—new or used—are fine. As long as your camera has at least 5 megapixels, you'll be able to achieve the quality and resolution needed for most situations.

## Preparing to Shoot

Manage your digital camera's settings to:

1. Disable the flash
2. Set the file size to the highest resolution
3. Shoot in TIFF or RAW settings, if possible
4. Set the white balance (the proxy for Kelvin)

Use a tripod. By using a tripod you'll make it easier to later combine reference photos because everything was shot at the same height. Even with a tripod, it's best to use a cable release or self-timer to minimize lens movement during the exposure.

Attend to the details of your model's pose—the hair, jewelry, collar, scarf, hands and so on—before taking the photos. Get any close-up photos that you may need later on. Take one photo of your subject holding a gray card or color checker so more accurate color adjustments can be made later on your computer.

If your computer and image management skills permit, consider adjusting the color on your computer screen while your model is still posing.

You'll be able to avoid focal plane distortion by the lens you use and the distance between your camera and your subject. A lens that zooms within an approximate range of 70–135mm is a good choice. It's very important to stand back from your subject and zoom in to minimize foreshortening problems and distortion of the overall image.

**Weak Photo Reference**
Although this photograph is a beautiful picture, it's not suitable as a painting reference. The light is too diffuse and flat to show form well, and the broad smile creates crinkles under the eyes and shadows in the nasal-labial folds.

**Strong Photo Reference**
In this example, the light rakes across the features and gives the painter the best opportunity to show three-dimensional form. The shadows are light enough to show good visual information, and the pose is dynamic, even though it's just a head/shoulder composition.

# Sizing Reference Photos

For the first seven or eight years I painted portraits, I worked from little 4" × 6" (10cm × 15cm) prints, or if I was lucky, an 8" × 10" (20cm × 25cm) image. Then I attended a lecture where the speaker asked, "WHY would anyone do that? It is so much easier to paint from a photo that's the same size as what you're painting!" Indeed. Having your prints the same size as what you're painting allows you to use the photos in a way that mimics "sight-size" painting, standing back from both your painting and the reference to compare.

You can have your digital images printed by many widely available services, or you can print them yourself with the proper equipment. Experiment with your photo editing software—whether in Photoshop or the software included when you purchased your digital camera. There are usually several adjustments I need to make in Adobe Photoshop. You don't need an expensive version of Photoshop to get the basics of what you'll use, nor do you need to understand every nuance of the program. Check out online tutorials and videos to help you get started.

## SIZE THE HEAD

Measure the height of the head in Photoshop, or simply use a ruler to measure its height on an existing print. Resize the head according to the size you'd like for the painting, using this simple formula:

target head size ÷ existing size = percentage that the head size must change

In this case I've selected a target head size of 7" (18cm) in height, and 16.235" (41cm) is the existing head height. So 7 ÷ 16.235 = .431, or a target head size of about 43.1 percent.

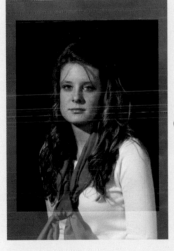

12 inches (30cm)

16 inches (41cm)

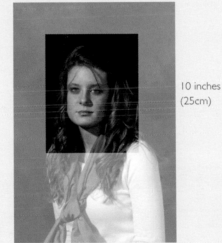

8 inches (20cm)

10 inches (25cm)

**Fit the Head Size to Your Canvas Size**
Change the canvas size (perimeters) to reflect the canvas you intend to use, or decide what size of canvas best suits your plan. You can do this in Photoshop or with a small, proportional thumbnail sketch. In this case, the portrait would fit nicely on a 16" × 12" (41cm × 30cm) canvas, composed to include a comfortable amount and shape of the scarf at the bottom of the canvas.

**Work Out the Composition**
Evaluate your design options and decide on the placement of the figure. In this case, the 7-inch (18cm) head size would be too large for a 10" × 8" (25cm × 20cm), crowding the negative spaces and cropping the scarf in an awkward place. If you needed to use this format size, then you'd have to go back to make the target head-size proportionally smaller.

# Photo Pitfalls: Edges

It is the nature of photography that edges are defined by the camera's images—that is, everything on the focal plane is shown equally in focus. Yet that is not how our eyes work. Without the artist's purposeful handling of edges, it's difficult if not impossible to create the center of interest, which is, after all, the point of the painting.

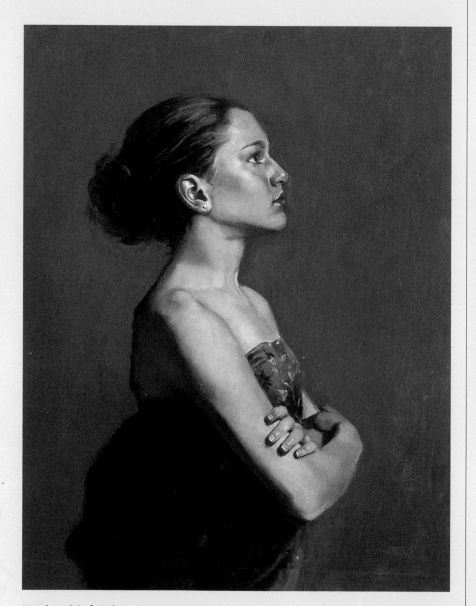

**Hard and Soft Edges Determined by the Painter**
By limiting fabric detail to the upper front of the dress, I kept the viewer's eye on the focal point of this portrait, while the lost detail supports the overall composition with a shadowed structure.

**Threshold**
Oil on linen
24" × 18" (61cm × 46cm)

**Too Many Sharp Edges**
In this example there is far too much detailed information in the shawl, so it's necessary to soften some edges and lose others to preserve the painting's center of interest.

# Photo Pitfalls: Color

Unless you are skilled in printing great photographs, it's pretty difficult to get reasonable color in your reference prints, especially in shadows. In this example, the shadows appear as a dull grayish brown, nothing like you'd see in life. This is where regular, focused study from life will pay off in spades.

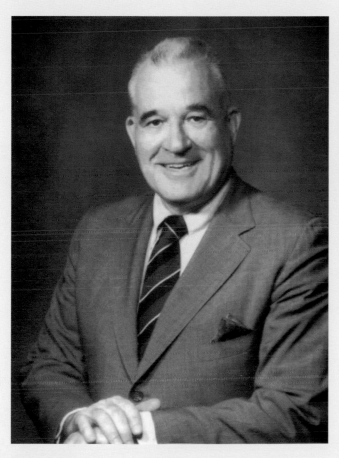

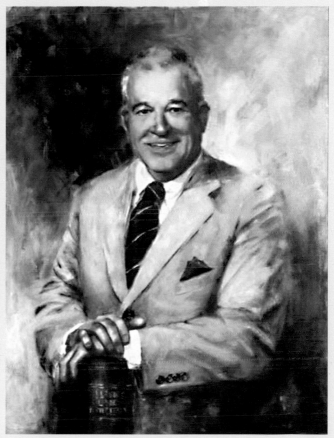

**Dull, Inaccurate Photo Reference**
Sometimes you're limited in photo reference material for posthumous portraits. In this case, a faded studio photograph was a challenge. However, to underscore Judge Dougherty's legal career, I substituted my husband's hands holding a copy of *Black's Law Dictionary* (instantly identifiable to any bar association member by its color and girth), and selected one of the judge's favorite ties to personalize the portrait for family members.

**Color Scheme Selected by the Painter**
The color scheme for this portrait arose when I learned of the judge's favorite album, Frank Sinatra's *September of My Years*, and its cover art.

**The Honorable William Anderson Dougherty**
Oil on linen
24" × 18" (61cm × 46cm)
Private collection

# Printing Suitable Photos

I usually adjust the values and saturation of my images before printing. You may or may not need to make adjustments; you'll learn your preferred corrections through experimentation with your computer and printer. Use photo-quality paper and your best printer settings.

**PRINT FEATURES TRUE-TO-SIZE**

If you'll be printing on regular 8½" × 11" (22cm × 28cm) paper and your canvas is larger than that, you'll need to print some sections of the image separately (for example, true-to-size prints of the head and hands). You can decide whether you want larger images of other details, such as jewelry or clothing.

**Uncorrected Image**
This is often the way my photos look right out of the camera, a little gray and a little dull.

**Improved Values**
Photo-editing software can make your values beautifully crisp. In Photoshop, the tools for this are called Levels and Curves. Consult your program manual (or teenage neighbor) to learn how to use them.

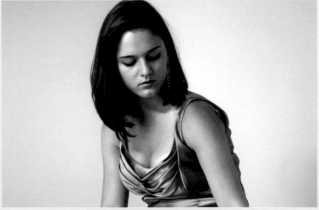

**Adjust the Color Saturation**
Most digital cameras have an inherent color cast. With my camera, the reds tend to be oversaturated, so I adjust the image by reducing the reds in color saturation.

# Painting a Multiple-Subject Portrait From Photos

Perhaps the most challenging request you'll face as an artist is to create a portrait with more than one subject. The main problem is that very few photographs have everyone looking their best in a single frame. For each additional subject, the difficulty compounds exponentially. However, by learning how to manage your photo resources, you'll pave the way to make more creative, more exciting paintings.

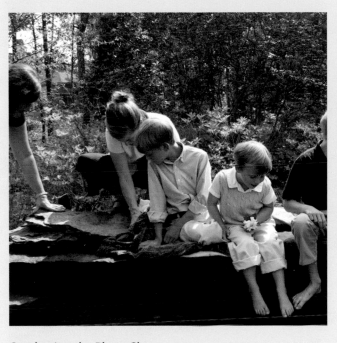

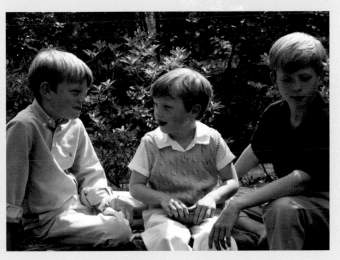

**Document Relative Head Sizes**

Be certain that you have at least one photo with all of your subjects in their relative positions. Assume that you'll need to combine photos for the painting, and that many may need to be resized. As your subjects' placement moves away from a perpendicular relationship to your camera, the relative sizing is even more critical to make your painting convincing. In this case, all three boys are on the same focal plane.

**Conducting the Photo Shoot**

Think through the compositional options before the photo shoot—especially when young children are involved—so you can place your subjects together in the context of the lighting you'll be using. For example, the taller subjects could cast the smaller people in shadow. Here, the natural light from above and slightly behind is a good solution.

The more you think through and discuss clothing options beforehand, the easier all will go. Try to think *value* instead of *color* so you don't have to contend with distracting black-white-black-white patterns.

## ARRANGING YOUR SUBJECTS

Set your subjects exactly where you want them. Often this means you must physically move into the figure's place and say, "Sam, sit here just like this, your hands go like this," and so on. Then leave Sam in place and take the position of the subject next to him, and say, "John, you sit here, just like this." In this case I was thrilled to have some adult help. The towel the boys are sitting on is similar in color and value to the rocks, so it keeps the boys comfortable on sharp edges and cold stone without introducing illogical reflected color.

Visit artistsnetwork.com/portrait-painting for a free demonstration on painting a vignette

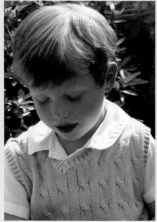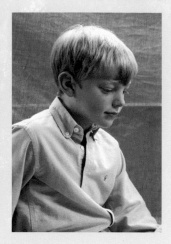

## Take Additional Reference of Any Missing Visual Information

I initially photographed many images I'd be able to use including hands, feet and body language. Then I reviewed all the images for expression, lighting and narrative and realized a couple of problems. First, the bright day made the boys squint a bit, and second, several details were missing, including an appropriate prop for the youngest child to hold on which he and the middle boy could focus their attention. To fix the problems, I softened the lighting by setting up a partially shaded place on the porch, using a neutral gray backdrop and my artificial warm light to mimic the lighting direction in the sunlight. There I was able to photograph details of hands, feet, expressions and the toy boat.

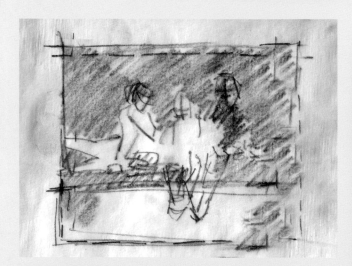

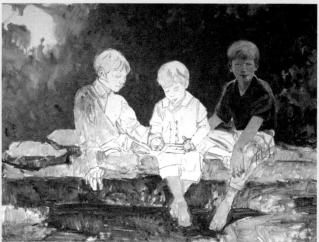

## Work Out the Composition Including the Canvas Dimensions

Develop the composition with a few quick thumbnail sketches. I was able to add the right amount of space at the bottom to avoid crowding the feet, plus balance the overall space from left to right. For this canvas, I used a 36" × 48" (91cm × 122cm) format that would give me head sizes of about 6 inches (15cm). Here, the solid line represents the original photo; the dash lines show adjusted space and perimeters.

## Adjust the Photo Composite to Scale and Begin the Drawing

Because I had at least one photo that showed the relative sizes of the boys, I could resize the details properly before I got ready to paint. I used thinned Raw Umber and a medium cat's tongue brush to draw all the major shapes, then immediately committed to the background's general color and value. Since I knew this portrait would require many sessions, it didn't really matter whether I started on the left or the right. However, if you know you will be painting wet-into-wet, you might want to start toward the top, and from the left if you are right-handed, or from the right if you're left-handed.

**The Rock Pond Boys**
Oil on linen
36" × 48" (91cm × 122cm)
Private collection

## CREATING INTEREST THROUGH STORYTELLING

Given the complexity of painting the multiple-subject portrait, there's little reason to make one unless the subjects relate to each other, which generally argues against each person looking directly at the viewer. Sometimes it can be difficult for parents to think about one or more of their children not making eye contact, so part of your job is often to help educate them about the strength of the painting as a whole. If a parent wants each child to star in his or her own painting, then it makes more sense to paint each on a separate canvas, but with compatibility of lighting and settings so that they can hang on a wall effectively in a group.

In this example, the parents were very clear that they wanted a piece about their boys' relationships. We chose to show the kindness and affection the middle child demonstrates to the youngest boy and the protectiveness that the oldest boy exhibits toward his younger siblings.

Visit artistsnetwork.com/portrait-painting for a free demonstration on painting a vignette

# Keys to Photographing Multiple Subjects

To create natural looking composites from which to paint, you need to set up your photo shoot correctly from the start. Here are some techniques I've picked up over the years.

- **Do not move your camera relative to your subjects.** This means you don't get closer, you don't move farther away (use your zoom instead), and you don't change the height of your camera relative to your subject (you'll need a tripod).

- **Neither you nor your subjects may move relative to the direction of the light source.** This is especially critical when photographing subjects in strong artificial light or direct sunlight because the light and shadow patterns are crisp and unforgiving.

- **Stand back from your subjects.** You want to be at a place that lets you zoom in to the face, hands and features for detail, and then zoom out for the full-frame image.

- **When you look through your viewfinder, start with the person on your left.** Direct her head placement, gaze, body language and hands, snapping each time. Get the full-frame shots and then zoom in for detail. Then move to the person next to her, doing the same thing. You are the only one who knows who your focus is on (not to be confused with the camera's focus).

- **Get all the resource information you need at the time of the photo shoot.** That means hands, feet, jewelry and, of course, the faces. It is not fun, nor always possible, to go back for something that's missing. Fix uneven collars, awkward folds and strange hair shapes. I always ask my subjects beforehand if they mind if I touch them. I have never had anyone say no; it's just a matter of courtesy.

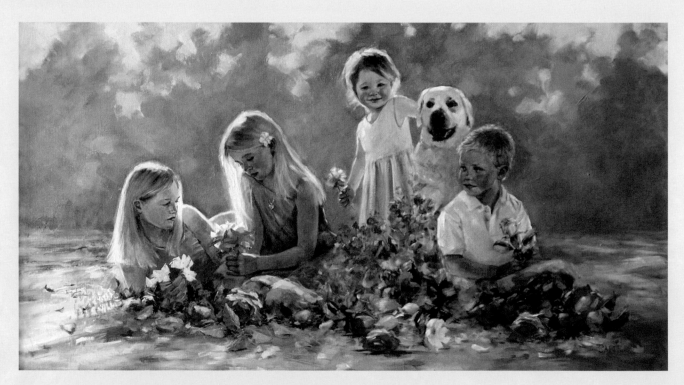

Similar skin tones among siblings offer opportunities to create natural color harmonies.

**Sonny and Friends**
Oil on linen
28" × 40" (71cm × 102cm)
Private collection

Watch a free video lesson by Chris Saper at artistsnetwork.com/portrait-painting

Plan for simplified arrangements of lights and darks in the overall composition.

**Jaime and David**
Oil on linen
42" × 34" (107cm × 86cm)
Private collection

Careful placement of heads and arms can let you incorporate a complex pattern into a canvas of simple, large shapes without losing your center of interest.

**Sheldon and Betté**
Oil on linen
36" × 50" (91cm × 127cm)
Private collection

Visit artistsnetwork.com/portrait-painting for a free demonstration on painting a vignette

# Painting Portrait Details

In each of the exercises in this chapter, we discuss approaches and techniques to paint unique facial details you're likely to encounter in portrait painting including facial hair, glasses and wrinkles.

Although we all have eyes, noses and mouths, their infinite variety is what makes us unique—and uniquely beautiful. It's important to rely on your own observation of each individual you paint, rather than set formulas for generic shapes and placement.

**Katie's Pearls (detail)**
Oil on linen
30" × 24" (76cm × 61cm)
Collection of the artist

# EXERCISE
# Painting the Eyes

For many portrait painters, the eyes are not just the destination, but the most fun part of the portrait's journey—no doubt because they are so frequently the focal point of the portrait. The infinite color and pattern variety in the human iris is truly beautiful, and the individuality of the muscles and tissues that surround the eye delivers tremendous expression. In this exercise, my model is a young woman with deep-set blue eyes.

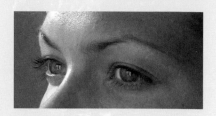

**Reference Photo**

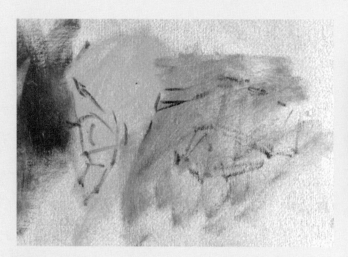

**1 Set Up the Basic Shapes**
Use a small cat's tongue brush and Raw Umber, thinned with a bit of medium, to lightly draw the structural shapes on a ground of Flesh (light) and Flesh + Raw Umber (shadow). With a ⅞ viewpoint, where the head is angled to show very little of the far side of the face, be sure to draw the perspective of the distant eye—with the inner corner of the eye hidden behind the nose—which provides a clear view of the structure of its lower lid.

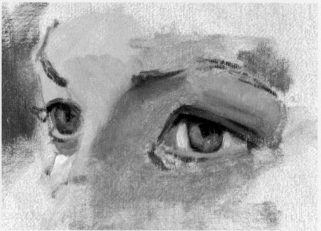

**2 Set the Irises and Paint the Sclera**
With Raw Umber, paint the initial upper lash lines. Paint the lids' creases (any area where skin touches skin) very dark and very warm with Asphaltum + Alizarin + Transparent Earth Red. Once you place the initial lash lines, it's easier to identify where to "hang" the iris. Here, the iris on our right hangs from the lashes at about 11:00 and 2:00. Fill in the irises with the specialty color Indigo, which works well for blue eyes. Place the sclera (the white of the eyeball) with small strokes of Foundation Greenish and Raw Umber.

Lighten the Indigo with Foundation Greenish to paint the iris inside the outer, darker blue rim. The darkest part of the iris will sit directly under the highlight's location. Use your smallest cat's tongue brush to place Ivory Black ovals to represent the pupils. Indicate the tear duct's shape with a small stroke of Flesh + Raw Umber. Correct the values of the left and right parts of the sclera, letting the top of the whites of the eyes run a little darker to suggest the shadow cast upon them by the upper lashes.

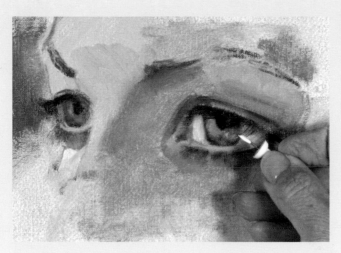

### 3 Place the Highlights

It's always better to understate rather than overstate highlights. There isn't a brush tiny enough to paint the eye highlight properly, so experiment using the pushpin trick. Dip the point of a pushpin (or safety pin or other fine-point object) into your highlight color, in this case, Flake White. The paint should form a soft peak extending past the point of the pin, similar to the peaks that are made when you whip cream or egg whites. Touch only the paint to the exact place of the highlight. You'll need a mahlstick or your little finger to stabilize your hand for this step. If you accidentally make the highlight too large or place it incorrectly, just start over from the previous step.

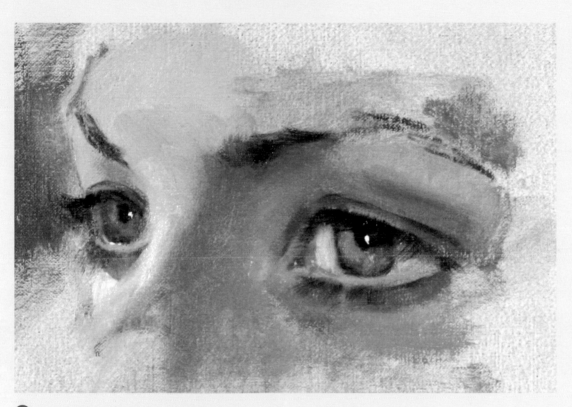

### 4 Complete the Highlights and Adjust the Lashes

Use a small comb brush with Raw Umber and medium to drag a small counterclockwise stroke from the lash line over the sclera and lower lid. (If you still have enough wet paint from the lash line, you can just drag some of the paint already there.) Paint the ledge of skin that holds the lower lashes using a stroke of Flesh.

Add the highlights to the iris and lower lash line on the eye on the left. There's often a small highlight in the shapes that make up the tear duct, but it's best to use Flesh instead of Titanium White so it doesn't become too prominent. Make any small adjustments to the lashes, but keep them smudgy and resist painting individual lashes.

## Examples of Eyes

### Blue Eyes

I've painted iris #1 with Ultramarine Blue instead of Indigo. The saturation of the Ultramarine Blue makes the iris look unconvincing, and it almost seems to float in front of the picture plane. Iris #2 was painted with Ivory Black + Flake White. Because the Ivory Black has a blue cast to it, the iris still reads as blue, but is more realistic. The Ivory Black + Flake White mixture is a suitable alternative to using Indigo.

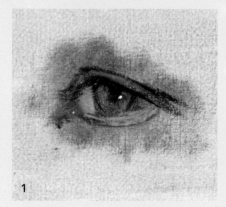 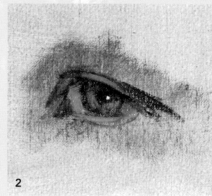

1  2

### Asian Eyes

My Japanese model in this life study was lit by warm light, positioned just slightly off center. Characteristic of Asian subjects, the bridge of her nose is flatter than typical Caucasian subjects, so a raking light source helps define the shapes. Prominent epicanthal folds on the lids create deep-set eyes whose rounded forms show beneath the upper lid. Her brows sit rather flat on her forehead, due to a slightly high brow ridge.

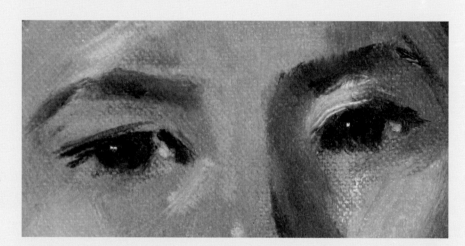

### Brown, Shallow-Set Eyes

Most of the young children I've painted have deep-set eyes, but this little guy has big, brown, shallow-set eyes that show a lot of lid. With a lighting source from above, the lids above the upper lashes will always be a bit lighter in value than the parts of the lids just below the eyebrows. Look for the structure and amount of depth you'll need to properly render the structure of the lower lid, between where it touches the sclera and sprouts the lower eyelashes. In the eye on our right, that little ledge holding the lashes is lighter in value than the sclera as it moves away and out of sight. To make an iris luminous, light it opposite the highlight with a touch of Cadmium Red Light added to its basic dark brown. Here, the highlights come from both directions, but I've emphasized the light from our left, consistent with the highlight on the nose. One light source needs to be dominant in your painting, even if it's ambiguous in the reference photo.

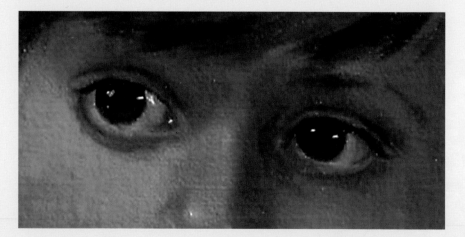

# Painting Eyeglasses

As your experience in portrait painting grows, you're likely to encounter subjects who wear eyeglasses. The primary challenge in painting glasses is to be sure that the portrait remains a painting about the person, rather than a painting about the eyeglasses. Because glasses have straight lines and hard edges, you need to make conscious decisions in order to let the viewer see past them to your center of interest. In this exercise our subject is an older man wearing aviator-style glasses.

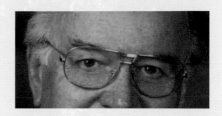

**Reference Photo**

**1** **Set Up the General Shapes of the Glasses**
Use a small synthetic flat and Raw Umber thinned with a bit of medium to rough in the shapes of the eyeglasses at the same time that you begin laying in the underlying skin color. Estimate the shapes in a geometric manner so that you are recording where the forms break in direction (the shapes can curve later). Notice the slight color and value changes caused by the light passing through the curved shape of the lenses.

**2** **Set Up the Areas for Lost and Found Edges**
Having established the color and value shifts inside and outside the frames, paint the skin tones right over the previously drawn shapes. In painting wire-rim or rimless eyeglasses, there are wonderful opportunities to manage lost and found edges so your result looks fresh and convincing. When you speak to someone with glasses, you focus on their eyes, not the frames; if the frames are painted uniformly and completely, and with sharp edges, they can become an unintended focal point. Suggesting the shapes of the eyeglasses is all that's needed for your viewer to complete the lost edges.

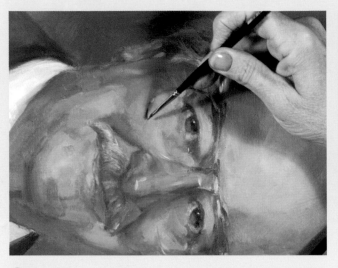

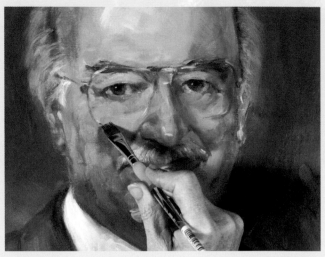

### 3 Paint the Found Edges of the Frames in One Stroke

Wet the canvas with a little medium and paint the found edge of the frames in a single gliding stroke with a small cat's tongue brush using a bit of Transparent Earth Red + Flesh. Actually, you'll be finding the edge of the skin it touches, not the edge of the frame itself. If the found edge you paint in one stroke is wrong, you'll need to take the skin tones back to the previous step. If you prefer to paint wet-into-wet, lay more fresh paint over the mistaken stroke. If the tones are dry, it's much easier to wipe off the errant line. Don't fight the natural arc of your hand; as a right-handed painter, my natural arc runs from about 7:00 to 11:00, so I turned the painting on its side for just that one stroke. Lefties may have an easier time turning the canvas upside down.

### 4 Create the Shadow Under the Frame

Turn the canvas right-side up, and use a small, clean comb brush, wet very slightly with medium, to pull the stroke downward in the direction of the form of the cheek. Again, one stroke is all you need.

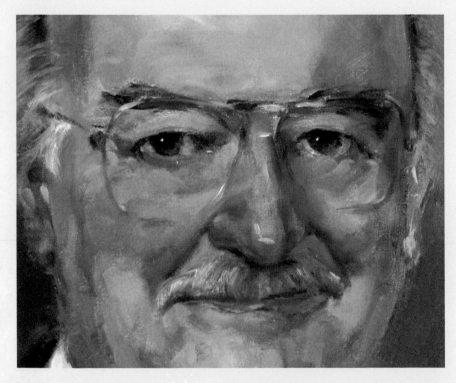

### 5 Finalize the Eyeglasses

The only parts of the eyeglasses that are actually painted are the hinge, the earpiece and the highlights. Everything else is suggested by illusion—the painting of negative shapes created by light and shadow.

## Examples of Eyeglasses

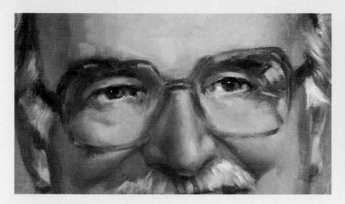

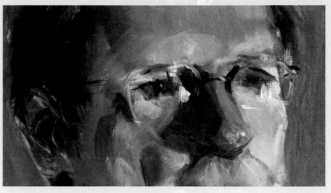

### Full-Frame Glasses, Older Style

This is an older photograph of the subject in the exercise on painting glasses. The darker, larger or more colorful the frame style, the more it will compete with the face for the portrait's focal point. The challenge here is to keep as much of the frame as close as possible to the value and hue of the skin tones.

### Wire-Rim Glasses

In this monochrome oil, the eyeglasses are far more abbreviated. A two-hour session doesn't provide enough time to fuss over details, and in some ways that's better. These glasses were painted with just twelve tiny strokes. The highlight on the lens is much bolder than the highlights in the eyes.

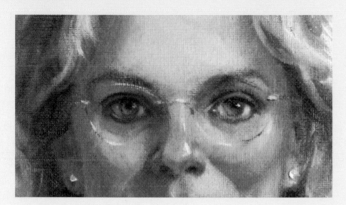

### Rimless Glasses

I painted this self-portrait life study from a mirror. The difficulty is that I am very nearsighted, so my eyes look much smaller when I'm wearing glasses. I first painted the entire study without glasses, then added them later. I gave up a bit of likeness in exchange for emphasizing the eyes.

## A CASE AGAINST PAINTING EYEGLASSES

I generally prefer to paint subjects without glasses for a couple of reasons. First, like fashion, styles of eyeglasses change over the years and can date the portrait and diminish its timeless quality. Second, the eyes may appear distorted because of prescription lenses—very nearsighted subjects' eyes will appear much smaller, and very farsighted subjects' eyes will appear much larger. Try photographing your subject both with and without glasses so you'll have an undistorted image of the eyes as well as an idea of how the glasses sit on the face. In a half-figure or larger portrait, consider having your subject hold his glasses. You might find that the eyeglasses are so much a part of an individual's appearance that it's best to paint them on the face.

# EXERCISE
# Painting the Mouth

In this exercise the subject is a fair-skinned four year old girl. It is common to find a lot of natural red color in the lips of little children, especially in very light-skinned Caucasians. Ask for a clear lip balm or gloss (even for boys) so that it will be easier for you to see the curves of the lip forms; how much you choose to show highlights is a choice you can make later.

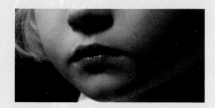

**Reference Photo**

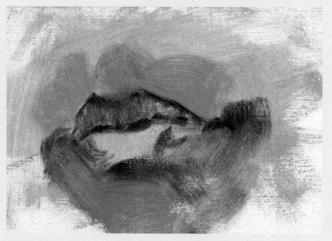

### 1 Locate the Key Landmarks of the Mouth
Use a straightedge to determine the relationship between the width and the height of the lips. Here, the width is approximately twice the height. In this ¾ view, the center of the mouth's anatomy is about one-third of the distance from the corner of the mouth on our left, and the left corner is slightly lower than the right corner. The upper lip and lower lip are similar in height. On a lightly toned ground of Flesh + Flake White + Naples Yellow, make the landmark points with a small cat's tongue brush using thinned Raw Umber.

### 2 Model the Lips and Surrounding Shapes
Switch to a small synthetic flat, and draw the shapes of the upper and lower lips with Alizarin Crimson Permanent thinned with a little medium. Fill in the upper lip with the same color. Use Flake White + Caput Mortuum Violet + Cerulean Blue to lightly indicate the shadowed areas around the lips, using a small- to medium-size cat's tongue brush.

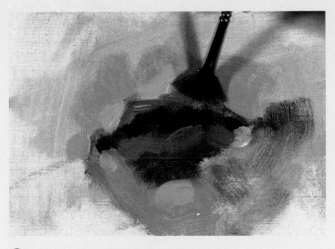 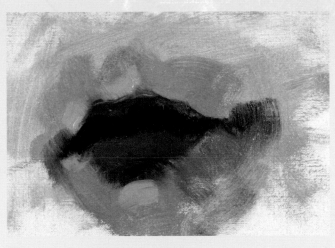

### 3 Color and Soften the Shapes of the Lips

Set up the deep shadow between the lips with Transparent Earth Red + Caput Mortuum Violet and the rich color of the lips in light with Vermilion + Flesh. Indicate the very lightest part of the lips by painting a dab of Vermilion + Alizarin Crimson Permanent + Transparent Earth Red + Flesh on top of the rich underlying color. To soften the edges and slightly blend the color, use a small, soft, dry fan brush to gently pull the color from the lips into the skin tones surrounding them. Wipe the brush between strokes.

### 4 Correct the Shapes and Values

Shape the upper lip by adjusting the location of the darker value where it disappears into the corner of the mouth. Add more of the Vermilion + Flesh to even out the pigment on the lower lip. This will set up the color and value for the final modeling and highlight step.

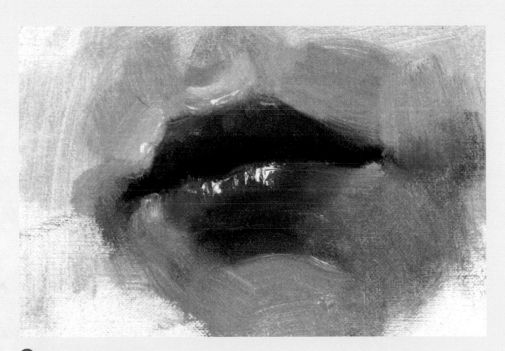

### 5 Complete the Details

Mix up a tiny dab of paint in Flake White slightly tinted with Phthalo Green and place it below the seam of the lips on our right where the skin color meets the lip color. Use a small comb brush to drag the skin color across the pale green daub and into the skin color. A single stroke should do it and will simultaneously amalgamate the colors without overblending them, allowing the lower edge of the mouth to disappear into the skin. Light the area just above the upper lip and the outer corner of the mouth on our left with a stroke of Flake White. Because the paint on the upper barrel of the mouth is still wet, the Flake White won't be overpowering (it would if you were to use Titanium White or paint on a dry surface). Use a pushpin to place the highlights on the lower lip, making sure to touch only the paint to the surface and not the pin itself.

Visit artistsnetwork.com/portrait-painting for a free demonstration on painting a vignette

# Examples of Mouths

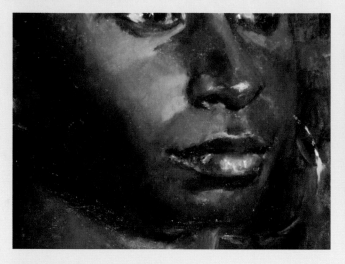

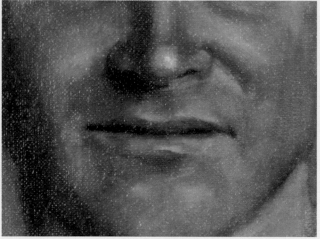

### Adult Black Female, ¾ View
In this life study, my model was painted under a cool natural light. Her skin is very smooth, a common characteristic of black subjects. The barrel of her mouth is strong and she has full lips. The cool light is catching the upper rim of her upper lip, under-scoring her youthfulness. Both warm and cool red color notes are visible, and the seam between her lips is suggested rather than literally rendered. Sometimes less is more.

### Adult Caucasian Male With Beard Shadow, Straight On
When you paint mouths of adult men, keep your edges very soft so the actual lip color is close to the skin color, blending along the outer edges as the lips approach the corners of the mouth. To define the shape of the forms of the mouth, look for areas where they catch light—here, above the upper lip and the highlight on the lower lip as it turns under. The influence of a very dark beard can be effectively conveyed by slight shifts in value, using variations of desaturated blues, greens and violets. In this example, a pleasant expression just short of a real smile provides a great reference. If your camera allows you to shoot multiple images in quick succession, you can experiment to give yourself lots of options as you ask your subject to smile.

### Young Fair-Skinned Girl, ¾ View With Smile
Although I usually recommend against smiling subjects, it can often work out well if the smile is slight. Even in young children, too wide a smile will result in your photos showing the nasal-labial fold as too dark, so it's important to paint it a little lighter in value than is shown in the photograph. To make the teeth look realistic and fresh, avoid painting each tooth. Instead, look for slight value changes as the planes of the teeth move around the mouth's barrel. Suggest the shapes of the bottom edges of the upper teeth with a warm, desaturated red, only slightly darker than the lip color. In a ¾ view, attend to the perspective of the mouth and dental arch as they move away in space.

# EXERCISE
# Painting Wrinkles and Skin Folds

One of my favorite models, Les, is a cowboy and a true gentleman. His outdoor life has given him the world's best crinkles to paint. Always in character, he dresses the part, ready to tip his hat and say "Ma'am." Think about painting wrinkles with shapes, not lines, and remember that the darkest values usually appear falsely darker in a printed photo. The stronger the light source and closer it is to your subject, the more pronounced the wrinkles and skin folds will be.

**Reference Photo**

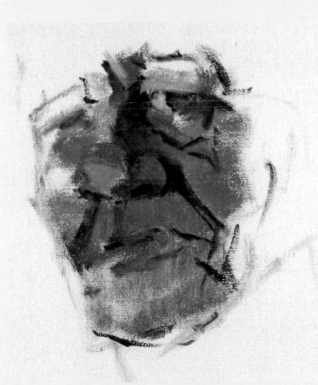

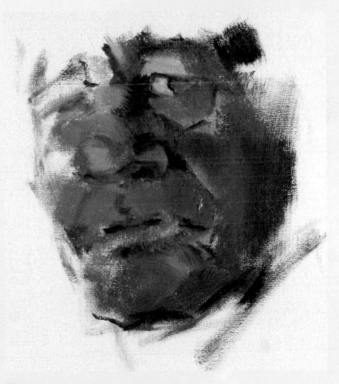

**1 Locate the Major Shapes Separated by Skin Folds**
Once you get paint on the areas of skin, squint at the photo to find the major wrinkles. Draw them with a small cat's tongue brush using Transparent Earth Red + Asphaltum + Alizarin Crimson Permanent. The lines should be thicker than the actual wrinkle, so they do not need to be very precise. You'll be covering up almost all of this paint in subsequent steps, making corrections as you go.

**2 Paint the Largest Shapes First**
Use a medium or large comb brush to paint the shapes that run up to the wrinkle—for example, the shapes over and under the eyes, the side of the nose and the cheek. Concentrate on value and color as you compare each shape to the one next to it.

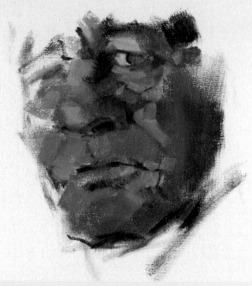

**3** Paint the Areas on Both Sides of the Drawn Wrinkles
Most obvious is the way that the nasal-labial line drawn in the earlier step has virtually disappeared. Use a mid-size cat's tongue brush to paint the barrel of the mouth to its proper shape, overlapping the line from our left. Use lighter strokes of color to paint the cheek up to the line from our right. Only the slightest shadow of the original dark stroke remains. Use this same two-sided approach to paint up to and over the other dark strokes, correcting shapes as you go.

**4** Pull the Paint Away From the Wrinkles
Use a small, soft fan brush to pull the paint away from the wrinkles to integrate the colors. Here, I've turned my canvas on its side so that I don't have to fight the natural arc of my hand. Wipe the brush between strokes.

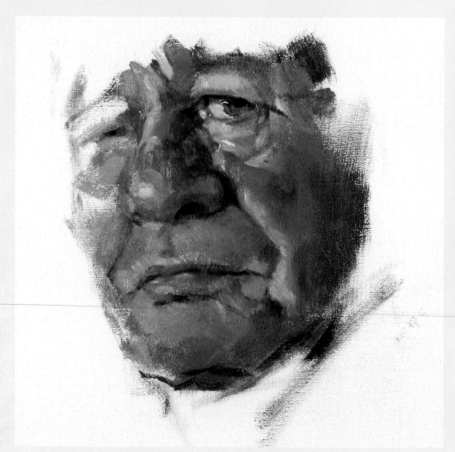

**5** Complete the Wrinkles
The illusion of a wrinkle is achieved by changes in value and by managing edges. The light source from the left makes the sharpest skin edges behind the wrinkles and then softer edges as they move away to our right. You can take the detail as far as you like; the more accurate one shape becomes, the easier it is to make its adjacent shape accurate, too. However, too much detail in wrinkles (or anything else) can make a painting too much about the wrinkles, rather than the person. I chose to leave the wrinkle shapes loose on Les, whereas on a woman's portrait I would blend them much more. Keeping details out of the neck is generally a good idea for anyone over the age of forty.

## Examples of Wrinkles and Folds

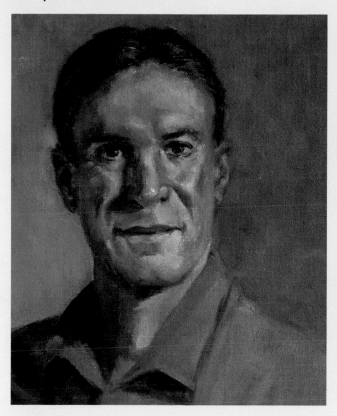

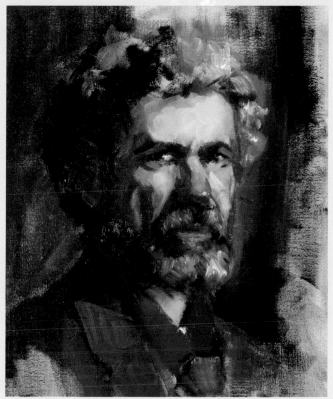

**Ron, Detail**
Ron's strong bone structure matches his character, and painterly brushwork underscores his personality. The nasal-labial fold is indicated by three simple shapes: the barrel of the mouth in light, the triangle that makes up the darkest part of the fold, and the middle tone surrounding the triangle on our right. The neck is indicated with simple, direct brushstrokes.

**Whit, Life Study**
In a typical 3-hour open studio session, your actual painting time is closer to 2½ hours. It's not possible to get into a great deal of detail with wrinkles; often it's enough just to suggest their character.

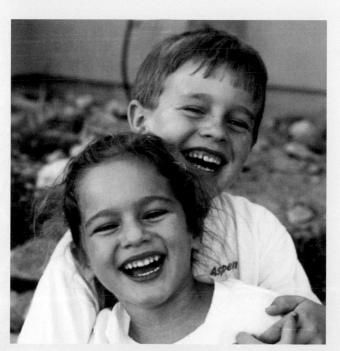

**Avoid Big Smiles Even on Small Children**
Once a smile becomes large enough, even young children show skin folds, especially around the eyes and the nasal-labial fold—one of the better reasons to avoid grinning subjects.

Visit artistsnetwork.com/portrait-painting for a free demonstration on painting a vignette

# Painting Facial Hair:
# A Natural Beard in Warm Light

My cousin Rick's gold and yellow skin tones are emphasized by using a warm light for his photograph. His salt-and-pepper beard is casually trimmed and wavy.

**Reference Photo**

**1** **Draw the Features and Major Planes of the Head**
Use a small cat's tongue brush to lightly draw the shapes of the features and shadow patterns on the face with Raw Umber thinned with a little medium.

**2** **Set Up the Shapes Adjacent to the Beard**
Before beginning the beard, set up the underlying skin tones and background so you have a basis for comparison in color and value. Use combinations of Yellow Ochre, Flesh, Transparent Earth Red and Naples Yellow to rough in general skin tones. Paint the underlying color of the beard at the same time but with somewhat cooler paint mixtures—for example, use Raw Umber instead of Transparent Earth Red in your mixtures.

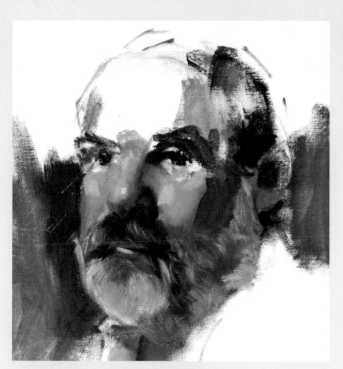

### 3 Place the General Values of the Beard

Since the light source is warm, use relatively cooler darks to mix the beard values in shadow. Switch to a small- or medium-size comb brush. Squint to see the values in the beard; they can be very confounding sometimes because they're so subtle as they move from light to dark. Just as you would paint a hairline, use the comb brush to drag adjacent colors into one another, wiping your brush after each stroke. Make your brushstrokes follow the direction of the beard hair. Use medium to thin the paint if you're getting the hair on too thick.

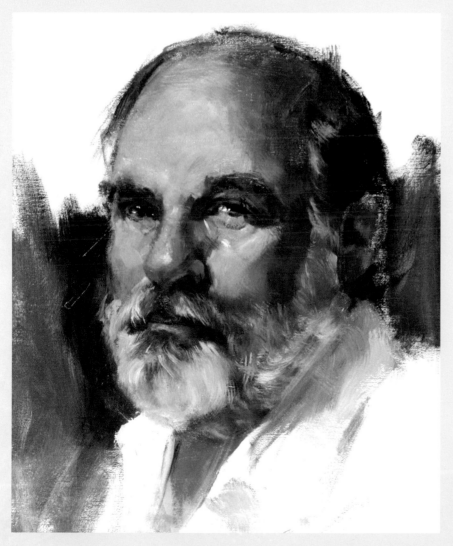

### 4 Complete the Beard and Adjacent Shapes

Take as much time and as many layers as you need to slowly build up the values in the beard to their lightest tone. Keep all of the beard's edges soft against the shapes they touch. No matter how light Rick's beard may appear in the lightest areas, no part of it is as light as his white shirt, which has a slightly yellow cast, consistent with the warm light source.

# Painting Facial Hair:
# A Trimmed Beard in Cool Light

My other cousin, Bob, has much more red and pink in his skin tones than his brother. To emphasize the cooler skin tones, use a cool light source—in this case, natural indirect light.

**Reference Photo**

**1 Draw the Features and Major Planes of the Head**
Use a small cat's tongue brush to lightly draw the shapes of the features and shadow patterns on the face with Raw Umber thinned with a little medium.

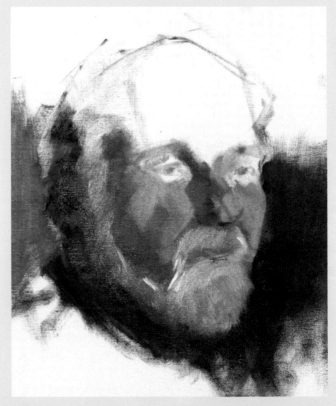

**2 Set Up the Skin Tones and Value Patterns of the Face**
Mix skin tones in a similar fashion as the previous exercise, but use less Transparent Earth Red and Yellow Ochre. Instead, incorporate Alizarin Crimson Permanent, Raw Umber, Naples Yellow and Flesh to convey the sense of the cool light source.

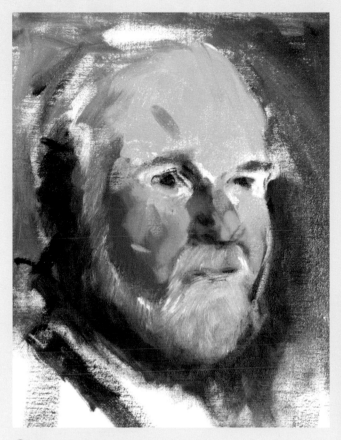

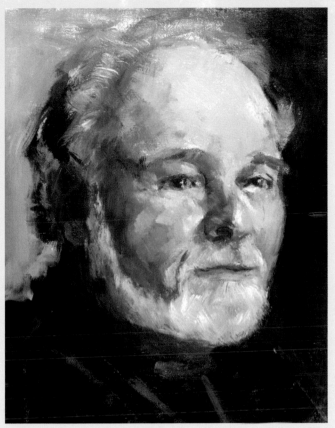

### 3 Place the Different Values in the Beard
Switch to your comb brush and slowly place small, thin strokes of gray along the shaved edge of the cheek where it touches the beard on our left. Keep the grays in shadow slightly warmer than the beard in light by using a slight bit of Asphaltum + Foundation Greenish to layer in the beard. There is a hint of skin color showing through the beard right below the mouth.

### 4 Complete the Beard's Details
Continue adding strokes that are progressively lighter in value. Detail and contrast in the lights will leave the shadow areas indistinct so they stay in shadow. Don't hesitate to have some fun with color— notice the stroke of Radiant Blue on the outer left edge of the mustache. You can decide what level of finish you'd like to have in painting facial hair.

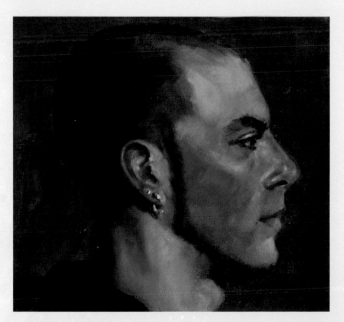

### Clipped Beard, Stylized
The shaved cheek in shadow was the most challenging aspect of this life study. It was only possible to figure out what to do by constantly squinting at the values.

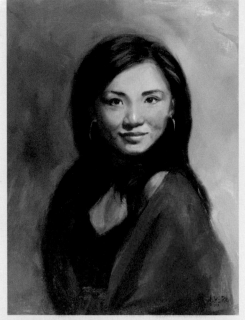

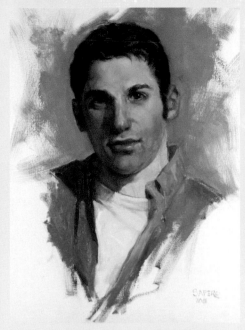

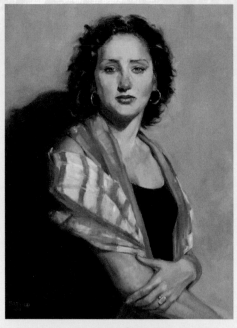

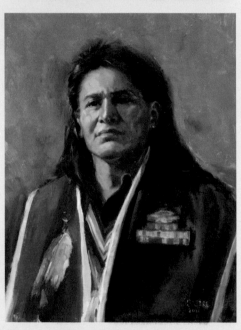

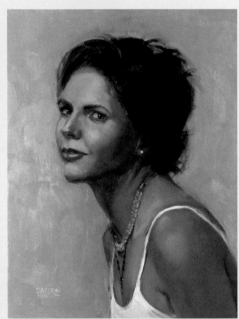

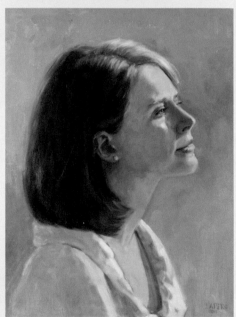

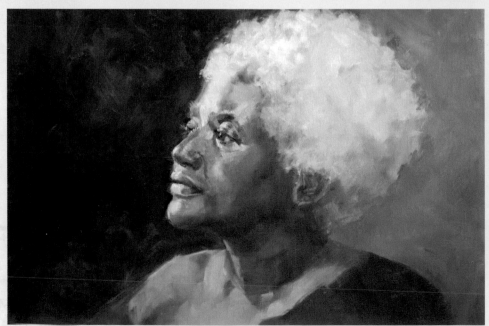

## MATERIALS IN LIFE AND PHOTO DEMONSTRATIONS

Please refer to chapter 1 for more in-depth descriptions of materials used throughout the portrait demonstrations. Each portrait was painted on oil- or acrylic-primed linen using my standard palette of paints and a variety of flat, fan, filbert, rake, comb, cat's tongue and mini round brushes. Of course, the tools I use are merely a suggestion for you. It's best to use what you like and are comfortable with.

# Skin Tone Demonstrations

While a few portrait artists paint exclusively from life, far more utilize photographs in their work. There are advantage and disadvantages to both approaches, but combining the two offers tremendous opportunities to the artist.

**Pros of Painting From Life**
- observe and interact with your model
- offers chance to observe true, rich color
- enables you to more accurately judge value differences in light and shadow
- subtle edge differences are easier to see

**Pros of Painting From Photos**
- the model in the photo doesn't move
- no time constraints in either the length of time required to paint to the desired level of finish or the time of day you prefer to paint
- allows you to paint interesting poses that a live model may not be able to maintain for long periods of time
- makes pets and children easier to paint

# DEMONSTRATION: ASIAN SKIN
# Bonnie From Life

Bonnie is a professional dancer and dance instructor of Chinese ancestry. Typical of Asian skin tone groups in general, Bonnie's skin is extremely even in color from hairline to chin. Bonnie was lit from above and almost frontally with a tungsten (3200K) light.

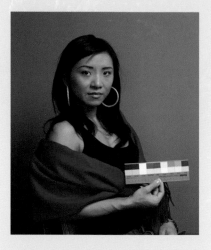

**Reference Photo**

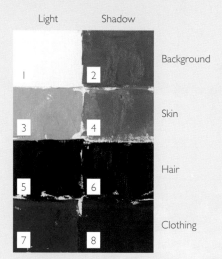

**Color Notes**

1 n/a

2 Cadmium Yellow Medium + Ivory Black + Radiant Blue (background in shadow)

3 Flesh + Transparent Earth Red (skin in light)

4 Flesh + Transparent Earth Red + Ivory Black + Cadmium Yellow Medium (skin in shadow)

5 Ivory Black + Caput Mortuum Violet (hair in light)

6 Ivory Black + Ultramarine Blue (hair in shadow)

7 Cadmium Red Light (clothing in light)

8 Cadmium Red Light + Caput Mortuum Violet (clothing in shadow)

**1 Size and Place the Head**
On a dry canvas lightly toned with Raw Umber, size the head a little over 6½ inches (17cm) from her chin to the top of the hair's silhouette. Bonnie is facing head-on, but the direction of the light is slightly to our right, also the direction her throat and chest face. Leave breathing room on the right side of the canvas. Make sure to leave enough room to let the black shirt act as a circular design element to bring the viewer's eye back into the painting. Make small marks to indicate the top of the silhouette of the head, the chin and the level of the eyes through the tear ducts. Then estimate the width of the head and neck.

**2 Draw the Large Shapes**
Together, the horizontal and vertical measurements will allow you to locate and draw the general larger shapes in the painting, including the hair, shoulders and neckline. Recheck your placement of the head and shoulders. If something needs to be moved, it's best to do it now. The longer you wait, the less likely it is that you'll make the move!

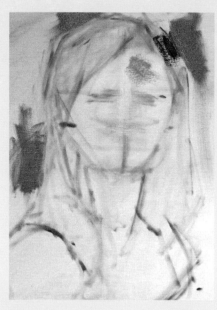 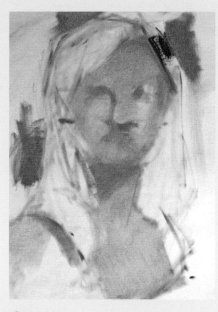 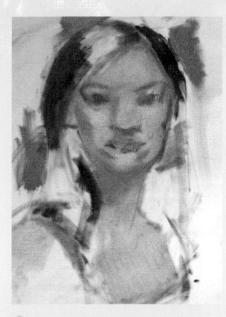

### 3 Mix the Color Notes for the Hair and Background

Mix up the background color note with Cadmium Yellow Medium + Ivory Black + Radiant Blue. Place some color swatches right up against the hair and then place the color note for the hair in light (Ivory Black + Caput Mortuum Violet) touching both background color and skin. Mix Flesh + Transparent Earth Red to the value that represents the skin in light.

### 4 Block In the Light and Shadow Patterns of the Skin

Paint the lit skin on the face and chest area with the Flesh + Transparent Earth Red mixture. Add Ivory Black + Cadmium Yellow Medium to place the shadows under the nose and chin, and to indicate the sides of the nose. The shadows between the eyes and on the sides of the nose are subtle, characteristic of Asian bone structure, where the bridge of the nose is shallow and the epicanthal fold close to the tear ducts.

### 5 Begin to Locate the General Shapes of the Features

Estimate the placement and width of the eyes. The distance between Bonnie's eyes is about 1½ eye widths. Not only is this wider distance more common in Asian subjects, but it underscores how important it is to note the uniqueness of each individual subject's face, and to not rely on "recipe" measurements (for example, it is not always true that there is one eye's width between the eyes).

Begin to model the planes of the face. Look for geometric relationships at first, including the chin, cheekbones and mouth.

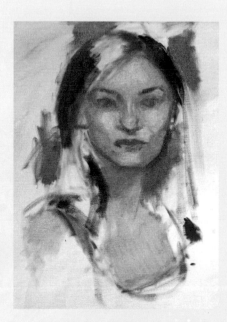

### 6 Refine the Shapes of the Face and Hair

Use the paint you've mixed for the hair in light and shadow to carve out the shapes of the face that lie next to the hair. In this way, you can get more specific with the shape of the jawline and the placement of the ears. Place a stroke of Cadmium Red Light on part of the shawl in light.

### THE EPICANTHAL EYE FOLD

An epicanthal fold is the web of tissue between the nose and the inner corner of the eye. When you paint young children, you'll notice the prominence of their epicanthal folds. Once the bridge of the nose begins to develop, it will often pull the skin away from the inner corner of the eye and establish relatively deeper shadows as the child's skull matures.

Visit artistsnetwork.com/portrait-painting for a free demonstration on painting a vignette

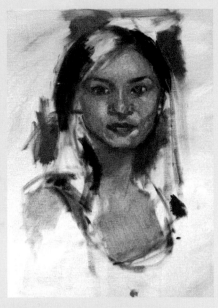

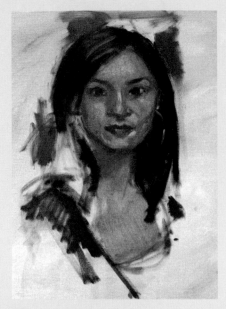

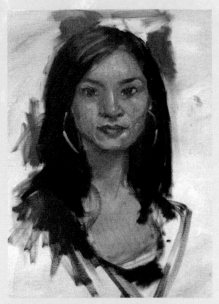

**7** **Correct and Remodel the Mouth and Nose**

Use a medium-size cat's tongue brush to model the barrel of the mouth by picking out the shapes that are lighter in value than the general skin tone—in this case, the small shapes just under the outer corners of the mouth, the ball of the chin, and the planes above the lips and inside the nasal-labial folds. Use Naples Yellow to lighten the general skin tone mixture so you can retain the warmth of the color (adding Flake White will cool the color into which it's mixed). Indicate the placement of the irises by painting the sclera with the general skin tone, lightened slightly with Flake White. You can get a small enough tip by using one of your cat's tongue brushes or a small synthetic flat.

**8** **Model the Hair**

By squinting at the hair, you'll be able to see its various planes, which is much easier to do with sleek hair than curly hair. Use a clean comb brush to paint the hair's highlights on our upper left side and in the part with Radiant Blue, thinned with a little medium. In a life study, the dark areas of hair will still be wet, but if the underlying dark hair becomes dry, just mix more dark paint so the entire surface under and to all sides of the highlights is wet. Place the highlights in single strokes, dragging the Radiant Blue into the dark hair. Wipe the brush and add the next stroke. In turn, use a clean brush to drag the dark back into the Radiant Blue highlight. Use a small cat's tongue brush to suggest the earring on our right. It's not necessary to model the ear in order for it to appear—all that's required is careful placement of the earring. Use just three brief "hit and run" strokes to keep the paint fresh. If you find that one of the strokes is incorrect, just remove the paint and start again.

**9** **Complete the Hair and Earring, and Finish the Shawl**

Use the mixture of Ivory Black + Ultramarine Blue to paint the hair along the side of the face and neck on our left. To match the earring height, check to make sure that you start your earring brushstroke exactly across from the stroke on our right. Add enough of the shawl color (Cadmium Red Light, mixed with Caput Mortuum Violet for the darker areas) to balance the vignette on the canvas. Use a wide synthetic flat to drag Cadmium Red Light into the unpainted canvas areas, allowing the paint to thin out at the end of the stroke. This gracefully integrates the lower edges of the painting into the canvas.

### DON'T FIGHT THE HAND!

In this example, a right-handed painter would drag the Radiant Blue highlight from the lower left to the upper right, and back again. However, that's an awkward direction for lefties. To retain the smoothness of the curving arc, left-handed painters can turn the canvas 90 degrees clockwise to place the strokes. Of course, when the highlights need to be painted from the lower right to the upper left, the right-handed painter can rotate the canvas 90 degrees counterclockwise. The same idea applies to painting the earrings in this example.

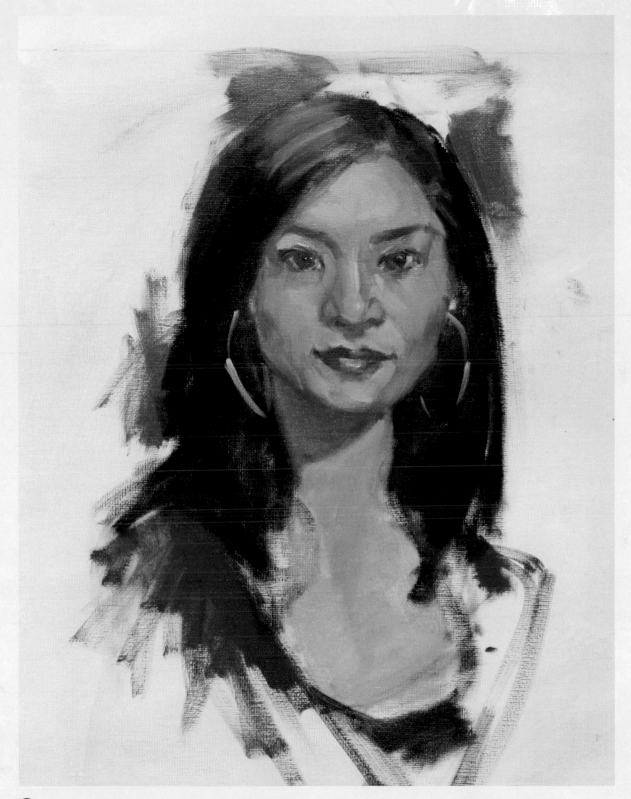

**10 Complete the Painting**

Finishing touches include smoothing the areas of the chin, softening the edges of the mouth and adding a touch of Flake White + Phthalo Green just under the nose to give a bit of temperature relief to the painting. Smoothing the skin on the chin and the inner corners of the epicanthal fold can be done in a couple of ways: either use a cat's tongue brush to add paint to some of the planes mixed to a color and value that's in between them, or use a dry sable fan to lightly pull the colors back and forth. The dry sable fan is a great tool to soften the edges of the mouth.

**Bonnie, Life Study**
Oil on linen
20" × 16" (51cm × 41cm)

# DEMONSTRATION: ASIAN SKIN
# Bonnie From Photograph

When you're fortunate enough to paint a professional dancer and dance instructor like Bonnie, every pose and movement is graceful enough for you to want to capture it. Born in Hong Kong, Bonnie has near-black hair, wide-set eyes and coloring that begs for a red accent. Although she is lit from above and to the right, her eyelids and the shallow bridge of her nose minimize the shadow pattern on the front of her face, but still emphasize her cheekbones and full mouth.

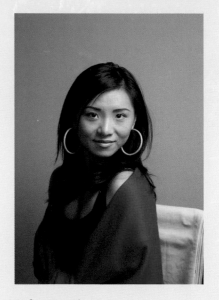

**Reference Photo**

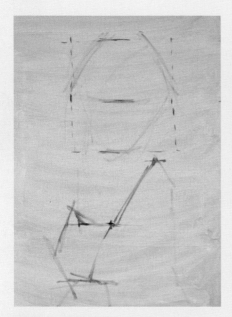

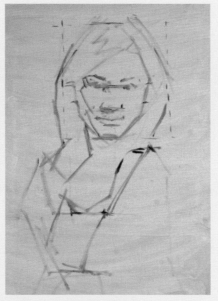

**1 Size and Place the Head**
To include the shawl's knot in the composition (and avoid casting the viewer's eye down and out of the canvas), I composed the head size at 7 inches (18cm), placed about 2 inches (5cm) from the top, working on a 20" × 16" (51cm × 41cm) canvas. Comparing the height of the head to its width will let you measure the box into which the head's silhouette will fit.

**2 Draw the Major Shapes**
Lightly draw the major shapes in the portrait with Raw Umber and a small or medium-size cat's tongue brush thinned with a little medium. Keep the shapes geometric and angular so you can keep track of places where the forms change direction. Measure the distances between the features to estimate their placement.

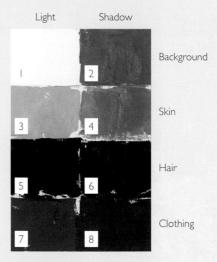

Light   Shadow

Background

Skin

Hair

Clothing

## Color Notes

1 n/a

2 Cadmium Yellow Medium + Ivory Black + Radiant Blue (background in shadow)

3 Flesh + Transparent Earth Red (skin in light)

4 Flesh + Transparent Earth Red + Ivory Black + Cadmium Yellow Medium (skin in shadow)

5 Ivory Black + Caput Mortuum Violet (hair in light)

6 Ivory Black + Ultramarine Blue (hair in shadow)

7 Cadmium Red Light (clothing in light)

8 Cadmium Red Light + Caput Mortuum Violet (clothing in shadow)

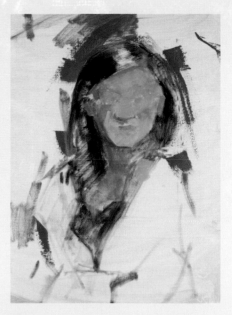

**3 Separate Light From Shadow and Place Background Color Notes**

Use a large cat's tongue brush and Raw Umber to block in the shadow shapes. Keep the paint very thin and light. Commit to the background color right away by placing notes of background color right up against the adjacent shapes of the silhouette—along the outside edges of the hair, shoulder and shawl.

**4 Place Color Notes for the Hair and Skin in Shadow**

Mix your color notes for the darkest part of the hair and skin in shadow, then block in the shapes. Place the darks of the hair up against the neck and forehead, and behind the ear on our right, to help you later judge the value of the adjacent skin areas.

**5 Block In the Skin Tones in Light**

Use your large cat's tongue brush or synthetic flat brush to cover the remaining areas of the skin in light. This will give you some paint to move around in subsequent steps.

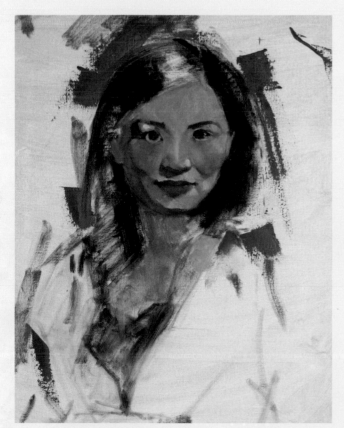

**6 Begin to Paint the Features As You Work the Light and Shadowed Areas of the Face**

Return to measuring the vertical and horizontal distances between the features, as much of the previous measuring is now covered up with paint. (This must be done many times during the course of the painting process.) Find areas within the shadows that will show where the planes are located.

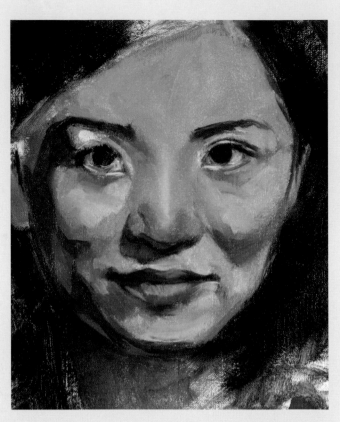

**7** Use Slight Changes in Color and Value to Model the Features and Shapes in the Face
Lay strokes of color on top of underlying paint without blending yet. Keeping the paint unblended on the surface will preserve its color and saturation until you're ready to decide which areas you want to transition most smoothly into others.

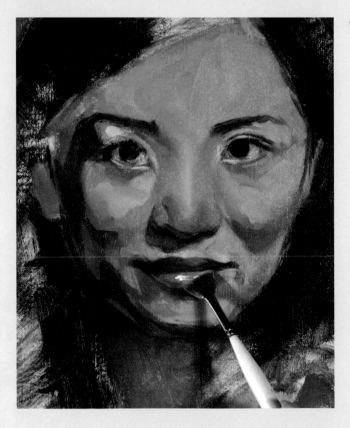

**8** Blend and Model Selected Areas With Your Small Fan Brush
To lend a three-dimensional sense to small areas, such as the lower lip in this example, your smallest fan brush can be your best tool. First, use a small cat's tongue brush to paint a thin stroke of Flake White (Titanium White will be too opaque) onto the still-wet paint of the lower lip, following the location of the highlights. Then use your smallest fan brush to drag the lighter paint downward, following the form of the lip. If you need more than one stroke, wipe the brush in between strokes.

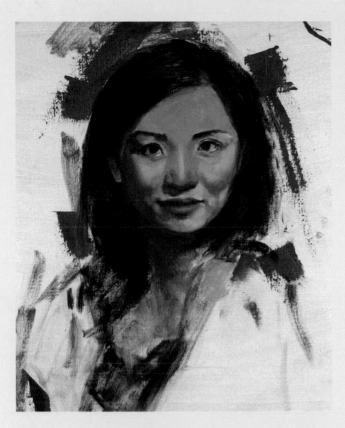

**9** **Refine the Drawing and the Color and Value Transitions**
Gentle blending works well to model areas where you want shifts to be subtle, especially in the areas surrounding the mouth and chin. Paint the remaining hair, using your color notes for hair in light. Restate the darks at the same time so that you can use your comb brush to integrate the light and shadow areas of the hair. Take the opportunity with every brushstroke to find and correct drawing mistakes.

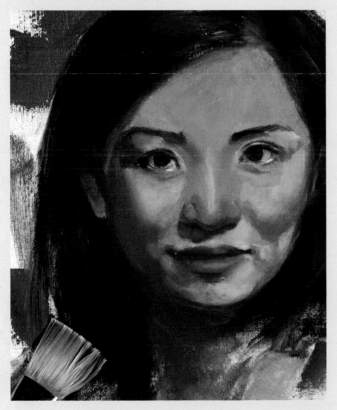

**10** **After they Dry, Restore Dark Areas to Their Proper Values**
Many passages in a painting, but most specifically the darks and areas painted with earth tones (ochres, umbers and siennas), dry much lighter than they appear when first painted. To properly revaluate a painting that has dried, you'll need to temporarily restore the darks, using a retouch varnish or a bit of medium. Notice how dramatically the values in the hair change as a little retouch varnish is dragged over the dry paint with a wide synthetic flat. This step makes it far easier to remix color values accurately. (The values in your finished work will be permanently restored with your final varnish.)

Visit artistsnetwork.com/portrait-painting for a free demonstration on painting a vignette

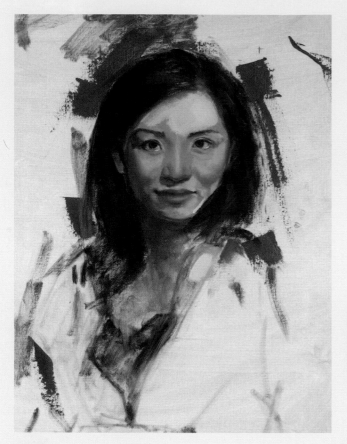

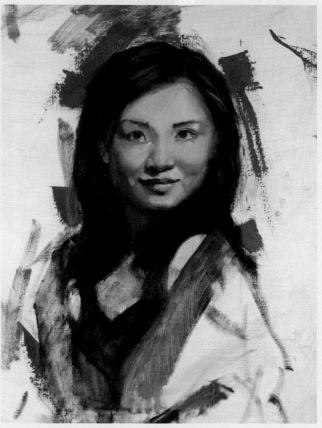

**11 Review the Entire Painting to Find Opportunities for Improvement**

It's much easier to be objective after you let a painting sit for a period of time without looking at it. In evaluating where to go next, I decided that the skin tones in light were too dark and too saturated. Should this happen, go back and remix your original color notes with adjustments. To make it both lighter and cooler, add a little Flake White. (To lighten it, use Naples Yellow + Flake White; the Naples Yellow is already very light in value and doesn't have the same dramatic cooling effect when mixed into other paint colors.) Paint the lit areas with the new mixture, but mix it with a little medium to gradually make the changes, almost as if you were glazing a color. Going too light too fast makes for a chalky appearance. Identify drawing mistakes such as the asymmetry and shaping of the jawline, and the uneven size and placement of the eyes.

**12 Correct Drawing Mistakes, Lay In the Shawl and Add Depth to the Hair**

Correcting the eyes and jaw makes a big difference in conveying Bonnie's delicate features. Continue to model the highlights on the hair using a mix of Transparent Earth Red + Yellow Ochre, applying the highlights one stroke at a time, again wiping your comb brush after every stroke. Lightly lay in the overall color of the shawl in light.

**EDIT YOUR COMMISSION WORK WITH CARE**

In this case, I made the judgment to change Bonnie's earrings. Although they were fashionable at the time of the sitting, their trendiness will date the painting years in the future. When you're painting a commissioned piece, be sure to check with your subject before changing pictorial elements that might be meaningful to her, but may not be evident to you. The best solution is to communicate in advance with your clients in choosing clothing, jewelry and other accessories.

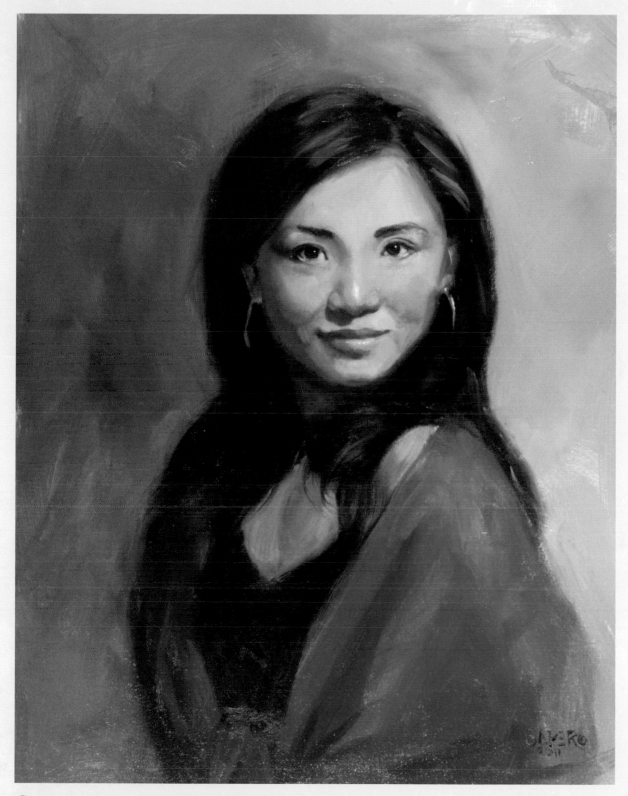

**13** Paint the Earrings and Complete the Portrait

Suggest the earrings with a single stroke of Yellow Ochre + a mixed green (Ivory Black + Cadmium Yellow Medium) using a small cat's tongue brush. The idea is to set up the jewelry to later carry a highlight or two without over-emphasizing the earrings. Lose the upper edge of the upper lip on our right by blending it into the skin above it. Once you light the irises from 6:00 to 8:00 with Transparent Earth Red + Naples Yellow, you are ready to place the highlights in the eyes.

Add final highlights to the lips and make any remaining adjustments to details.

**Bonnie from Photo**
Oil on linen
20" × 16" (51cm × 41cm)

# DEMONSTRATION: CAUCASIAN BRUNETTE
# Joel From Life

Joel is a professional musician and model whose classic Italian skin tones and beautiful facial structure are well articulated in the warm light placed above and to our right.

### ① Size and Place the Head
Begin with a dry 20" × 16" (51cm × 41cm) canvas toned with Ivory Black + Cadmium Yellow Medium + Foundation Greenish and enlivened with scattered strokes of Radiant Blue. Size the head about 80 percent of life-size or 8 inches (20cm) high. Joel is looking slightly left, so leave a little breathing room on the left side of the canvas. Place the head high enough on the canvas to allow room for the V in the shirt placket to be painted without crowding the bottom of the canvas and to make a pleasing design. Small marks indicate the top of the head, the chin and the level of the eyes through the tear ducts. Carry these key marks to the far right edge of the canvas so the head size can be checked throughout the painting sessions to be sure it doesn't grow.

### ② Establish Key Horizontal and Vertical Measurements
Use a small synthetic flat and a little Raw Umber and medium to lightly locate the features and other key landmarks of the face. The vertical measurements are the hairline, base of the nose, mouth and ears. Horizontal measurements include the width of the head, nose and mouth. It's important to relate the head to the neck, and the neck to the shoulders early in the layout process.

**Reference Photo**

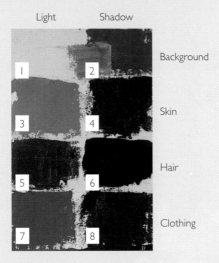

Light  Shadow

Background

Skin

Hair

Clothing

### Color Notes

1 n/a

2 Ivory Black + Cadmium Yellow Medium + Foundation Greenish (background)

3 Yellow Ochre + Radiant Blue + Naples Yellow + Raw Umber (skin in light)

4 Raw Umber + Monochrome Tint Warm + Cadmium Red Light (skin in shadow)

5 Monochrome Tint Warm + Alizarin Crimson (hair in light)

6 Raw Umber + Asphaltum + Ultramarine Blue (hair in shadow)

7 Radiant Blue + Permanent Rose + Cadmium Red Light (clothing in light)

8 Radiant Blue + Permanent Rose + Cadmium Red Light + Caput Mortuum Violet (clothing in shadow)

**3** Separate Light From Shadow

When you have a model with strong bone structure sitting beneath strong lighting, it's much easier to find planes and the division of light and shadow, than, for instance, in a young child. Use the same Raw Umber to draw the planes and shapes of the face and indicate the hairline. Include the shapes of the ears and collar.

**4** Establish and Place the Key Color Notes

Joel's rich coloring is evident in the noticeable variations of color across his face the saturated, warm color in his nose, lips and ears and strong blue-green tones in his beard shadow. Mix the skin in light and shadow and record the slightly more neutral colors in the forehead and place solid strokes of color on the face.

There is little difference in color and value for Joel's hair in light and in shadow. Paint the hair in shadow in a rich, dark, cool brown. In light (not highlights), note that the hair catches the warmth of the light source.

The shadow color is a dark, cool and desaturated version of the shirt in light. Place strong bits of the shirt color in light and shadow on the corresponding facial planes.

**5** Use Strong Warm Color to Paint the Nose, Ears and Mouth

Add a little Cadmium Red Light to the skin tone mixture and paint the nose, ears and mouth in a continuous tone. Now you're set up to add detail later.

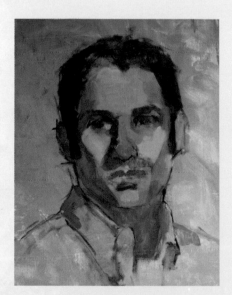

**6** Commit to the Darks

Use the overall hair color to lay in the hair and sideburns. Establish the basic shapes and values of the eyebrows and eye sockets. Indicate the irises very lightly using only enough pigment to show their locations. If there's too much paint on the irises this early, it will be difficult to complete the detail work in the eyes later on.

It's important to get the darks in before going much further so that it's easier to evaluate the values of the shapes that are adjacent to the darks. Use the same mixture as the shirt in shadow to drag color across the lower jaw on our left, and with a small linear stroke to mark the location where the jaw meets the neck.

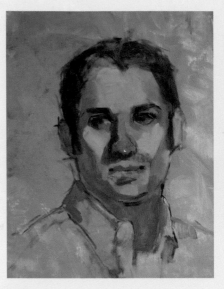

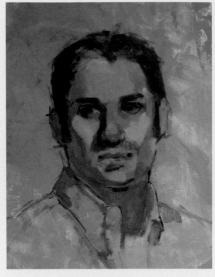

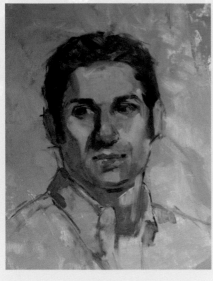

### ❼ Begin to Model the Mouth and Eyes

Rather than trying to paint the shapes of the mouth directly, try shaping the mouth by carving into the existing warm color of the upper and lower lips with skin color. Paint the planes of the chin.

In starting to model the eyes, find the different shapes of the upper lash line, the crease above the upper lashes, and the vertical distance between the crease and the brow. The lower eyelashes sit on the edge of the tiny shelf created by the thickness of the skin that touches the sclera, so you'll want to leave room for these small shapes.

Locate and mark the darker edge that defines the chin, before the plane turns back under the throat.

### ❽ Correct the Iris Placement and Begin Sculpting the Nose

Once the structures of the eyes are in (lash lines, lids, creases), you can start to correct the placement of the irises, but keep the paint thin until you know that the direction of the gaze in both eyes is in agreement. It's very difficult to complete one eye to a finished level and then try to bring the second up to the same finish.

By painting lighter warm shapes on the planes of the nose that catch light, the underlying red tones help the nose turn under at the tip. Locate the shapes that make up the wing of the nose on our right. Reinforce the dark shapes of the nostril with deep, dark, warm colors.

### ❾ Paint Smaller Facial Planes and Begin to Refine the Eyes

Continue to locate and paint the shapes of the planes that make up the barrel of the mouth and chin. Use the basic skin tone in light mixture, lightened with a little Naples Yellow, to describe the plane that joins the front of the face to the side of the face on our right, as well as the shape of light on the neck.

Despite the warmth of the light and skin, the color temperature is mitigated by the strong blue-green cast that commonly occurs in subjects with heavy five o'clock beard shadow.

Use a small cat's tongue brush to indicate the whites of the eyes, which in turn establish the shapes of the irises. Paint the sclera with Flesh + Raw Umber. This sets up the darker part of the sclera and leaves enough room to go lighter in value when you model the details of the eyes.

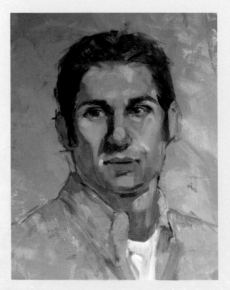

### ❿ Paint the Neck and Shirt, and Continue Modeling the Features

The strong white of the T-shirt creates a kind of value anchor and helps in judging the accuracy of surrounding values, just as the dark hair and sideburns do.

Joel's mouth is gravitating to our right, but its placement can be fixed by correcting the shapes of the tissues that surround the mouth, bringing in the corner of the mouth on our right.

Slightly lighten the skin tones on the top of the forehead where it moves backward to join the hairline.

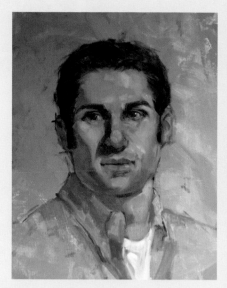

### 11 Refine the Ears and Mouth

Soften the edges of the mouth, without losing its overall structure or sense of fullness, by gently dragging a small comb brush over the edges of the lips. The ear that's in shadow doesn't really need anything. The ear that's in light can be modeled with three strokes of Cadmium Red Light: a strong color with a relatively sharper edge at the top of the ear, a softer stroke to represent the inside of the ear, and the softest stroke at the outside bottom of the lobe.

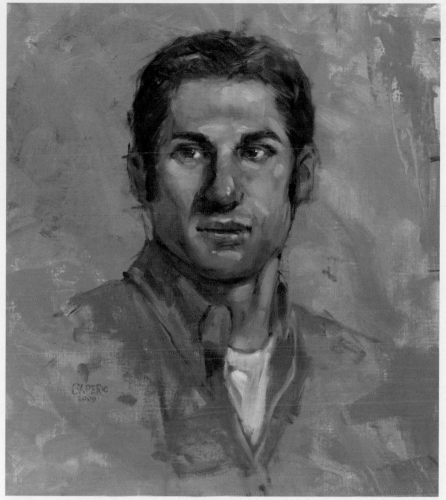

### 12 Evaluate for Errors and Make Corrections

The edge that defines the cheekbone and shadow along Joel's face on our left needs softening, the color and value transitions also need to be made much more subtle, and the shadow itself lightened and warmed. Warming the shadow with desaturated greens integrates and relates the figure to the background and reinforces the color temperature of the shadows.

The edge of the hairline needs to be made very soft to transition well with the adjacent skin tones. Both hair and skin are still wet, so drag a clean rake brush back and forth with medium and a small amount of pigment, wiping the brush after each stroke.

Adjust the shapes of the forehead planes, including the brow ridge. Using your smallest comb brush, model the whites of the eyes with a single stroke of Foundation Greenish on the lower part of the sclera to create the shadow cast on the top of the sclera by the lashes and lids. Highlights on the nose, lower lip, chin and mouth should stay understated.

**Joel, Life Study**
Oil on linen
20" × 16" (51cm × 41cm)

# Joel From Photograph

Joel's reference photo is similar to the pose for his life study, but the direct eye contact makes it more engaging. Joel's pose suggests a contrapposto stance (shoulders at different heights) that makes it more dynamic, which is very often the case when comfort is not a concern for a model who needs to sit for an extended period of time.

**Reference Photo**

### ① Size and Place the Head
On a 20" × 16" (51cm × 41cm) canvas, leave about 2" (5cm) at the top between the canvas edge and the silhouette of the hair against the background. You'll have room for a 9-inch (23cm) head, close to life-size, and still have enough space at the bottom of the canvas to provide a good canvas-to-image transition, necessary to create a successful vignette. Leave about one extra inch (3cm) of negative space on the left. Lightly measure and mark the vertical levels of the features as well as the tilt of the head with Raw Umber, using a small cat's tongue brush or synthetic flat.

### ② Draw the Basic Shapes
Complete the horizontal measurements. Together with the vertical marks, you'll have enough information to connect the marks in an angular fashion (with lines, not curves) and to map out the basic shapes of the portrait.

### Color Notes

1  n/a

2  Ivory Black + Cadmium Yellow Medium + Foundation Greenish (background)

3  Yellow Ochre + Radiant Blue + Naples Yellow + Raw Umber (skin in light)

4  Raw Umber + Monochrome Tint Warm + Cadmium Red Light (skin in shadow)

5  Monochrome Tint Warm +Alizarin Crimson (hair in light)

6  Raw Umber + Asphaltum + Ultramarine Blue (hair in shadow)

7  Radiant Blue + Permanent Rose + Cadmium Red Light (clothing in light)

8  Radiant Blue + Permanent Rose + Cadmium Red Light + Caput Mortuum Violet (clothing in shadow)

### DON'T RUSH THE HEAD MEASUREMENTS

Although I might spend 15 minutes or so making measurements in a life session, I can easily spend more than an hour working out the same measurements when I've no time constraints. In a more complicated portrait, especially a full figure or a group, I might spend half a day placing measuring marks.

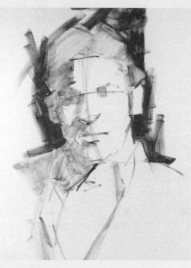
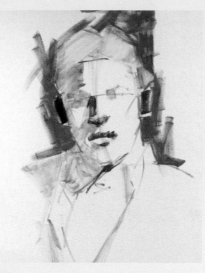
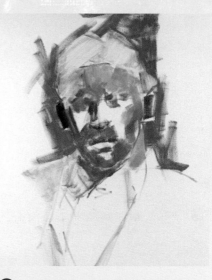

**③ Separate Light From Shadow**
Switch to a large comb brush to mark off the shadow shapes and lightly block them in with the same Raw Umber mixture. In mixing the background color I decided to combine the two background colors from the life study to create a middle value, but cooler in temperature and slightly less saturated. Place strokes of background color right up against adjacent areas you'll be painting.

**④ Locate the Warmest Skin Tones**
Use the same comb brush to paint quick, simple strokes of Vermilion in the ears, the shadowed areas of the nose, the mouth and the neck. Even though the strokes look garish right now, they'll set up beautiful warm colors for subsequent steps.

**⑤ Lay In the Shadow and Light Areas**
Start by placing short, direct strokes of varied color in the light areas in the forehead and the cooler areas of beard shadow. For the skin in light, mix the basic color note, then modify it alternately by adding bits of warmer color (Yellow Ochre or Naples Yellow), cooler color (Alizarin Crimson Permanent or Radiant Magenta) and desaturated color (Foundation Greenish, Raw Umber or Cerulean Blue). Look for subtle areas where the planes can be found in Joel's face. For the shadowed beard area, apply several strokes of background color over the blocked in Raw Umber. For the beard in light, also use some background color modified with Yellow Ochre + Transparent Earth Red.

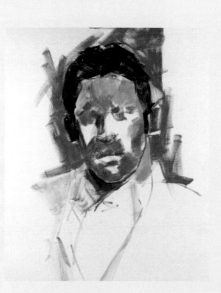

**⑥ Paint the Shapes of the Hair**
Use Raw Umber to locate the shapes that comprise the hair and sideburns, which in turn will establish the shapes of the forehead and sides of the face.

## CHOOSING BEARD SHADOW COLOR

When the light source on your subject is warm, the beard stubble, or five o'clock shadow, is cooler than the forehead or cheeks, even in light. Desaturated greens are usually a good choice. However, if your subject is lit by a cool light, try painting the stubble with Raw Umber or a desaturated blue-gray.

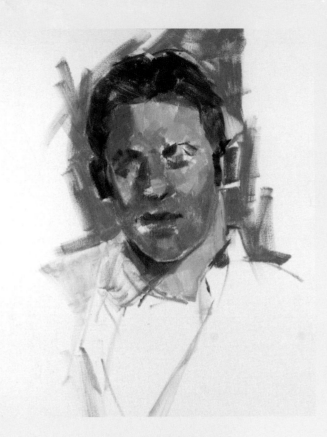

### 7 Lay In the Remaining Areas of the Face

Continue using the mosaic method of laying and leaving strokes of paint across the lit areas of the face. Paint the forehead in shadow. Add a color note for the shirt in light. Then, once you suggest the eyebrows, you'll have the beginning of a likeness, as well as enough paint to start moving it around.

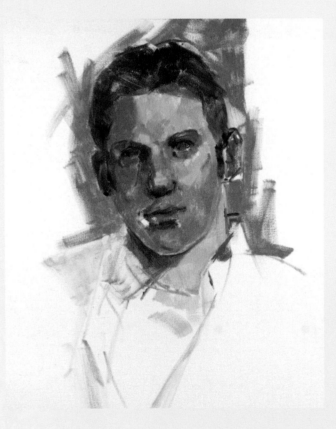

### 8 Restate the Features

Use Transparent Earth Red + Asphaltum and a small cat's tongue brush to add refinement to the drawing. Re-measure and restate the shapes and locations of the features. Set up the creases of the eyelids, the seam between the lips, and the nostrils, keeping the color very dark but very warm, since all of these accents are where skin touches skin.

### 9 Model the Eye Sockets and Nose

Use a small or medium cat's tongue brush to model the areas around the eyes and nose. Continue to apply the paint in the mosaic method, but with smaller strokes and colors closer in value to those on either side of the fresh strokes. Although you'll be able to preserve the freshness of the color you apply, as you step back, the areas will appear increasingly smooth. Only very slight changes in color and value are required to describe the side of the nose on our right. Model the shapes in the ears; the ear in light will get much more detail than the ear in shadow. Everything you do in this step is designed to set up following applications of paint.

### 10 Restate the Shadows, and Model Color and Value Transitions

Switch to a medium or large comb brush to paint shadow color over all canvas areas on the side of Joel's face on our left, including the entire mouth area. Smooth the transitions between cheek and beard on our right by lightly dragging one color into the other.

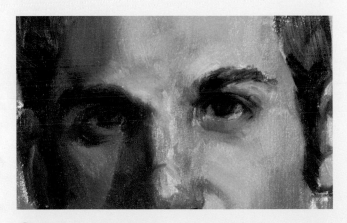

### 11 Add Detail to the Eyes

Restate the creases with your smallest cat's tongue brush using Alizarin Crimson Permanent + Asphaltum + Transparent Earth Red, and the lash lines with Raw Umber. Model the lower lips in both light and shadow, adding more detail on the lower lid in light. Add shape to the brows with Raw Umber, using your smallest comb brush. Refining the eyebrows' outer edges makes it much easier to correct the shape of the hairline on the sides of the face.

### THE MOSAIC METHOD

To apply paint in a mosaic fashion, load your brush and lay a short stroke on the surface. Keep your touch just light enough that the paint sits on top of what's already there. Pressing the brush too hard against the surface will mix the new color with the underlying paint and it will lose its fresh, saturated look. Repeat this technique until you've created a mosaic of color swatches.

## Mini Demonstration: Paint the Mouth

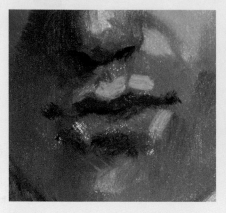 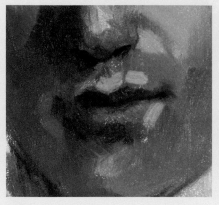 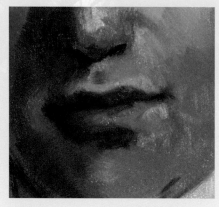

**1 Set Up the Lights to Model the Mouth**

Use a small comb brush to lay strokes of Flesh + Naples Yellow above the lip. This will establish where the philtrum (midline groove on the upper lip) is located and the shapes of the three bundles of tissue that comprise the upper lip. Another stroke along the right of the lower lip will act to carve out its shape from the barrel of the mouth. Just one small stroke of Transparent Earth Red + Naples Yellow is enough to create the shape of the corner of the mouth in shadow.

**2 Restate the Light to the Left of the Mouth**

Paint two strokes of color mixed very close to the shadow color, but lightened and warmed slightly with Flesh, to separate the lit and shadowed planes to the left of the corner of the mouth.

**3 Model the Area of Skin Around the Mouth**

Part of getting any shape right includes getting the shapes around it right, too. Model the chin and upper lip in light, integrating the color of skin and beard, using a medium comb brush, just as in the cheek in step 2. Take note of the very slight reflected light under the upper lip in shadow. Although it is lighter than other shapes in shadow, it still has to remain part of the shadow, so the value change has to be very subtle with soft edges and desaturated color. Stand back and squint at your painting to make sure that part of the mouth doesn't jump out at you.

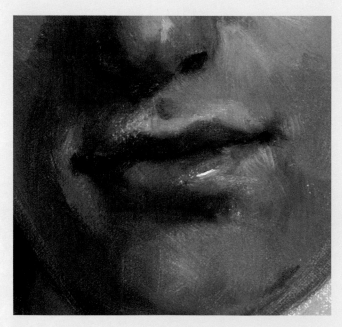

**4 Complete the Mouth**

Use a small, soft, dry fan brush to soften all the edges of the mouth, allowing the lower lip to disappear into the skin of the lower lip to our right. The upper lip describes all that your viewer will need to envision the entire mouth. Use the pushpin trick to place a tiny bit of Brilliant Yellow Light for the highlight on the lower lip.

### 12 Paint the Hair and Eye Detail

Set up the hair for modeling by painting the darkest planes, keeping the edges soft against the skin with your comb brush. Add detail to the eyes by painting the irises with Asphaltum and the pupils with Ivory Black, keeping sharp edges out of the eye in shadow. Lighten the iris in light using your smallest cat's tongue brush to paint Asphaltum + Yellow Ochre between 6:00 and 9:00, adding a highlight at 2:00 using Brilliant Yellow Light. To paint the iris in shadow, use the Asphaltum with a little less Yellow Ochre. Add a small highlight to the iris in shadow using your pushpin and Radiant Blue + Raw Umber. It shouldn't have the same sharpness as the highlight in the lit eye. Use your large comb brush to model the coral shirt with strong, unblended strokes. Use Foundation Greenish to set up the white T-shirt to accept the lightest areas, which you'll paint with Brilliant Yellow Light.

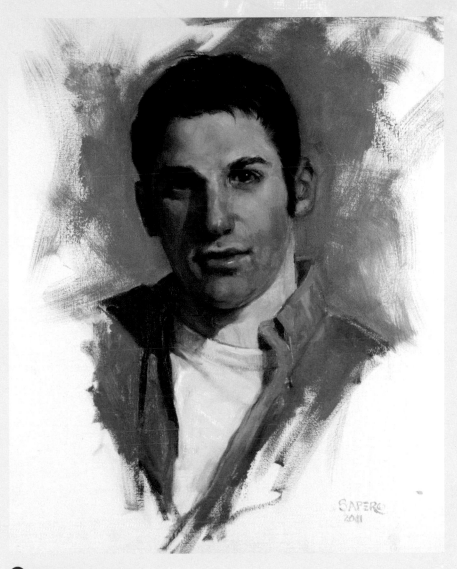

### 13 Complete the Portrait

Add highlights to the hair by painting various small strokes of Alizarin Crimson Permanent + Flake White + Radiant Blue, using a small cat's tongue brush, wet over wet. Take the shirt and background as far as you'd like. I liked the way the overall vignette was working here, so I just stopped.

**Joel from Photograph**
Oil on linen
20" × 16" (51cm × 41cm)
Private collection

# DEMONSTRATION: BLACK SKIN
# Faith From Life

Painted in open studio, this life study of Faith was a pleasure to do. The studio was indirectly lit by a window on our left, and a full-length mirror on the wall opposite the window provided fill light. Overhead fluorescent lights and a very warm, artificial incandescent light slightly above and to our left also provided lighting. The overall setup was a bit complex, but the fluorescent lights read as cool next to the stronger incandescent light. The strength and proximity of the artificial light overpowered all the other lighting.

**Reference Photo**

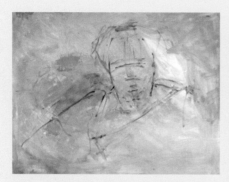

### 1 Place the Figure
Place the figure horizontally and to the right of center on a 16" × 20" (41cm × 51cm) canvas roughly toned with Raw Umber and Raw Sienna. The direction of the light from our left and the diagonal design of the dress support leaving more breathing room on the left side of the canvas. I measured the head at 8 inches (20cm) from the top of the hair to the chin, then located the features, width of the face and hair, and general shape of the dress.

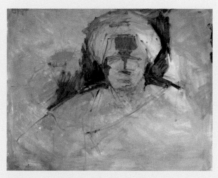

### 2 Mix and Place Color Notes for the Background and Skin in Shadow
Create the mixed green color note for the background and place swatches on the canvas right up against the skin, hair and dress areas. Mix and place the skin color in the slightly shadowed area just under the cheekbone on our left. The angle of the light is such that shadow areas appear on both the right and left parts of the face. For this study, treat the forehead as a separate color of skin in shadow. Cool the background color with violet by adding Ultramarine Blue + Flake White + Permanent Rose to reflect color from the dress. Pull some of the skin color used under the left cheekbone into the bridge and center of the nose.

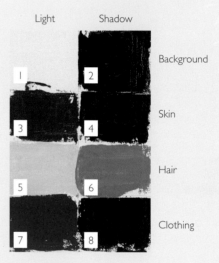

Light    Shadow

Background

Skin

Hair

Clothing

## Color Notes

1  n/a

2  Ultramarine Blue + Ivory Black + Cadmium Yellow Medium (background)

3  Yellow Ochre + Monochrome Tint Warm + Transparent Earth Red (skin in light)

4  Yellow Ochre + Caput Mortuum Violet + Transparent Earth Red + Monochrome Tint Warm (skin in shadow)

5  Brilliant Yellow Light + Naples Yellow + Raw Umber (hair in light)

6  Brilliant Yellow Light + Raw Umber + Asphaltum + Cerulean Blue (hair in shadow)

7  Cadmium Red Light (clothing in light)

8  Cadmium Red Light + Alizarin Crimson Permanent (clothing in shadow)

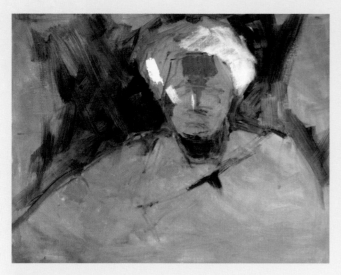

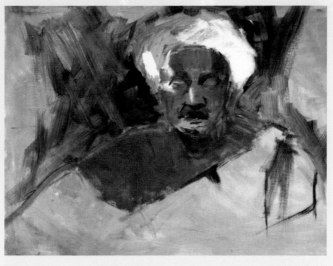

### 3 Mix and Place Color Notes for the Hair in Light and Shadow and the Dress Fold in Shadow

Naturally gray or white hair is generally cooler in color, but Faith's hair is a warm color, as it has been lightened by a hairdresser. When mixing the hair in light, note that it's warmed by the light source. The hair in shadow reads cooler than the hair in light, but only slightly darker. Paint a swatch of the dress in shadow, and pull a bit of skin tone in shadow into the neck area, generally finding the shape of the cast shadow on the throat.

### 4 Place the Skin Tones Where Light and Shadow Meet

Paint the remaining areas of skin in shadow and continue to reinforce the shapes and locations of the features. The shoulders and chest are slightly lighter and slightly warmer versions of the first mixed skin in shadow, so you'll need to get some wet paint on the raw canvas in order to have something to move around to modify.

With Raw Umber + Asphaltum, measure and place the eye sockets, base of the nose and mouth. Make these drawing strokes more angular than circular so you won't lose sight of the place where you see the lines of the forms breaking. Work out the planes and angles of the cheekbones and lower third of the face. The structure of the chin is complicated, so it's important to try to locate its smaller planes. Restate the separate values of the neck and face.

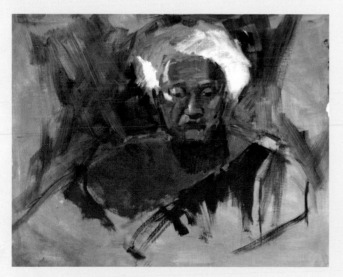

### 5 Refine the Drawing and Paint the Upward Facing Planes of the Face in Shadow

Use Raw Umber + Asphaltum to locate the deepest darks in the shadows of the eye sockets and place the irises. Use Naples Yellow + Yellow Ochre to paint the plane of the barrel of the mouth in light, which will serve to create the shapes of the upper lip on our left and the under plane of the nostril just above it. Painting this place also sets up the color and value of the nasal-labial fold adjacent to it on our left. Slowly begin to bring up the value and warm the color of other planes of the skin in light.

There are two areas where the facial planes in shadow face upward: the top of the cheekbone on our right and the top of the ball of the chin. Mix the color with Flake White + Phthalo Green and place it over the wet paint already there to mitigate its intensity. One dark, warm stroke of Asphaltum sets up the ear placement on our left. Establish the brightest color of the red dress in light with a few strokes of Cadmium Red Light out of the tube.

## Mini Demonstration: Paint the Mouth

**1** **Set up the Barrel of the Mouth**
By drawing the shapes that surround the jawline, chin and nose, the remaining canvas is set up to begin accepting the shapes of the mouth.

**2** **Paint the Shape of the Upper Lip**
Use a ½-inch (12mm) synthetic flat to lay in the basic shape and color of the upper lip, using Raw Umber + Transparent Red Earth + Naples Yellow. By starting with mouth shapes that are larger than they will end up, you can avoid the temptation to paint around the edges.

**3** **Carve the Surrounding Shapes**
Use a ¼-inch (6mm) synthetic flat to paint the skin between lip and nose, which will let you carve into the lip area itself, improving the shape and creating the surrounding values. The lower lip is lighter than the upper lip since it faces the light source, but the upper lip catches the powerful reflected red, so its saturation is higher.

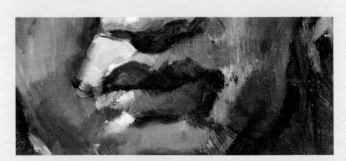

**4** **Complete the Mouth**
Finishing the mouth is every bit as much about finishing the shapes of the tissues surrounding the mouth as it is about painting the lips themselves. Use a small comb brush to integrate your edges and to keep the brushwork fresh and lively. Check at the end to see whether the highlights need to be adjusted. For Faith's mouth, these are on the upper edge of the mouth corner on our left and on the chin.

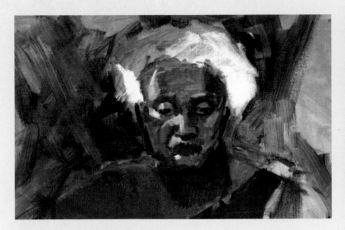

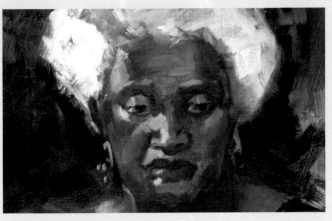

### 6 Paint the Additional Shapes of the Hair and Shoulder, and Add Reflected Color to the Skin

It would be impossible (well, certainly for me) to paint Faith's tiny curls; it's more sensible to suggest the texture of her hair. Make quick, loose brushstrokes with the comb brush to integrate the edges of the hair with the adjacent background.

Part of the fun in painting a subject with such strongly colored clothing is having the chance to find additional places to put reflected color. You can place very light strokes of Cadmium Red Light under the brow on our right, in the nostrils, and on the cheeks and upper lip.

Suggest Faith's earrings with small abstract strokes, just enough to provide information about the location of her ears and to help balance the negative space on the canvas's upper-left quadrant. To complete the ear on our left, use a 1-inch (25mm) brushstroke of Cadmium Red Light. The light striking the earlobe is nothing more than a ½-inch (12mm) dash of Cadmium Red Light + Naples Yellow.

### 7 Sculpt the Planes of the Nose, Cheeks and Chin

Use Naples Yellow + Yellow Ochre, slightly desaturated with a bit of Cerulean Blue, to paint the lit plane of the forehead and cheek. Then add more Naples Yellow + Yellow Ochre into the mix and place it on the lit part of the nose and the tissue that connects the nose to the front of the face. This paint is applied thickly, and not blended, to preserve its strength. This is the first step in which you'll actually begin to shape the lower lip. The small bit of Brilliant Yellow Light on the upper left of the ball of the chin helps to create a three-dimensional illusion.

### 8 Add Finishing Touches

As is always the case in an open studio setting, when you're down to the last ten minutes, review the canvas to see what improvements you can and should focus on and try to make those right. Just as in other areas where skin touches skin, paint the mouth's seam in your deepest, darkest, warmest colors—in this case, Asphaltum + Transparent Earth Red + Alizarin Crimson Permanent. Make tiny dark notes to indicate the corners of the mouth and a suggestion of lip separation from the center slightly to our right.

A bit of Cadmium Red Light under the chin exaggerates the reflected color of the dress on the downward-facing plane closest to it. Use a tiny drift of Flake White paint clinging to the tip of the pushpin to touch tiny points to suggest the highlights in the eyes. Don't allow the pin point itself to touch the canvas.

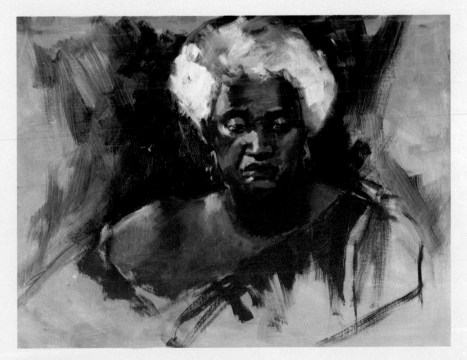

**Faith, Life Study**
Oil on linen
16" × 20" (41cm × 51cm)

# Faith From Photograph

While at times you'll have a number of good photographic reference choices, sometimes a review of photos makes the decision obvious. Such was the case with Faith.

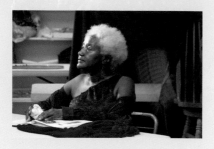

**Reference Photo**

### 1 Size and Place the Head

Mark off measurements to size the head at about 8 inches (20cm) in height, just smaller than life-size. All three considerations—the direction of the light, the direction of the face and the direction of the gaze—support placing the head slightly to the right on the canvas.

Place the vertical measurements first: the top of the head, bottom of the chin, height of the tear duct, and base of the nose and mouth. Then establish the horizontal relationships: the width of the head and placement of the eyes, nose, chin and ear. Carry the vertical marks over to the right edge of the canvas so you can continue to check head size and relationships throughout the painting process.

### 2 Outline the Figure's Main Shapes

Connect your initial measurements using a small flat and Raw Umber. Move the brush in an angular fashion, looking for the places where the forms turn.

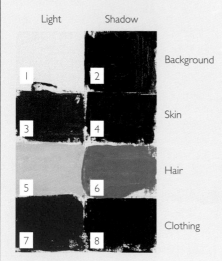

Light    Shadow

Background

Skin

Hair

Clothing

### Color Notes

1 n/a

2 Ultramarine Blue + Ivory Black + Cadmium Yellow Medium (background)

3 Yellow Ochre + Monochrome Tint Warm + Transparent Earth Red (skin in light)

4 Yellow Ochre + Caput Mortuum Violet + Transparent Earth Red + Monochrome Tint Warm (skin in shadow)

5 Brilliant Yellow Light + Naples Yellow + Raw Umber (hair in light)

6 Brilliant Yellow Light + Raw Umber + Asphaltum + Cerulean Blue (hair in shadow)

7 Cadmium Red Light (clothing in light)

8 Cadmium Red Light + Alizarin Crimson Permanent (clothing in shadow)

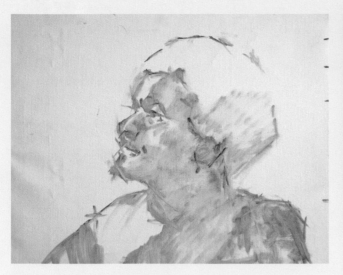

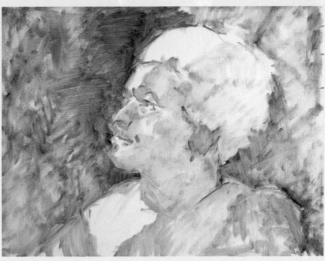

### 3 Block In the Main Shadows

Lightly block in the shadowed areas of the head with thinned Raw Umber. Move lightly with your strokes so that the surface doesn't become too wet. Light tones represent a much smaller portion of the canvas than the shadows.

### 4 Establish the Value Pattern of the Painting

The design and the compositional strength of every painting are created by clean separation of values. Begin the design with as few values as possible by using a simple 3-value design scheme. More values will be added later, but it's important to keep a general idea of the pattern in mind as the portrait progresses.

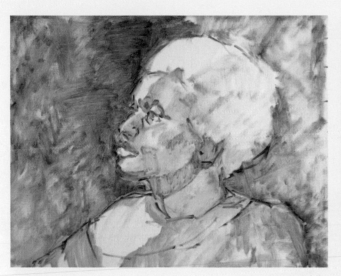

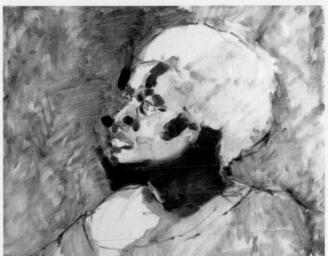

### 5 Refine the Drawing

Using Raw Umber without thinning the paint, redraw and continue to measure more details in the figure. The darker Raw Umber will allow you to see the corrections easily, while still making it easy to rub out mistakes.

### 6 Begin Adding Color to the Background and Shadows

Mix the background color with Ultramarine Blue + Cadmium Yellow Medium + Ivory Black. Place strokes of color next to areas of skin in both light and shadow. Mix the skin tone in shadow in the same fashion. Add a small amount of Transparent Earth Red to slightly warm the core of the shadow on the forehead, as well as rich shadow spots (wing of the nose, eye socket and shadow on the chin).

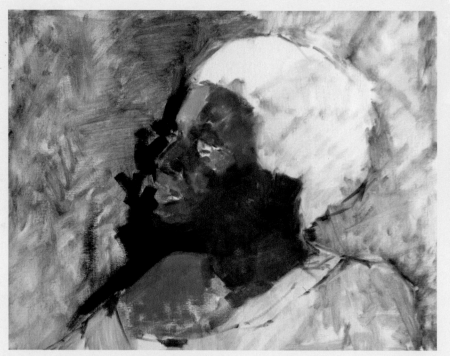

**7  Mix and Place Skin Tones in Light, and Fill In the Darkest and Lightest Skin Tones**

Paint the planes of the head that face the light in the most perpendicular direction with Yellow Ochre + Monochrome Tint Warm + Transparent Earth Red. Look for areas to incorporate cooler shadows in the forehead and under the eye. Mix these cool notes by adding Caput Mortuum Violet, which will serve to change the temperatures slightly without changing the values.

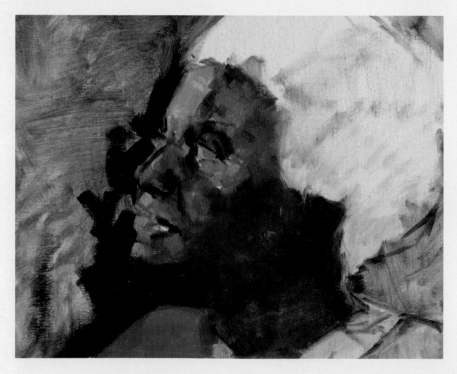

**8  Paint the Darkest Darks and Set Up the Eyes**

Use a mixture of Transparent Earth Red + Alizarin Crimson Permanent + Asphaltum + Raw Umber to paint the creases and deep shadow around the eyes, nostril, wing of the nose and the nasal-labial fold. Instead of a linear stroke, paint the shapes with a series of tiny strokes across the creased areas. This will make their edges easier to manage in subsequent steps.

Angular strokes of Asphaltum indicate the crease and shadows of the eye socket. Raw Umber indicates the lash lines on both eyes.

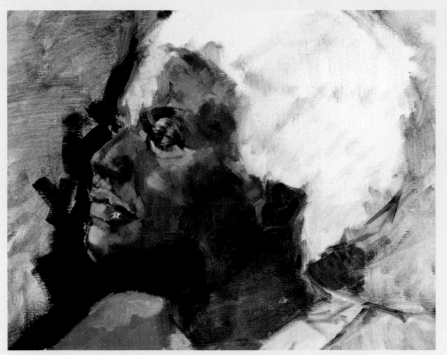

### 9 Paint the Eyes and Model the Forms in Shadow

Decrease the value of the sclera with Foundation Greenish + Raw Umber. The catchlight strikes the iris at about 10:00 and is painted with a pinpoint of Brilliant Yellow Light. The iris catches the light between 4:00 and 6:00, and one small stroke of Cadmium Red Light gives illusion of luminosity and sparkle.

Use a comb brush to paint across the subtle forms of the nose and use very slight shifts in both color temperature and value. Make sure to control the values so they stay in shadow. Draw the major shapes of the mouth and the structure of the chin. Placing a swatch of background color behind the neck will give you a context within which to judge the color and value of the hair in shadow.

Paint the cheek area so it almost obscures the nasal-labial fold, and you can create the impression of a crease in the skin without an obvious line.

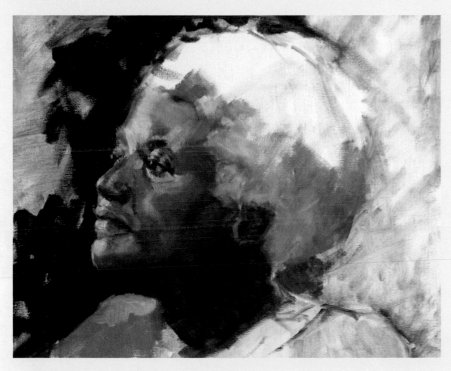

### 10 Paint the Hair in Shadow

Faith's hair is styled with tiny curls brushed out, resembling a fluffy cloud more than a sleek line. The soft edges of hair float against the face and background. Keep the paint wet so no hard edges are created. Paint the hair in shadow with a mixture of Raw Umber + Flake White, slightly modifying the value where the hair curves back into space.

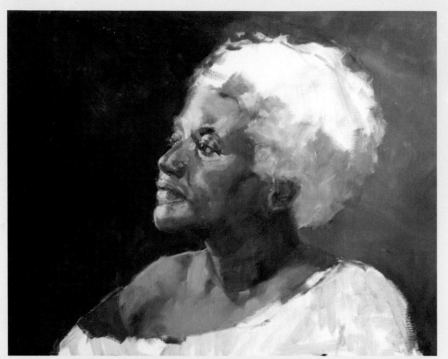

**11 Complete the Background and Form of the Shoulder and Chest**

As you continue to paint the background from the top of the head around to the lower-right part of the canvas, you'll need to make a decision its appearance. Although the actual background doesn't change in value, I wanted to keep all of the highest areas of contrast toward the profile of Faith's face. Because the value of Faith's hair was so light, I chose to reduce the relative contrast of the hair in shadow against a lighter background. The background is painted darker toward the lower right.

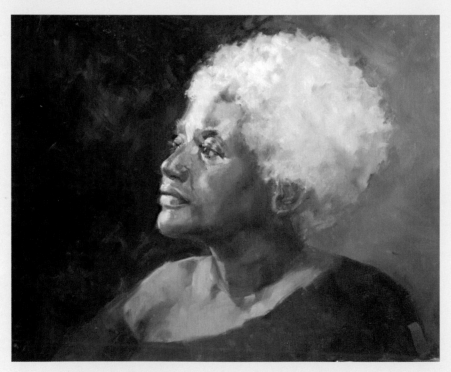

**12 Complete the Hair and Dress**

Complete the hair using the comb brush, dragging strokes of hair into the background, wiping the brush and dragging strokes of background into the hair.

Finish the shadowed areas of the dress with a mixture of Cadmium Red Light + Alizarin Crimson Permanent + Caput Mortuum Violet + mixed green (Cadmium Yellow Medium + Ivory Black) to darken, cool and desaturate the powerful color. A few strokes of Cadmium Red Light right out of the tube suggest folds of fabric that most directly face the light source.

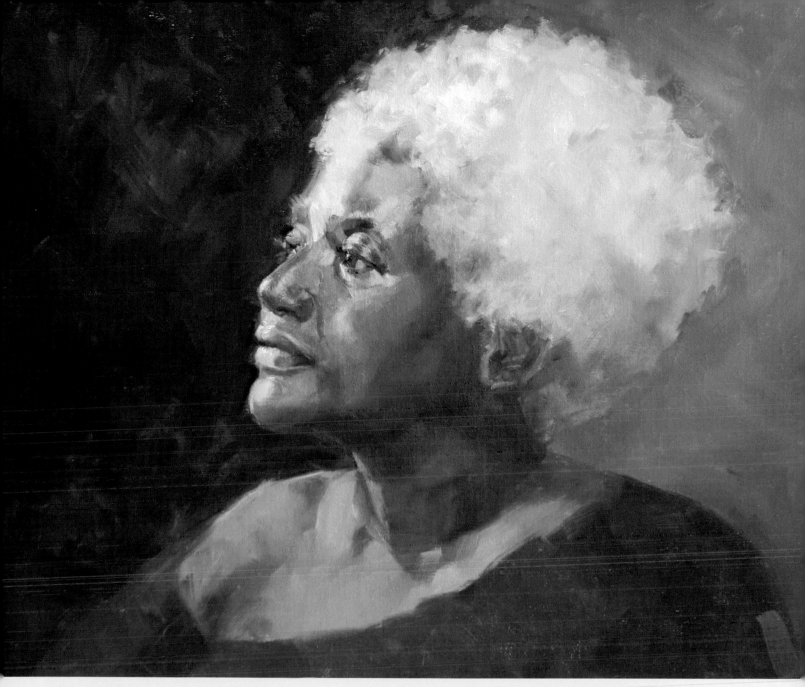

**13 Complete the Ear and Review the Painting**

Complete the ear and include an earring. I decided the shape of the neckline was distracting, so I repainted the dress and left very loose brushwork on the edges of the dress against both background and skin. Design decisions such as the earring and the neckline are part of what you as the painter can do to further your own vision for the painting. Add the signature, considering its color, size and location.

**Faith from Photograph**
Oil on linen
12" × 16" (30cm × 41cm)
Collection of the artist

# DEMONSTRATION: HISPANIC SKIN
# Tasha From Life

Tasha Dixon is a talented young actor whom I had the pleasure of meeting in 2000, when she posed for my book *Painting Beautiful Skin Tones With Color & Light.* I have delighted in following her acting career ever since.

She is lit by a warm bulb against a simple fabric backdrop similar in hue and value to the clear acrylic-primed canvas used in this demonstration. Her simple white top doesn't require color notes because the white will be yellowish in light and bluish in shadow.

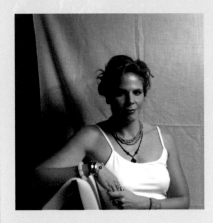

**Reference Photo**

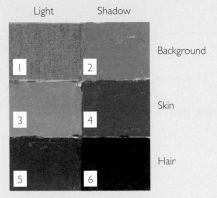

Light     Shadow

Background

Skin

Hair

## Color Notes

1 Clear acrylic-primed linen (background upper left)

2 Flake White + Radiant Blue + Raw Umber (background upper right)

3 Yellow Ochre + Flesh + Transparent Earth Red (skin in light)

4 Yellow Ochre + Flesh + Permanent Rose + mixed green (Ivory Black + Cadmium Yellow Medium) (skin in shadow)

5 Raw Sienna + Transparent Earth Red (hair in light)

6 Raw Umber (hair in shadow)

### 1 Size and Place the Head
The beautiful canvas color of the clear acrylic-primed canvas does not need to be toned; it's nicely suited to painting vignettes. On a 20" × 16" (51cm × 41cm) canvas, size the head 8½ inches (22cm), which is the length of the silhouette from the chin to the top of the hairline. Because the light is coming from our right, leave extra breathing room on the right as well. Use a small cat's tongue brush with Raw Umber and some medium to measure the vertical distances between the hairline, brows, tear ducts, nose, mouth and the top of Tasha's camisole. Then mark your horizontal measurements, including the width of the outer silhouette of the hair, the face, neck and shoulders.

### 2 Separate Light From Shadow
Use a large cat's tongue brush and Raw Umber with some medium to block in the shadow shapes and shapes of the hair. By using Raw Umber without medium, you can make darker strokes to locate the features. All of your cat's tongue brushes will come to a nice point, so you won't have to switch to a smaller brush.

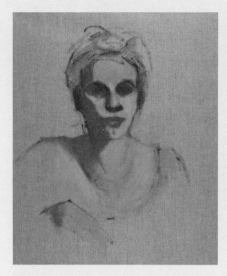 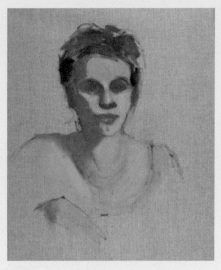 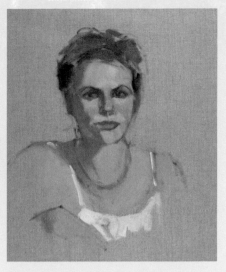

**3 Block In Skin Tones in Light and Shadow**

Mix the color notes for the skin in light and in shadow, and block in the general shapes with a medium cat's tongue brush. Paint the mouth in the shadow color, but a little redder and more saturated. You can correct the difference in values on the lips later.

**4 Block In the Hair in Light and Shadow**

Mix color notes for the hair in light and the hair in shadow. With curly or tousled hair it's more difficult to find the light and shadow shapes, so it's important to really squint to see the different values. In painting a vignette where the background remains the canvas color, take a little different approach to blocking in the hair—make the basic shapes smaller than they actually are so the surrounding canvas is left as clean as possible. Then you'll be able to keep the transition strokes between hair and background light and integrated.

**5 Begin to Model the Features**

To make the cheek in shadow appear to turn away, reinforce its edge with a redder version of the shadow's color note. Then slightly desaturate the remaining shadow (between its core, or turning edge, and the ear) by lightly dragging a mixed green (Ivory Black + Cadmium Yellow Medium), lightened to the value of the shadow with Foundation Greenish, over the top with a medium comb brush. Even with a vignette, it's important to relate the subject to the background, so the shadow's hue should be similar to the background color.

Start to find the smaller shapes in the eye sockets and other features, and start to refine the planes of the face. Suggest a color note for the turquoise beads, using Phthalo Green + Flake White. The white camisole is lit by a warm light source. Use direct strokes of Brilliant Yellow Light—it's got a bit of a yellow cast compared to Titanium or Flake White and is opaque like the Titanium, or you can use Titanium with a touch of Cadmium Yellow Medium.

## HOW GROUND AFFECTS VIGNETTES

The way you paint outer edges in a vignette depends on the ground, and whether it's easy to completely remove unintended strokes. The texture of the clear acrylic-primed canvas is rougher than oil-primed portrait linen, and it's impossible to completely erase paint that makes its way into the weave. However, if you are working on a surface that you've created by toning, especially a smooth surface, you can readily wipe clean mistakes with a rag or paint more toning mixture over them.

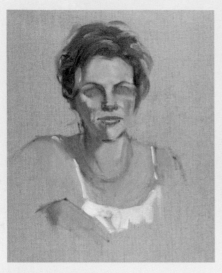

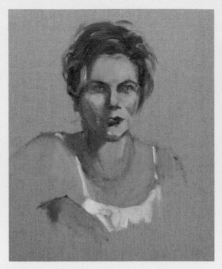

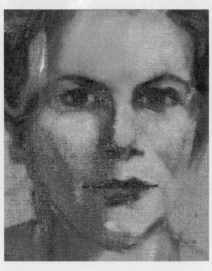

**6** **Model the Hair**
Use a medium cat's tongue brush to model the hair's smaller shapes, including the wave on our left that nearly touches the eyebrow. Keep the strokes very light around the edges of the hair, letting some of the canvas peek through. At this point, the eyes weren't going the way I wanted, so I wiped them out with a paper towel. Sometimes if you get a lot of wet paint on the surface, it's too difficult to modify the painting by adding more paint and easier just to wipe it off and start over. Don't be afraid to abandon what's not working!

**7** **Restate the Drawing**
Every time your model returns from a break, recheck your drawing. The now-empty eye sockets are ready to accept fresh detail. The slight shift in Tasha's position has changed the light and shadow shapes a tiny bit, but I liked the shapes and decided to change them to agree with the pose at this point in time.

**8** **Remodel the Eye Sockets**
Reestablish the gaze by placing the irises (Raw Umber) and sclera (Raw Umber + Foundation Greenish) by applying the paint very thinly and with a light touch. Keeping the paint very thin will allow you to better manipulate further detail in the eyes.

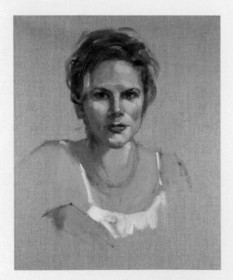

**9** **Correct Drawing Errors While Adding Detail**
As you model the eye sockets again, correct the shaping and placement of the brows, the tip of the nose and the mouth. Then add the details surrounding the eyes—the crease, the bit of lid that shows and the size of the sclera (to make the irises a little smaller). Use Ivory Black to place the pupil with a small cat's tongue brush, and light the iris opposite the highlight with Transparent Earth Red, from about 7:00 to 10:00. Use Foundation Greenish to place the highlight with a pushpin.

## LIVING MODELS MOVE

As your model settles into the pose, she'll assume an increasingly natural position. In this case, the shape of the cast and form shadows has shifted a bit. If I were painting a long pose or teaching, I'd be meticulous about helping my model return as accurately as possible to the original pose. However, with a shorter life study (about 2 hours or so here), I'm happy to simply make some slight adjustments as I proceed with the painting. When you have the time, it's always a good idea to let the model be in the pose for a while before beginning, since much of what's natural to an individual's positioning is very much part of the personality and temperament you want to capture.

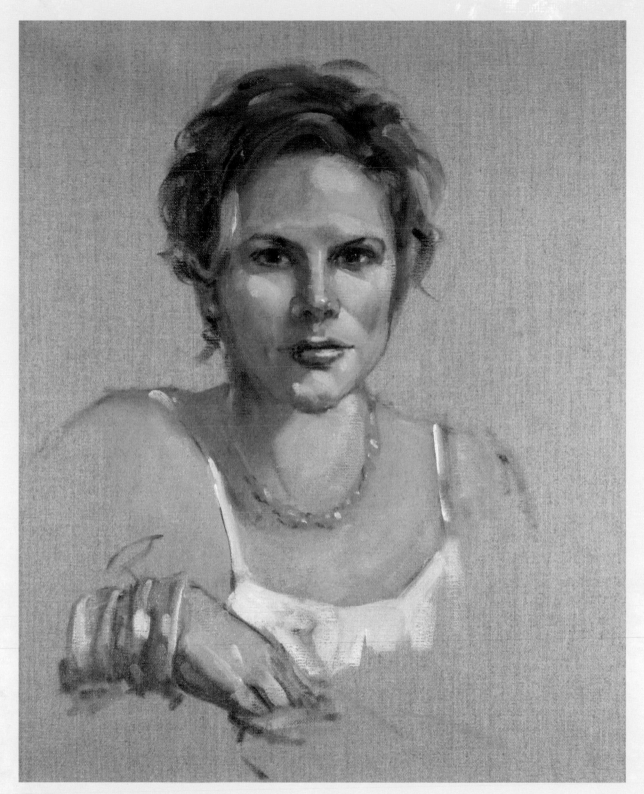

**10** **Add Details to Complete the Study**
Add detailed touches to the necklace, bracelet and earring. Add volume to the outside
edges of the hair, keeping your strokes soft and loose. Even a tiny cast shadow from the
strap of the camisole adds a touch of dimension.

**Tasha, Life Study**
Oil on clear acrylic-primed linen
20" × 16" (51cm × 41cm)
Private collection

# DEMONSTRATION: HISPANIC SKIN
# Tasha From Photograph

Occasionally you'll come across a situation where you want to use a reference photo that needs a bit of adjusting. In this case, I thought the pose in the original photo looked a little contrived. I rotated the photo before sizing and placing the head so I could work out the size and negative space placement based on the rotated image.

**Reference Photo: Original and Rotated**
I rotated the photo and sized it for a 20" × 16" (51cm × 41cm) canvas.

### 1 Size and Place the Head
The distance from the bottom of the chin to the top of the hair is about 9 inches (23cm), so the head is close to life-size. Leave about 2 inches (5cm) between the top of the hair and the top of the canvas, enough room to sit in a frame without feeling crowded. This size also allows enough room at the bottom for the white camisole's neckline to complete a compositional U-shape that will return the viewer's eye to the face. Use your medium cat's tongue brush with Raw Umber to generally place the head and to indicate its tilt, marking the vertical relationships first.

### 2 Draw the Basic Shapes of the Head and Neck
Continue drawing with your brush, carefully measuring the horizontal distances of the features. It's easy to let the tilt drift toward the horizontal as the painting progresses, so it's worth taking the extra time to maintain the angle at every stage.

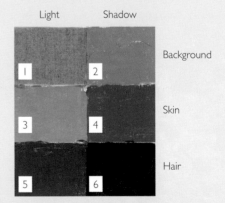

Light     Shadow

Background

Skin

Hair

### Color Notes

1 Clear acrylic-primed linen (background upper left)

2 Flake White + Radiant Blue + Raw Umber background upper right)

3 Yellow Ochre + Flesh + Transparent Earth Red (skin in light)

4 Yellow Ochre + Flesh + Permanent Rose + mixed green (Ivory Black + Cadmium Yellow Medium) (skin in shadow)

5 Raw Sienna + Transparent Earth Red (hair in light)

6 Raw Umber (hair in shadow)

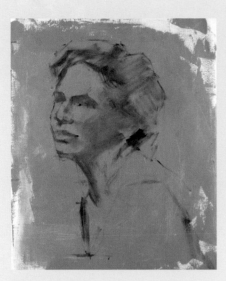

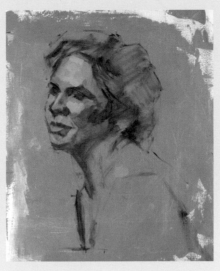

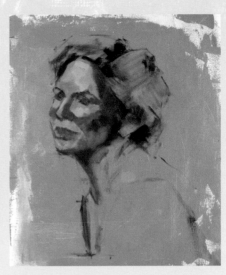

**3** **Separate the Light From Shadow**
Switch to your largest cat's tongue brush to lightly carve out and block in the areas of shadow. Keep the Raw Umber transparent by adding a little medium to the paint.

**4** **Paint a Mosaic of Light Shapes in the Face**
Let's try a slightly different approach to applying color—look for and exaggerate slight color differences among the planes of the face. Switch to a large comb brush, and using single strokes, place different color variations adjacent to one another, wiping the brush between strokes. This "lay it and leave it" method keeps your color saturated and fresh. You'll blend it in subsequent steps.

**5** **Continue the Mosaic Into the Dark Shapes**
Paint the light and shadow mosaic during the same session so the paint is uniformly fresh and set up to blend.

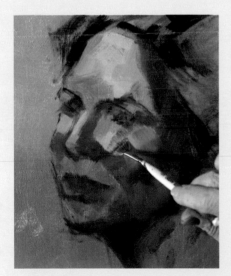

**6** **Integrate the Mosaic Shapes**
Use your small, soft fan brush to pull the light shapes into one another, the shadow shapes into one another and then the lights into the shadows, using one stroke in each direction. Be sure to wipe the brush between strokes. Integrating the colors in this way will soften both the color and value transitions without losing the color freshness that results from excessive blending of the paint on the surface.

## SELECTING THE RIGHT SURFACE
Although I loved the color of the acrylic-primed linen for Tasha's life study, its relatively coarser surface was rougher than I wanted for the subtleties I planned to include in Tasha's finished portrait. To paint her finished portrait from photographs, I opted to tone a finer weave oil-primed linen with an opaque coat of Flake White + Radiant Blue + Raw Umber, which I let dry completely. Of course, if you prefer more texture to your surface, you could stick with the clear acrylic-primed linen. You will develop your own preferences over time.

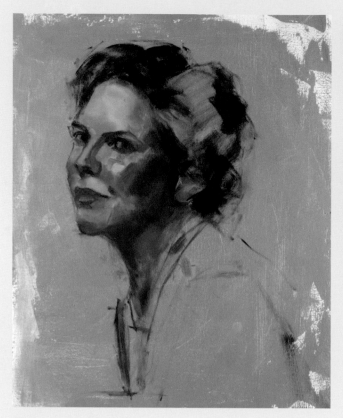

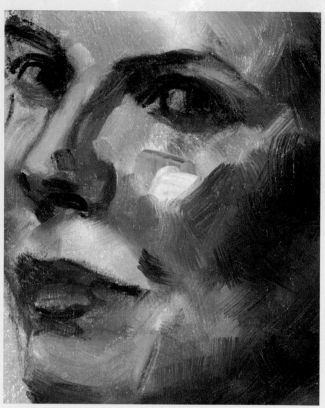

**7 Place the Features**

Once you get enough paint on the canvas to move it around, you can tend once again to your drawing, re-measuring distances and shaping the features to improve the likeness. Add color to the neck, and paint the darkest areas of hair.

**8 Prepare the Features for Blending**

The small marks from the fan brush are visible in this detail. The colors are layered to make the transitions even smoother in the next step.

**9 Soften the Edges and Colors**

Switch to a medium cat's tongue brush to further soften the edges and colors. You'll need to do this step while the previous step's paint is still wet enough to drag. From this point on, choose how much blending you want to do, according to your own preferences.

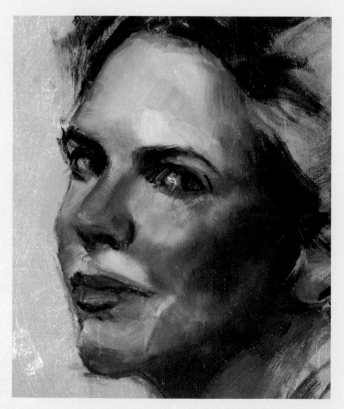

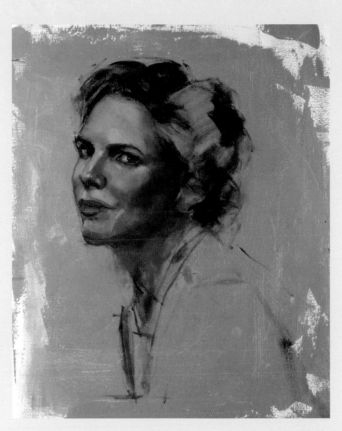

### 10 Add Detail While Correcting the Drawing

Add detail to the eyes and their surrounding shapes. Refine the shapes of the nose and mouth so they are more accurate. Although all the cat's tongue brushes come to a nice point, you'll probably want to switch to your smaller brushes to work detail into the eyes.

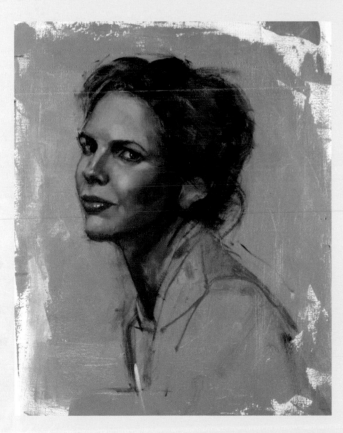

### 11 Model the Mouth and Hair

To model Tasha's mouth, use Vermilion for the deepest, richest color, then modify the Vermilion with mixtures of Flesh + Naples Yellow. Avoid using Flake or Titanium White since it will cool the warmth of the Vermilion. It's relatively easy to see the two bundles of tissue that make up the lower lip.

Squint at the shapes that make up the hair and block in the remaining areas with Raw Sienna + Transparent Earth Red. You'll be able to suggest detail in later steps.

# Mini Demonstration: Paint the Jewelry

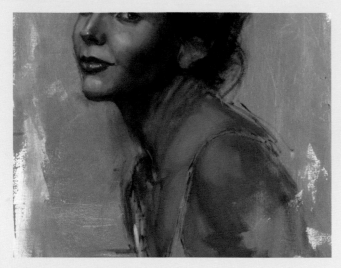

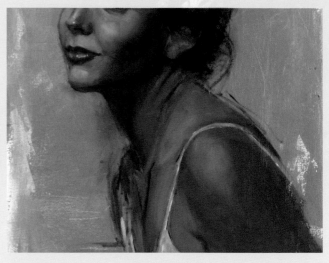

**1** **Set Up the Underlying Skin to Accept the Jewelry**
Cover the canvas with skin tone colors in both light and shadow. You can proceed to the next step on either a wet or dry canvas.

**2** **Lightly Paint the Darker Colors of the Jewelry**
Use Cerulean Blue + Raw Umber to paint a ground for the turquoise beads and thinned Ivory Black to paint the shape of the black beads. A small cat's tongue brush will work well here. Use a small synthetic flat to paint the camisole with Flake White.

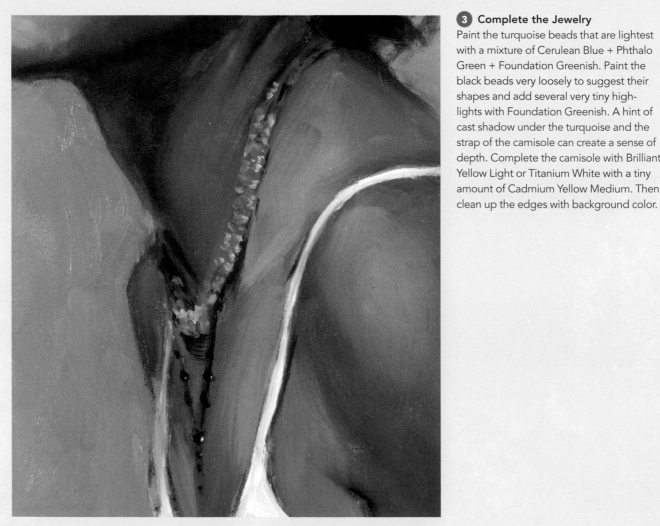

**3** **Complete the Jewelry**
Paint the turquoise beads that are lightest with a mixture of Cerulean Blue + Phthalo Green + Foundation Greenish. Paint the black beads very loosely to suggest their shapes and add several very tiny highlights with Foundation Greenish. A hint of cast shadow under the turquoise and the strap of the camisole can create a sense of depth. Complete the camisole with Brilliant Yellow Light or Titanium White with a tiny amount of Cadmium Yellow Medium. Then clean up the edges with background color.

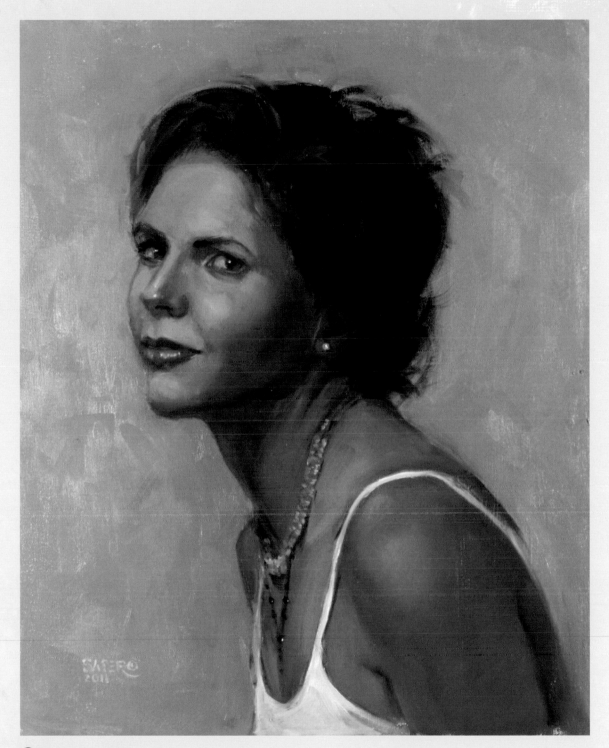

**12 Complete the Portrait**

Complete the background as you manage the final edges, especially in the hair. Add highlights to the hair with Raw Sienna + Yellow Ochre + Transparent Earth Red. Let the background and the back of Tasha's camisole flow together so the lower right corner of the canvas diminishes in importance. Complete any last adjustments you want to make. Here I spent a little more time on the mouth and the transition between light and shadow on the cheek.

**Tasha from Photograph**
Oil on linen
20" × 16" (51cm × 41cm)
Collection of the artist

# Soraya From Life

Soraya is a professional model and clothing designer whom I've painted several times. Part Moroccan and part Italian, she has classic olive skin tones often found in Mediterranean groups, but strikingly atypical pale blue-green eyes. She is lit from above and somewhat frontally with a warm light, about 3500K, against a midvalue, cool brown backdrop.

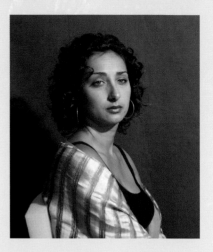

**Reference Photo**

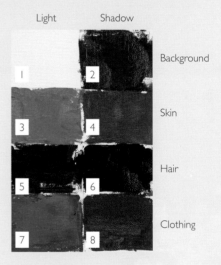

Light     Shadow

Background

Skin

Hair

Clothing

**1** Place the Head and Mix the Background Color
Use a small synthetic flat and thinned Raw Umber to make vertical measuring marks representing the top of the hair's silhouette, the bottom of the chin and the top of the shirt. Two horizontal marks indicate the edge of the hair on our left and the cheekbone on our right. Establish the box within which the head will sit. Mix the background color note and place on the edge of the canvas.

**2** Locate the Major Shapes and Features, and Separate the Light From Shadow
Vertically subdivide the spaces between the top of the hair and the chin, locating the eyes, nose and mouth. Horizontal measurements estimate the widths of the eyes, forehead, the base of the nose and the mouth, as well as the distance between light and shadow on the face. Other horizontal and angle measurements estimate the width of the neck and placement of the ear.

## Color Notes

1 n/a

2 Raw Umber + Transparent Earth Red + Foundation Greenish + Permanent Rose (background)

3 Raw Sienna + Monochrome Tint Warm + Naples Yellow (skin in light)

4 Raw Sienna + Monochrome Tint Warm + Naples Yellow + Asphaltum + Alizarin Crimson Permanent (skin in shadow)

5 Asphaltum + Yellow Ochre (hair in light)

6 Raw Umber + Asphaltum (hair in shadow)

7 Cadmium Orange + Yellow Ochre + Naples Yellow + Cadmium Red Light (clothing in light)

8 Cadmium Orange + Transparent Earth Red + Caput Mortuum Violet (clothing in shadow)

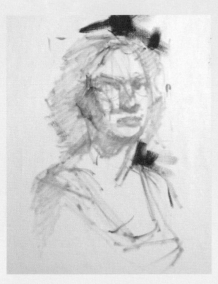

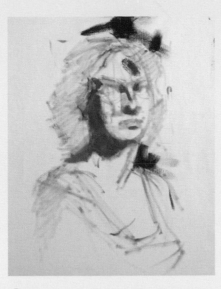

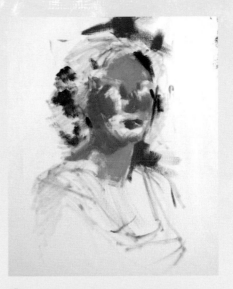

**3** **Begin the Background**
Place strokes of background color immediately, right up against areas of skin and hair to create a context within which to judge the color and value of adjacent skin and hair shapes. It's extremely difficult to accurately mix a skin tone—or any other color—in isolation.

**4** **Place the Skin in Light and Shadow**
Mix the skin tone in light and place on the forehead. Mix the skin tone in shadow and place one continuous tone over the shadowed areas on the right side of Soraya's face, along the bridge of the nose and under the base of the nose. Color differentiation in shadowed areas can wait for now, since to initially treat all shadowed areas of skin with one color will help keep your shadow values under control.

**5** **Place the Warmest Skin Color in Light and the Darkest Values in the Painting**
The darkest value in the portrait is the area of shadow in Soraya's hair, adjacent to shapes of skin in both light and shadow. Mark the darks with Raw Umber. It's cooler in temperature than Asphaltum, enabling you to wait until later to adjust color temperature in the hair.

The areas of rich color across the middle third of the face are characteristic of Caucasian subjects because the underlying areas of rich blood supply can be seen through the skin. Take that initial color note of skin in light and add Vermilion to change the hue. Loosely indicate the shape of the mouth with a few strokes of paint. If the color mixture for the skin in light is too dark, lighten with Naples Yellow. Paint the forehead, bridge of the nose and part of the lower face with the corrected color.

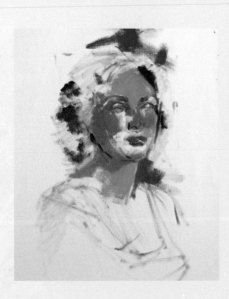

**6** **Draw the Overall Shapes of the Features**
Use Raw Umber and a small synthetic flat to draw the basic shapes of the brows, eye sockets and the lower part of the nose. Reinforce the position of the mouth by painting the shadow under the lower lip. Place a few linear strokes to estimate where the jaw meets the ear and where the side of the chin meets the adjacent side of the face.

Visit artistsnetwork.com/portrait-painting for a free demonstration on painting a vignette

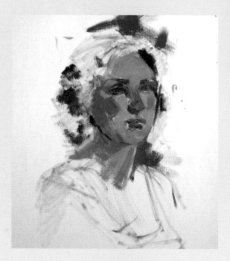

**7** **Model the Eye Sockets, Nose and Mouth**
Give attention to the shapes within the eye sockets, beginning with the eye on our left. Use a small cat's tongue brush to make tiny strokes of Raw Umber + Ivory Black to mark the upper lash line and the shadow beneath the lower lashes. Add a bit of Transparent Earth Red to indicate the crease of the lid and the tear duct. Place both irises. Set up the shadows under the brows with a mixture of Raw Umber + Transparent Earth Red.

Paint the various shapes that make up the nose. Emphasize the warm red on the nose to join with the more neutral color on the bridge.

Form the edges of the nose along our right and down around the tip by painting the lighter shapes around them with corrected color. Similarly, you can carve the mouth into shape by painting the areas of skin around the lips.

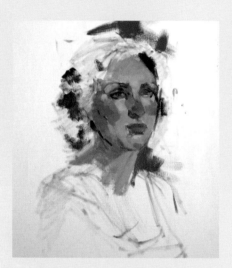

**8** **Paint the Shapes Connecting the Nose to the Cheek, and the Upper Lids to the Shadows**
Use Monochrome Tint Warm and a bit of mixed green (Ivory Black + Cadmium Yellow Medium) to desaturate the reds used in the nose and cheeks and to provide a relatively cooler and darker connection between the facial planes that are most perpendicular to the light. Add more detail to shadows above the eyes.

## Mini Demonstration: Paint the Eyes

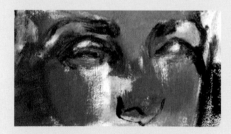

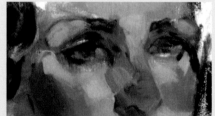

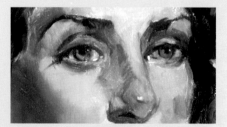

**1** Set up the general structure of the eyes by locating the brows and crease with Asphaltum.

**2** Use a small comb brush to paint the small planes that make up the lids and corners of the eyes. Don't forget to locate the shelf of skin that supports the lower lashes. Place the irises.

**3** To complete the eyes, use a no. 4 or 6 cat's tongue brush to soften both color and value transitions between the planes you've painted. To make the irises luminous, lighten the color of the iris directly opposite the highlight. In this case the highlight is at about 1:00, so the lightest part of the iris is at about 7:00. Leave a slight shadow on the upper part of the white of the eye. Use a pushpin to place the highlights in the irises, and in the whites of the eyes.

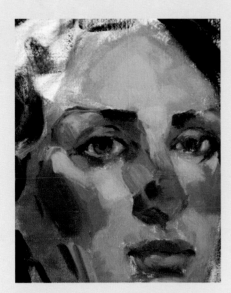

### 9 Soften the Color and Value Transitions

Use a ¼-inch (6mm) comb brush to add paint to the surface and to integrate and smooth the patches of color in the skin. Use Raw Umber to describe the darkest planes in the hair.

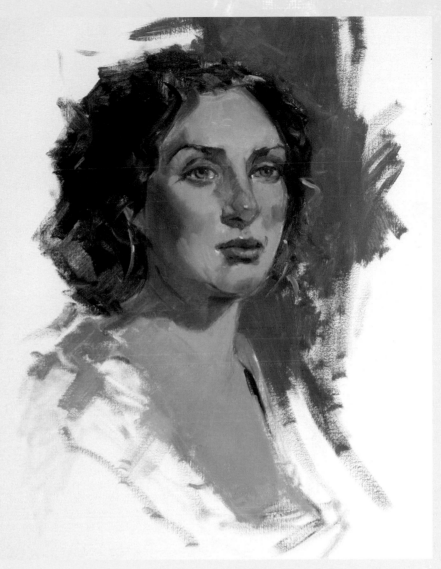

### 10 Complete the Study

Pull the background color down from the top of the canvas to meet the shoulder. Mix and place a color note for the shawl using Cadmium Orange + Yellow Ochre + Naples Yellow + Cadmium Red Light. Fill in the planes of the hair that are lighter. Just suggest the earrings with a few strokes of Portland Gray Medium, highlighting them with Foundation Greenish, rather than painting every detail.

**Soraya, Life Study**
Oil on linen
20" × 16" (51cm × 41cm)

# Soraya From Photograph

Each time I've painted Soraya, I've been struck by the extraordinary symmetry of her features, her amazing eyes, and her calm, elegant demeanor. This demonstration is designed to include a half-figure pose. Although it begins on a larger 36" × 26" (91cm × 66cm) canvas, keeping its odd size will require a custom frame, which is costly and impractical. It's better to design the painting to fit a standard-size frame. In this case, the portrait will comfortably occupy a 30" × 24" (76cm × 61cm) canvas, and it will be only a small task to restretch the completed canvas on smaller stretcher bars.

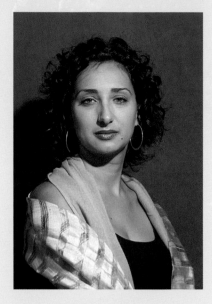

**Reference Photo**

### 1 Size and Place the Figure

Place the head to the left of center to leave enough negative space on our right. Size the figure to leave about 3½ inches (9cm) of negative space on the top and about 1 inch (3cm) of space beneath the lowest finger on the hand, so once framed, the composition won't cut off the fingertips. The head size will be about 8½ inches (22cm) from the chin to the top of the hair.

Make horizontal marks to locate key landmarks, including facial features, the neckline of the shirt and the top and bottom of the hand; then place horizontal marks to estimate widths.

### 2 Lightly Tone the Canvas With a Desaturated Yellow-Green to Underpaint the Skin Tones

Use your widest synthetic flat to very lightly tone the canvas with Ivory Black + Naples Yellow + Raw Sienna (creating a color often referred to as Terre Verte). Lightly cover the area that will become skin tone, but also cover other areas of the canvas so the entire surface has some level of integrated base color.

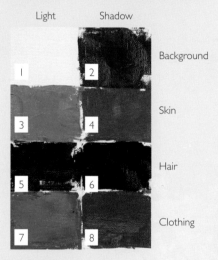

**Color Notes**

1 n/a

2 Raw Umber + Transparent Earth Red + Foundation Greenish + Permanent Rose (background)

3 Raw Sienna + Monochrome Tint Warm + Naples Yellow (skin in light)

4 Raw Sienna + Monochrome Tint Warm + Naples Yellow + Asphaltum + Alizarin Crimson Permanent (skin in shadow)

5 Asphaltum + Yellow Ochre (hair in light)

6 Raw Umber + Asphaltum (hair in shadow)

7 Cadmium Orange + Yellow Ochre + Naples Yellow + Cadmium Red Light (clothing in light)

8 Cadmium Orange + Transparent Earth Red + Caput Mortuum Violet (clothing in shadow)

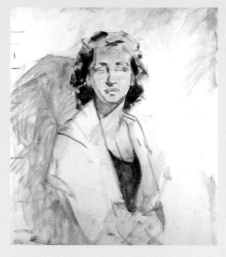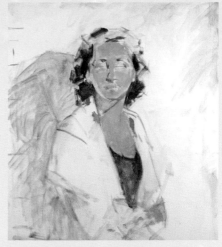

**3 Separate Light From Shadow**
Use the same large synthetic flat and Raw Umber thinned with a little medium to declare areas of shadow. This is the point where you should stop to reevaluate the overall composition and design of the painting. If you want to make any major changes to the design, or if you have other areas of uncertainty that require resolution, this is the time to do so.

**4 Place the Darkest Darks**
Use Raw Umber to locate the darkest areas of the painting, which will result in a three-value tonal scheme. At this point, I haven't decided whether the cast shadow will remain as a middle or dark value.

**5 Block In the Skin Tones in Light**
Still using the large flat, block in the skin color in light. Place an immediate color note of the scarf's light orange up against several areas of skin tones and shadow.

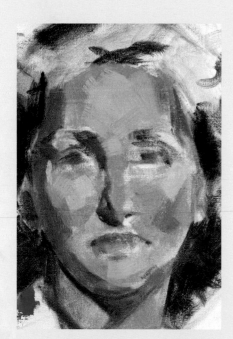

**6 Place Color Notes for the Skin in Shadow and Begin to Model the Skin in Light**
Switch to a medium to large comb brush to place patches of clean, fresh color (slight variations of the base color) on top of the skin tone base. To keep the color separate and rich, don't mix it into the underlying paint; just lay it on top, then wipe your brush and add another color. This approach will allow you to explore and sculpt the forms in light. At this point the locations of the features are only estimates, but you need to get paint onto the surface to have something to push around as you refine the drawing.

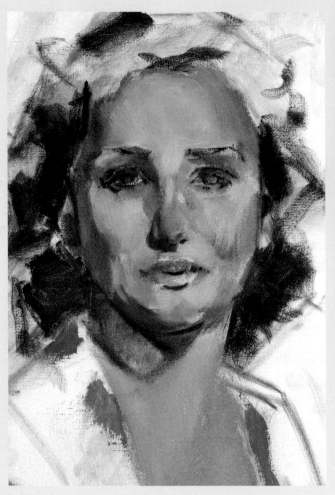

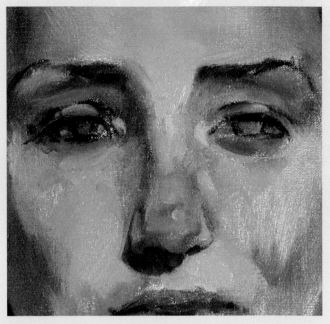

**8** **Add Detail to the Nose and Eyes**

Restate the nostrils and eyelid creases with a small cat's tongue brush and small strokes of Transparent Earth Red + Asphaltum, keeping the darks very warm in color. Be careful when reshaping the nose's cast shadow, because it will provide a great deal of information about the shapes over which it falls.

Paint the slight shadows under the eyes, only a tiny bit darker in value than the surrounding skin. This is important in creating Soraya's expression. Set up the irises for color and the upper part of the sclera for the shadow cast by the upper lashes.

**7** **Correct Drawing Errors**

Use a small to medium cat's tongue brush to correct the size and location of the features and outer shapes of the jawline and chin.

### MAKE DECISIONS THAT MAINTAIN HARMONY

Despite the photo setup and background color notes I made during Soraya's life study, I judged the background as too dark and too warm. I adjusted it by retaining the Raw Umber + Foundation Greenish mix, but replacing the reds with Monochrome Tint Warm. Such an adjustment can work because it fits with the overall color harmony of the painting, lightening the value and cooling the temperature a bit. But a dramatic change in background hue—for example, to a Cerulean Blue or strong violet—would throw off the color harmony so much you'd have to repaint the entire canvas.

## Mini Demonstration: Paint the Eyelashes

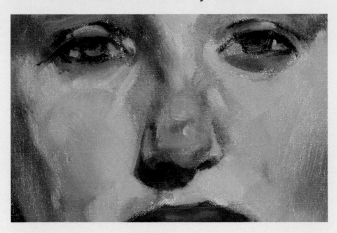

**1** **Set Up the Lash Line**
Painting individual eyelashes usually looks amateurish and fails to create the impression of the lash softness you see when you look at a person. After the irises are colored and the sclera completed, subtly suggest the lashes. Use a small cat's tongue brush to paint the upper lash line with Ivory Black.

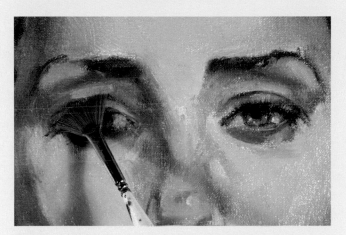

**2** **Push the Paint**
Switch to a small sable fan brush that is clean and dry. Gently push the paint upward and away from the lash line in the direction the eyelashes go.

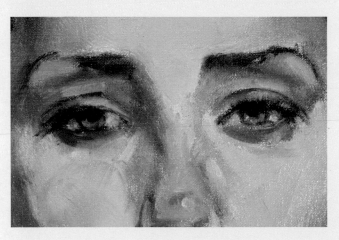

**3** **Complete the Lashes**
When you have finished the lashes, if you decide you don't like the way they look, just wipe off the paint to the previous step and start again, rather than trying to fix already-placed lashes.

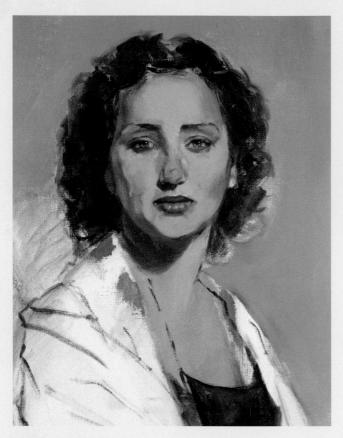

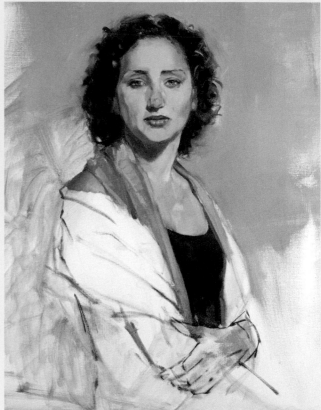

### 9 Set Up the Edges

To this point, only the major planes of the hair have been painted. To proceed in finishing the hair's edges against the background and the face, the paint on the areas adjacent to the hair needs to be wet. If your canvas is dry, just remix the skin tones, scarf and background colors. Paint the background, scarf, face and neck up to and just past the places where you anticipate the edges of the hair to be, since you'll want all the edges to be soft.

### 10 Paint the Hairline Against the Face, Scarf and Background

Use a variety of sizes of comb brushes to gently pull skin color into hair color and vice versa, wiping the brush clean between strokes. As you get ready to make final edges, turn the canvas so you can paint them with the natural arc of your hand. As a right-handed painter, I turned the canvas 90 degrees clockwise to pull the hair into the background to the right of the neck. Lefties, turn the canvas counterclockwise.

### 11 Simplify Shapes to Complete the Hand and Shawl

Hands are very complex structures to paint, and if they're not right, they're clearly wrong. It can take as much time to paint a pair of hands as it does a face. Keep the fingers simple in shape, rather than try to paint every fold and knuckle. You can select the details to paint so they suggest more information in the skin tones than actually exists. Here, I've limited details and edges to the ring, the area where the thumb touches the forearm, and the modeling of the first fingertip and its fingernail.

Squint at the gold shawl to get the impression of it and paint simple stokes to suggest it. Lighten very slightly the background along the shirt on our left to create a sense of space between the subject and background.

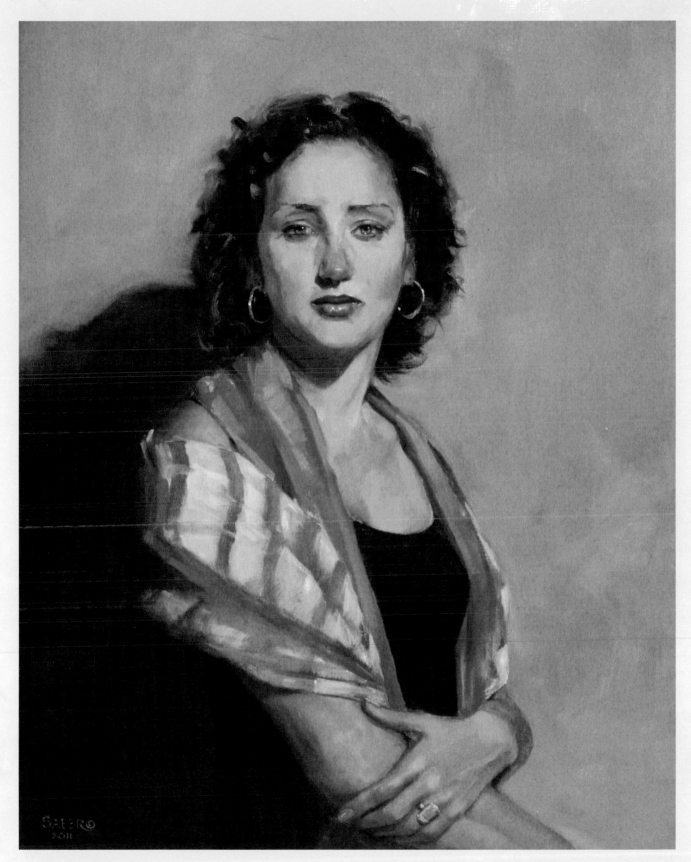

**Soraya from Photograph**
Oil on linen
30" × 24" (76cm × 61cm)

# DEMONSTRATION: NATIVE AMERICAN SKIN
# Filmer From Life

In this demonstration my Hopi friend Filmer, an accomplished artist, wears a traditional ribbon shirt. It is typically worn by men at various tribal ceremonies such as the Buffalo or Butterfly Dances, where they also sing. His Hopi name, Yoimasa, was given to him by his paternal grandmother. It roughly means the view of the sky when rain clouds are coming in from the horizon, flapping as if they had wings.

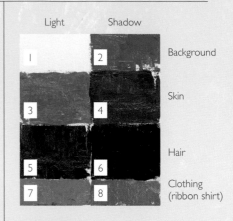

Light    Shadow

Background

Skin

Hair

Clothing
(ribbon shirt)

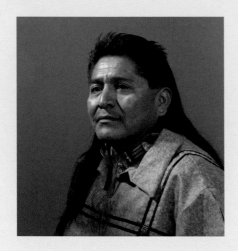

### Reference Photo
Fil is lit from above and from our left with a warm light source, about 3500K. The lighting accentuates the rich red-orange skin tones, a combination of his natural skin color and tanned complexion. There is some natural indirect light coming in from a window to our right, giving soft highlights in shadow that are quite cool in color temperature.

### Color Notes

1  n/a

2  Ultramarine Blue + Ivory Black + Cadmium Yellow Medium + Foundation Greenish + Monochrome Tint Warm (background)

3  Yellow Ochre + Transparent Earth Red + Foundation Greenish (skin in light)

4  Yellow Ochre + Transparent Earth Red + Caput Mortuum Violet + Cerulean Blue (skin in shadow)

5  Raw Umber + Transparent Earth Red + Raw Sienna (hair in light)

6  Raw Umber + Ultramarine Blue + Ivory Black (hair in shadow)

7  Foundation Greenish + Portland Gray Medium + Raw Umber (ribbon shirt in light)

8  Foundation Greenish + Portland Gray Medium + Raw Umber + Ultramarine Blue (ribbon shirt in shadow)

**1 Size and Place the Head**
From this ¾-plus view, the width and height of Fil's head are about the same: 7½ inches (19cm). Draw the box that will enclose the head's silhouette, placing it slightly to the right to allow extra breathing room on the left. Estimate the tear ducts to be about halfway from the chin to the top of the hair.

**2 Place the Features and Large Shapes**
With a medium cat's tongue brush, use Raw Umber thinned with a bit of medium to mark the locations of the base of the nose, mouth, hairline, ear, neck and collar.

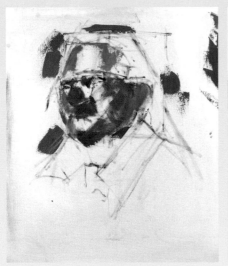
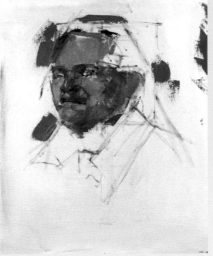
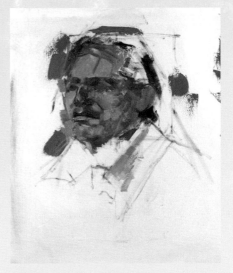

**3** **Place the Initial Color Notes**
Use a large comb brush to place color notes in light and shadow, as well as the background notes. Be sure to place some background color up against edges of the subject, skin, clothing and hair so you'll be able to judge adjacent colors more easily. For the color on the nose, add a little Cadmium Red Light to underscore its rich color.

**4** **Indicate the Features As You Separate Light From Shadow**
Cover the canvas with the light and shadow colors, refining the shapes as you go. This will create the beginning of the drawing. If you are more comfortable drawing with Raw Umber first, you certainly can do so. In this step, the main thing is to get enough fresh paint on the canvas that you can start to manipulate.

**5** **Sculpt the Forms of the Face and Shadow**
Mix up variations of the shadow color notes to add subtlety to the planes of the face in shadow. Mix variations that become either bluer, redder or more violet. You can accomplish this by staying within the value of the shadowed side and adding bits of Ultramarine Blue or Alizarin Crimson (or both) to the base color. Keep the resulting color desaturated, so it stays in shadow. Also limit the saturated color in the lit areas. Continue to use a large comb brush to lay down the paint.

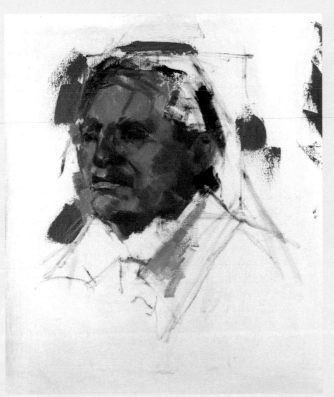

**6** **Lightly Blend Shadow Colors and Shapes**
Use a clean wide comb brush to lightly drag the shadow colors into one another across the cheek and chin. Use a medium cat's tongue brush to find shapes and planes within the very small change in value to make a big difference in your modeling.

### 7 Lay the Remaining Areas of Hair, Neck and Collar

Leave all of the throat as one basic value, differentiating the underside of the chin by adding Cadmium Red Light. Indicate Fil's hairpipe (bone) necklace with just a few soft-edged strokes of color. Lightly brush in the darks of the hair with your large comb brush. Once you get the hairline placed more specifically, it becomes easier to identify drawing errors. Here, the shape of the profile and the locations of the eye sockets and nose all need to be addressed in the next steps. I just used my thumb to obliterate the drawing in the eye sockets to set them up for the next step. If you get too much paint on the surface, you can remove some by pressing (not rubbing) a paper towel over the area.

### 8 Correct Drawing Errors

Corrections work a little like dominoes—once one shape is moved, the next shape must move, then the next and so on. The most obvious error is the angle of the left of the forehead between the eyebrow and the hairline. Correct the shape with a single strong stroke of Asphaltum. Once the forehead angle is adjusted, the correction needed in the angle of the nose becomes easier to see, which in turn forces the bridge of the nose farther to our right. Raise and reshape the tip of the nose, widening the base slightly. A plumb line upward from the corrected base of the nose on our right helps to locate the proper place for the eye on our right.

### 9 Smooth Your Brushwork and Render the Eyes

My personal preference is to leave more brushwork. If you choose to smooth out your strokes, use a large cat's tongue brush to brush the strokes together in a left to right, repetitive motion. Use a medium cat's tongue brush and crisp strokes of warmer flesh color (add Naples Yellow) in the darkest areas of skin and paint across the front of the forehead to separate the turning planes of the skull into shadow. Also place this mixture in the inner corners and under the eyes, inside the ear shapes, and at the corners of the mouth. A medium cat's tongue brush works well for this job.

Place the lid creases and lash lines with Asphaltum + Alizarin Crimson Permanent, using your smallest cat's tongue brush. Paint the irises with Asphaltum. Separate the lash line and eyelid crease by a single stroke of lighter paint over the center of the lid and above the iris. Use the same light paint to describe the shape of the light and shadow pattern from the cheek all the way up into the sclera. Stop the light paint at the lower lash line. You'll find that the sclera becomes automatically well defined and won't need much more attention.

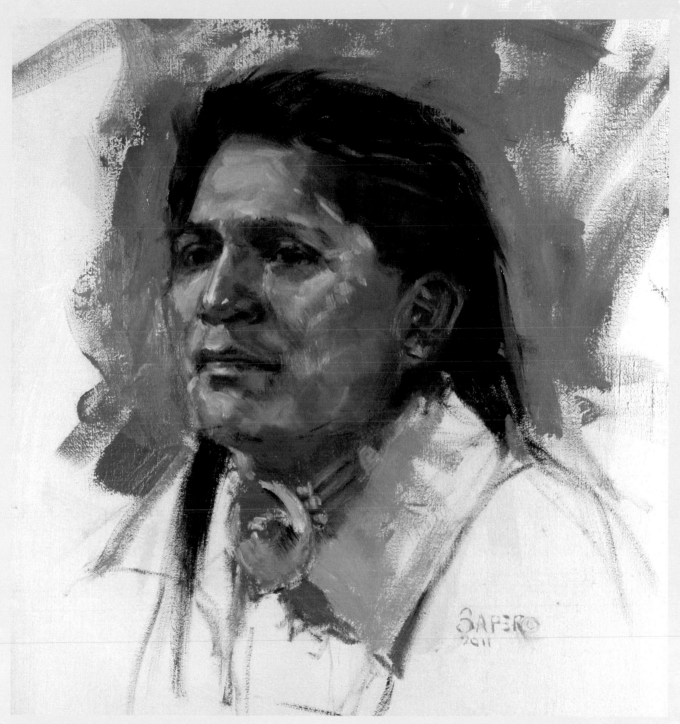

**10 Complete the Hair, Background and Highlights**
Keep the outer edges of the hair soft and integrated with the background by brushing the hair color into the background, from the lower left to upper right, and the background into the hair from the opposite direction. Paint the earring by first laying a tiny stroke of Transparent Earth Red along the lower base of the triangle, then paint the turquoise earring with Phthalo Green + Flake White. Use the same mixture of Phthalo Green and Flake White to add highlights to the shadowed side of the face in the inside corner of the eye as well as areas just to the right of the eye in shadow. Not only will this create the impression of a second, cooler light source entering from our right, but it will integrate the turquoise color with the skin tones. A few dabs of the turquoise mixture into the necklace add to the integrated color throughout the canvas. Paint the highlight along the side of the nose with a single stroke of Naples Yellow. Use Radiant Blue to place the smaller highlights on the right tip of the nose in shadow.

**Filmer, Life Study**
Oil on linen
20" × 16" (51cm × 41cm)

# Filmer From Photograph

Filmer is wearing different clothing for this demonstration than in the life study; however, the lighting and backdrop are identical. He's wearing the official outfit of the Gourd Society, which is open to Native Americans who have served in the United States Armed Forces. The red and blue sections of the shawl represent the American flag. The medals and other elements worn on and with the shawl, such as the eagle feather, are symbolic and represent both Fil's service to his country and his Hopi heritage.

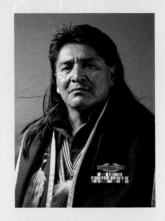

**Reference Photo**

| Light | Shadow | |
|---|---|---|
| 1 | 2 | Background |
| 3 | 4 | Skin |
| 5 | 6 | Hair |
| 7 | 8 | Clothing (shawl, red side) |
| 9 | 10 | Clothing (shawl, blue side) |

**Color Notes**

1  n/a

2  Ultramarine Blue + Ivory Black + Cadmium Yellow Medium + Foundation Greenish + Monochrome Tint Warm (background)

3  Yellow Ochre + Transparent Earth Red + Foundation Greenish (skin in light)

4  Yellow Ochre + Transparent Earth Red + Caput Mortuum Violet + Cerulean Blue (skin in shadow)

5  Raw Umber + Transparent Earth Red + Raw Sienna (hair in light)

6  Raw Umber + Ultramarine Blue + Ivory Black (hair in shadow)

7  Alizarin Crimson + Cadmium Red Light or Vermilion (Gourd Society shawl in light, red side)

8  Alizarin Criumson + Caput Mortuum Violet (Gourd Society shawl in shadow, red side)

9  Ultramarine Blue + Raw Umber + Portland Gray Medium (Gourd Society shawl in light, blue side)

10  Ultramarine Blue + Raw Umber (Gourd Society shawl in shadow, blue side)

**1  Size and Place the Head**
Rather than beginning with a general concept of head size, consider the overall composition so the significant pictorial elements in the shawl can be included without being crowded. On a 20" × 16" (51cm × 41cm) canvas, lightly toned with a wash of Ivory Black and mineral spirits, the placement results in a head size of approximately 6½ inches (17cm). The direction of both the light source and the face support leaving extra negative space on our left.

**2  Draw the Major Shapes**
Use a small cat's tongue brush to paint the geometric shapes in the face with Raw Umber lightly thinned with medium. It's important to locate the shapes under the chin, and the location and placement of the ears, because these are important indicators of the position of the head, which is chin up. Getting the measurements in early is extremely helpful in maintaining proportion and perspective throughout the painting process.

**PLACE THE COLORS YOUR WAY**

My approach in this demo is to block in the shapes first, but it's not the only approach. Sometimes I enjoy laying down a mosaic of color patches right from the start. Other painters begin directly with color and let the drawing occur as the painting progresses. After experimenting with several different approaches, you'll find yourself gravitating to the approach, or unique combination of approaches, that works best for you.

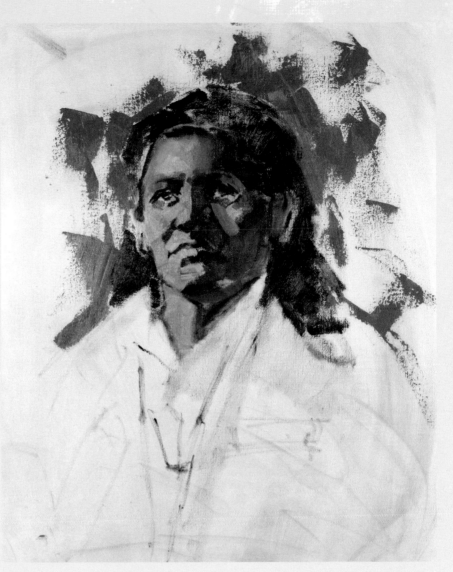

### 3 Separate Light From Shadow
Switch to a medium-size cat's tongue brush to lightly tone areas of shadow, separating them from the areas lit by the light source. At this point, don't worry about getting the values accurate; just concentrate on the light and shadow.

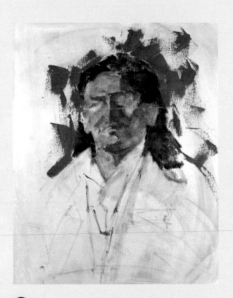

### 4 Use Your Color Notes to Block In Key Areas
Mix some piles of paint (about the size of an almond, or more if you paint thickly) for the color notes you created from the life study, representing the background, skin in light, skin in shadow and hair in shadow. Add color notes adjacent to each other (hair against background, skin against hair, light against shadow), to help relate the values to each other more accurately.

### 5 Refine the Values and Colors in the Skin
In the lit areas, use the base colors you've mixed and begin to mix more piles of paint to adjust color and value. Adjust one pile by adding more Yellow Ochre, one by adding Vermilion, one by adding Raw Umber and so forth. Lighten the values in light by adding Naples Yellow (instead of white, which would cool the temperature, requiring an extra step to warm it back up) to preserve the rich color of Filmer's skin tones as well as the warm light source. In the shadowed areas, adjust your shadow color notes by adding Transparent Earth Red + Caput Mortuum Violet to one pile of paint for the forehead. Add Raw Umber to desaturate the lower parts of the face in shadow, then use Caput Mortuum Violet + Flake White (enough to cool the color without appreciably changing the value) to describe the area under the cheekbone on our right. Use strokes of Raw Umber + Asphaltum to begin sculpting the nostrils, chin and eye sockets.

Visit artistsnetwork.com/portrait-painting for a free demonstration on painting a vignette

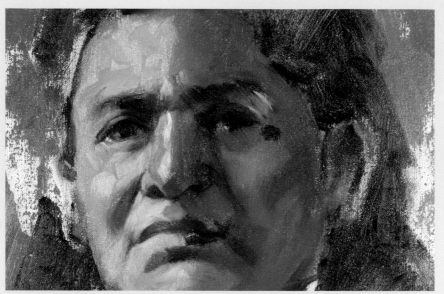

**6 Continue Modeling the Forms, Always Looking for Errors**

Every time you apply new layers of paint, it's important to check whether your drawing needs correction. Add paint freshly without worrying about filling in—or avoiding—already painted areas so the edges and color transitions look natural and well integrated. In this detail, there are some major drawing errors in the mouth: the bows on the upper lip are too close together, the right half of the mouth is much too short from left to right, and the cast shadow on the philtrum is nonexistent. Errors are also located on the nose, especially in shadow.

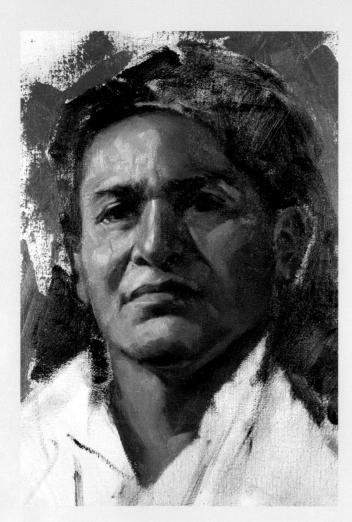

**7 Make the Corrections Within the Context of Your Continued Modeling**

To correct the errors in the drawing, just keep adding paint right over the mistakes, and as you go, bring up the finish on all of the shapes that are adjacent. Compare this to the previous step and you'll notice that I also corrected the shape of the nostril on our left, not by repainting the nostril, but by repainting the light on the upper lip and carving the correction into the mistake. Likewise, the shape of the lower lip is corrected in relation to modeling the shapes of the shadow under the lip and the ball of the chin.

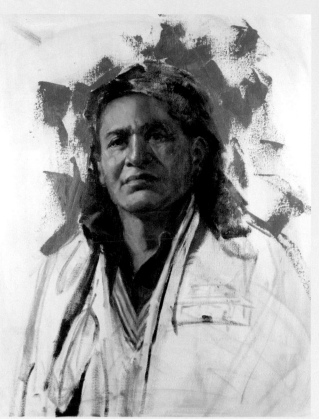

### 8 Continue Painting Shapes Adjacent to the Skin Tones

Painting the shirt more accurately also gives you the opportunity to model the throat more carefully. The reflected light under the chin still needs to remain in shadow, so the value can't change very much. However, adding a small amount of Cadmium Orange to the underplane of the chin creates a temperature shift that is convincing as the rich, warm color of the chest is reflected back into the shadow. Use Caput Mortuum Violet to lightly lay in the red shadows in the shawl with a large cat's tongue brush. Mix Ultramarine Blue + Raw Umber to represent the shadows in the blue part of the shawl.

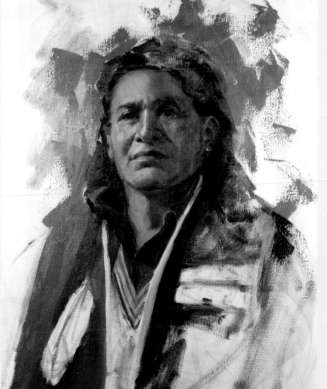

### 9 Complete the Shawl

Red fabric can be extremely challenging to paint in order to retain the intensity of the color without overpowering the entire canvas. In this case, desaturate areas of Cadmium Red Light or Vermilion by adding Caput Mortuum Violet (which will cool, darken and desaturate the color) or Monochrome Tint Warm (which will desaturate the red because of its complementary green cast, but not darken it, since it is so close in value). Leave only the lightest areas of the shawl for your most intense reds. Here, use strokes of straight Cadmium Red Light and touches of Cadmium Orange.

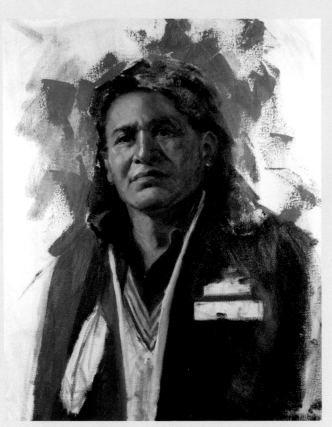

### 10 Reevaluate the Painting

Never stop asking yourself how the overall painting looks as you go through each step. Before I finished the red shawl, the colors and design held together quite well, as the background color was a beautiful complement to the skin tones. However, once the red shawl was painted, the overall painting looked garish because there were too many large areas of highly saturated color (sometimes referred to as the "beach ball effect"). This is a perfect example of why a small color study would have been helpful, or simply putting some small but strong color notes for the shawl in early. (In Fil's life study, the muted colors of his ceremonial ribbon shirt worked very well with the background.) The painting is now much too far along to drastically alter the background color without almost totally repainting the canvas. However, both the saturation and value of the background can be altered without changing the hue. In every painting, don't hesitate to abandon your reference and simply do what is right for that particular painting.

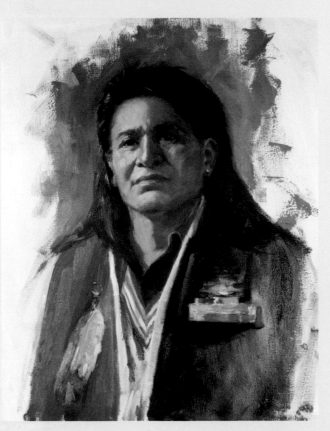

### 11 Correct the Background

Remix a generous pile of paint in your original background color, but lighten it with Foundation Greenish. Use your largest brush up to 2 inches (51mm) wide to place broad, haphazard strokes to cover the background areas. To further integrate the background with the subject, introduce other colors already on the canvas, but in values similar to the new background value. Using a clean brush, add strokes of Radiant Blue, Foundation Greenish and Monochrome Tint Warm, painted wet into wet. Paint background color up to, and just into, the outer edges of the hair so they're set up for you to paint the rest of the hair.

### 12 Integrate the Hair With Its Adjacent Areas

Restate the color of the hair along the forehead and the silhouette. You may want to add medium to make the paint workable. Be sure that the paint where the skin joins the hairline, and where the background meets the hair, is wet. Use various sizes of comb brushes to drag hair color into skin and background, and vice versa. Wipe your brush after every stroke but don't let it get wet with mineral spirits since you don't want to dilute the pigments.

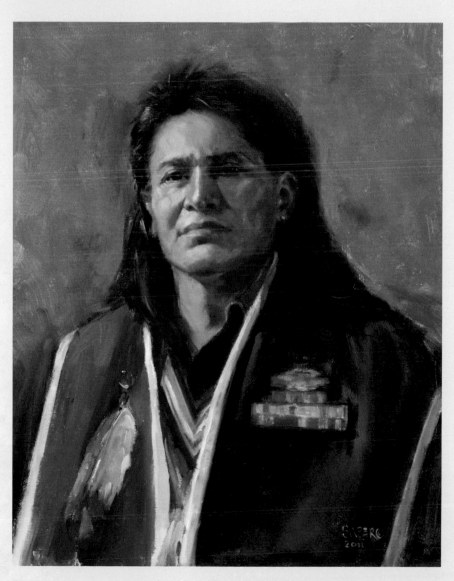

### 13 Complete the Portrait

It's a good idea to let a portrait sit for a while before calling it done. After some period of time, when I was ready to sign and varnish this portrait, I decided to make some last corrections to the eye on our right, and to add finishing touches to the clothing and background.

**Filmer from Photograph**
Oil on linen
20" × 16" (51cm × 41cm)
Collection of the artist

# DEMONSTRATION: CAUCASIAN REDHEAD
# Melissa From Life

Melissa is a lovely young mother with classic red hair that might be described as copper. This demonstration shows how it is possible to begin a portrait from life and to complete it from a photograph. The first five steps were painted from life, and the remaining steps from one of a series of photos I took at the time, selecting the image that most resembled the angle and pose I had observed in the life session.

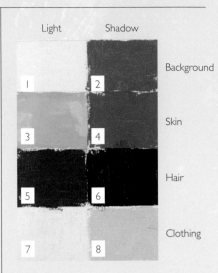

Light    Shadow

Background

Skin

Hair

Clothing

**Reference Photo**
The light on Melissa is warm (about 3500K) and strongly emphasizes the reds and yellow in her hair. The desaturated green backdrop is an excellent complement to her coloring. The ambient reflected color in the room helps to bring out the subtle cool colors in the shadows of her skin.

## Color Notes

1  n/a

2  Raw Umber + mixed green (Cadmium Yellow Medium + Ivory Black) + Foundation Greenish (background)

3  Flesh + Naples Yellow (skin in light)

4  Flesh + Asphaltum + Radiant Magenta (skin in shadow)

5  Transparent Earth Red + Cadmium Orange + Yellow Ochre (hair in light)

6  Raw Sienna + Transparent Earth Red + Asphaltum (hair in shadow)

7  Naples Yellow + Flake White (clothing in light)

8  Foundation Greenish + Radiant Blue (clothing in shadow)

**1** **Size and Place the Head**
On a 16" × 12" (41cm × 30cm) canvas, a 6-inch (15cm) head will leave enough space at the bottom to accommodate the neckline of the blouse. Leave a slight bit of extra space to our left. Use a small cat's tongue brush and Raw Umber to mark the large planes in the hair.

**2** **Block In Areas of Light and Shadow**
Mix color notes for the skin in light and shadow, as well as the hair in light and shadow. Use a medium-size synthetic flat to lightly block in areas of color. Mix a color note for the background and place it immediately against the edges of the hair and where you estimate the shoulder to be.

 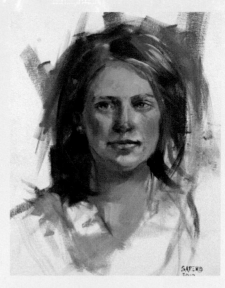

### 3 Paint Areas of Redder Color in the Skin

Melissa's fair skin tones allow the natural red band of color to be easily seen across the center part of her face—the nose, ears, cheeks and mouth. Paint these areas by adding Vermilion to the color note you've mixed for the skin in shadow.

Carve out the shapes along the sides of the face and neck by locating the hairline and ear. Slightly lighten and warm the hair in shadow, adding more Transparent Earth Red to the color note for hair in shadow, to paint the section of hair located between 10:00 and 11:00.

### 4 Locate the Features

Remeasure the relationships and distances between the features, marking the locations again with a light touch of Raw Umber. By adding dark notes for the hair in shadow, you can refine the chin, neck and jawline. There are some cool areas of skin above the eye on our left, and to the side of the nose on our left, which you can paint with simple strokes of Phthalo Green + Flake White + Raw Umber. Cover remaining areas of hair as it moves from shadow into light. Add Cadmium Orange + Naples Yellow + Transparent Earth Red to the paint you have already mixed for hair in shadow.

### 5 Paint the Features to Complete the Life Study

Paint the eyes, nose and mouth loosely, while you model the skin in light by using variations of the skin color in light. To lighten paint, use Naples Yellow instead of white to preserve the warmth of the light source. Quick strokes of Naples Yellow create highlights in the hair.

At this point my available two hours were up, so I signed the painting and took several photos of Melissa, including one that seemed similar to my viewpoint while painting her life study.

### 6 Review the Life Study for Drawing Errors

As I continued working on Melissa's portrait from her photo, my goal was to improve the likeness without losing the fresh color I had seen in person. Using my reference, I decided to make corrections in the life study to agree with a slightly different angle apparent in the photo. The greatest changes involved moving the cast shadows on the face and neck, and tilting the head upward a bit. Lifting the chin required raising the tip of the nose and moving the ears down.

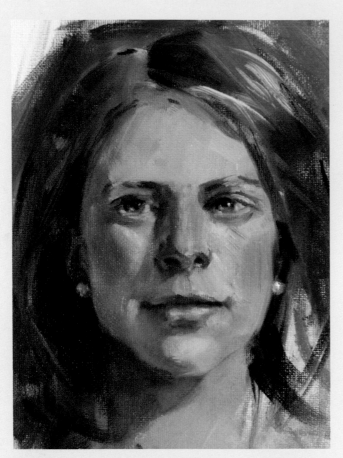

### 7 Correct the Nose, Ears and Mouth

The slight upward tilt of the head made visible the underplane of the nose (which wasn't visible during the life study) and lengthened the distance between the upper lip and the base of the nose. While these changes are very slight (less than ⅛ of an inch [3mm]), the visual impact is enormous.

Soften the color and value transitions in the lips while improving their symmetry. When all the paint around the lips is wet, lose the edges by dragging a dry sable or fan brush lightly across the form, lip into skin and skin back into lip. Wipe your brush between strokes. By adding the darkest darks in the hair, the corrected ear will appear and at the same time a more defined neck and jaw.

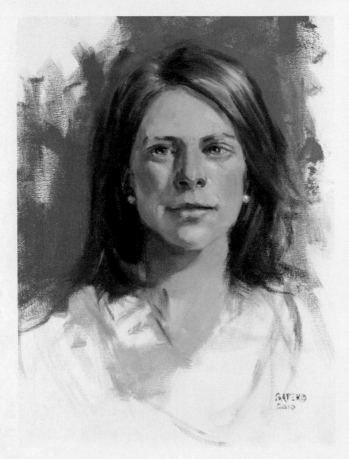

### 8 Complete the Hair

All the edges of the hair need attention, including the shape and size of its silhouette. To integrate the outer edges of the hair with the background, be sure the background has fresh color. Use fresh hair color to drag the sides and top of the hair into the background, and the background color back into the edges of the hair, keeping everything very soft. Any of your comb brushes will work well, just remember to wipe excess paint off the brush between strokes. Suggest the shadow cast by the hair against the forehead on our right. Extending the background color to two sides of the canvas anchors the image, while preserving the looseness of the vignette.

### 9 Suggest the Throat, Chest and Neckline

Use variations of the skin tones in light (add small amounts of Naples Yellow + Flake White to your existing skin tone) to suggest the shapes of the throat and neck. Unify the temperature shifts in the forehead so the skin tone is more even. Paint the neckline of the blouse, placing bits of color in both light and shadow. If you keep these strokes very loose, pulling them over the underlying canvas, you will make the subject emerge.

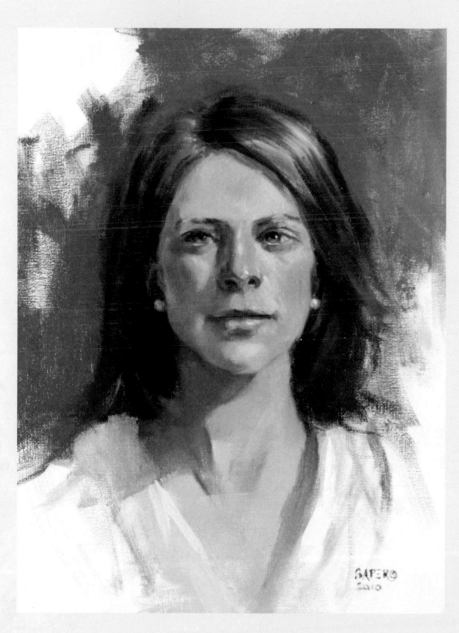

### 10 Complete the Portrait

There are several touches left to finish the painting. The eyes haven't been touched during the second part of this demo, as they were painted somewhat properly during the life study. However, they lack the sense of expression that shows in the photograph. All that's needed is to repaint the shapes of the lower eyelids, which is a good example of how very little is required to change an expression, as long as the change is not dramatic.

The last change is to paint over the color notes on the side of the canvas, leaving ⅜ of an inch (10mm) or less showing on the right edge so they won't be seen when Melissa frames her portrait.

**Melissa, Life Study**
Oil on canvas
16" × 12" (41cm × 30cm)
Private collection

# Melissa From Photograph

In selecting a photo as reference for a portrait, you'll sometimes have many choices. In this case, I loved the relatively small amount of light on Melissa's face, and the quiet darks and middle values that comprise most of the picture. To work out the composition, I rotated the head slightly counterclockwise and eliminated the arm. You can see how I played with the negative spaces in Photoshop to set the composition into a 20" × 16" (51cm × 41cm) format.

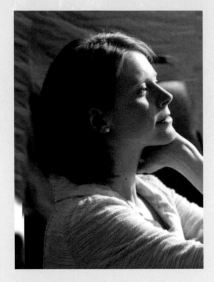

**Reference Photo**

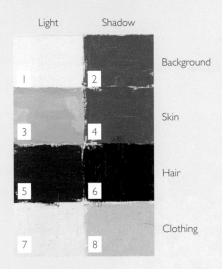

**Color Notes**

1  n/a

2  Raw Umber + mixed green (Cadmium Yellow Medium + Ivory Black) + Foundation Greenish (background)

3  Flesh + Naples Yellow (skin in light)

4  Flesh + Asphaltum + Radiant Magenta (skin in shadow)

5  Transparent Earth Red + Cadmium Orange + Yellow Ochre (hair in light)

6  Raw Sienna + Transparent Earth Red + Asphaltum (hair in shadow)

7  Naples Yellow + Flake White (clothing in light)

8  Foundation Greenish + Radiant Blue (clothing in shadow)

**1  Size and Place the Head**
The greatest advantage to working out the composition to scale (either through editing software or a thumbnail sketch) is that you already know how much negative space to leave and, generally, where things go. It's important to establish the angles for the tilt of the head early on. Measure and mark key vertical and horizontal relationships using Raw Umber, a little medium and a small cat's tongue brush.

**2  Draw the Basic Shapes**
Continue to measure and mark the largest shapes in the portrait, using geometric rather than curving lines. At this point, you'll have a solid idea of how the composition and head placement will work out. As the size of the canvas and complexity of the subject(s) grow, you may want to make compositional adjustments once you see the overall drawing. Things that look right on a small thumbnail don't always translate to a larger size—and if you are even the least bit uncomfortable with the placement, now is the time to change it.

### 3 Separate Light From Shadow

Use a medium to large synthetic flat to lightly block in areas of shadow. Although this canvas wasn't toned in advance, the background will constitute a value between light and shadow, keeping the overall value scheme simple and strong.

### 4 Commit to the Background

Although the color note for the background in the life study was painted to match the actual backdrop, here I wanted it to be a little lighter in value and a little less saturated. If you decide to change a background color, it's best to do so right away so the subsequent colors you apply will be in harmony with the ground. If you decide to make a dramatic change in the value of the background, it's helpful to review the compositional scheme in grayscale to make sure you still like the design.

### 5 Block In the Lights

Use your skin tone in light color note to paint one solid color over all the areas of skin that are in the light. You don't need any medium unless your paint seems too stiff. A medium to large synthetic flat works well for this step.

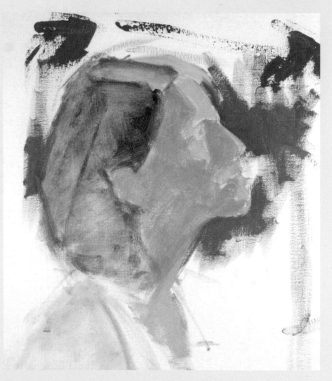

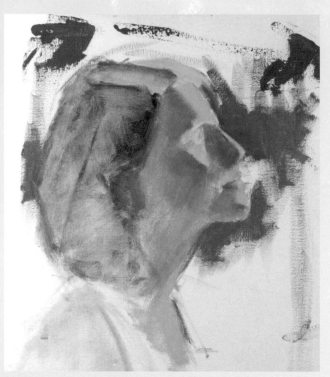

**6 Block In the Shadowed Area of Skin Using Violet**
For this demonstration, paint the shadowed areas of skin in the complement of the warm yellow light source. For a subject with skin tones as fair as Melissa's, this underpainting will set up a lovely cool surface on which you can lay relatively warmer color, yet still preserve a basis for the cool notes in her skin. Mix a violet with Ultramarine Blue + Alizarin Crimson Permanent + Flake White, but apply it lightly—not as opaquely as the skin tones in light. Lightly block in the overall areas of hair in shadow.

**7 Add Reds to the Center Band of Color in Shadow**
Use your synthetic flat to add a mixture of Vermilion + Raw Umber + Violet, lightly dragging paint over the areas that represent the center of Melissa's face in shadow—the nose, cheek, ear and lips—as well as places where the shadow's core is located along the forehead and chin. This warmer color will set up the illusion of the planes turning in space.

**8 Locate the Features**
Use your small cat's tongue brush and a little Asphaltum to measure and mark the placement for the brows, eyes, nostril, lips and ear. Although the light and shadow block-in was fairly well placed, it's not accurate. The little triangle of light on the cheek is very important in describing the shape of the face. Correct the shapes now and at every step in the process. Continue to add darker strokes in the hair to keep your values keyed to one another.

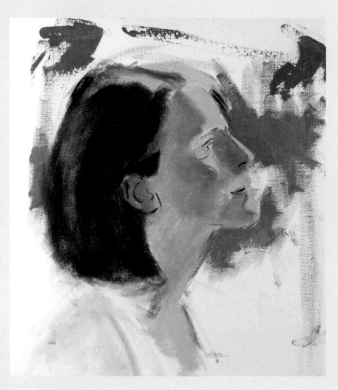

# Mini Demonstration: Paint the Hair

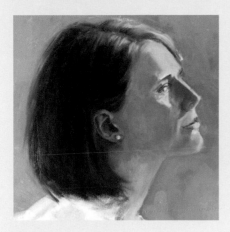 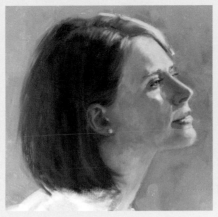 

### ① Set Up the Middle Values and Color

The hair has light, shadow, and transitioning colors and values. It's easiest to paint the darks first, then gradually work your way into the lights. Use a comb brush to paint strokes of hair in light into hair in shadow and back again, wiping the brush in between strokes. Getting the paint really fluid by adding medium will help the transitions.

### ② Set Up the Highlights

Use a cat's tongue brush to lay a relatively thin stroke of Brilliant Yellow Light (or Flake or Titanium White, slightly warmed with Indian Yellow or Cadmium Yellow Medium) across the form of the hair.

### ③ Integrate the Highlight With the Hair in Light

Use the same technique described in step 1 to move the hair in light and the highlights into each other.

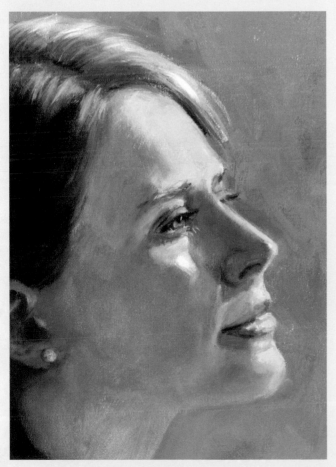

### ④ Soften the Outside Edge

Pull some background color into the lightest part of the hair to soften the edge between the hair and background.

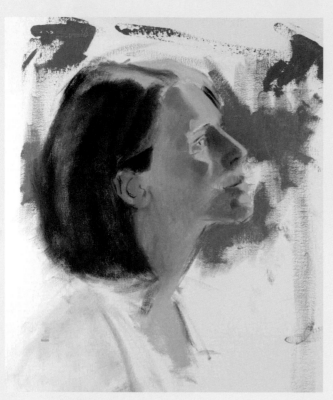

### 9 Adjust the Shadow Color and Transition Light Into Shadow

Use Monochrome Tint Warm (adjusted to the value of the shadow by adding Raw Umber) to desaturate some of the key turning planes. If you look closely, you can see patches of greenish color placed at the top of the forehead, to the left of the eye, nose and mouth, and below the corner of the mouth. The Monochrome Tint Warm takes on a decidedly green cast when it's placed next to a color that contains red. Desaturating these areas accomplished two things: first, it's actually more accurate in depicting those areas of skin. Second, it creates some temperature relief in the shadow, adding interest to the area while respecting the fact that it still needs to remain in shadow. Given the warm light source, the local color of Melissa's skin, and the ambient reflected color, the shadows will be relatively cooler in color temperature than the lights, but they can still have some temperature variety.

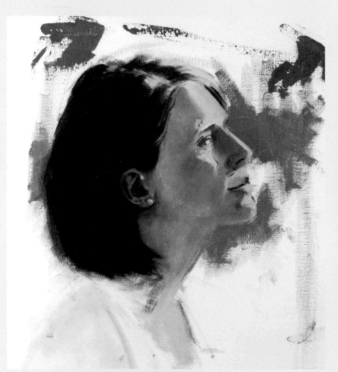

### 10 Model the Ear and Prepare the Hair for Lights

Continue to work on adjacent areas when both areas have fresh paint. Model the ear, using a small cat's tongue brush. Paint the surrounding areas of hair with a large comb brush using different values in the shadowed sections to create a sense of movement and depth.

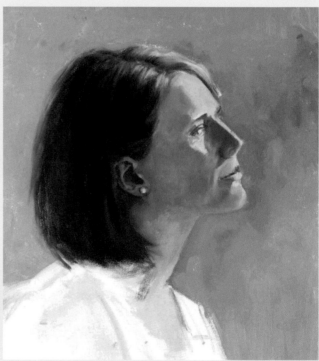

### 11 Complete the Background

To prepare the surface for painting the edges of the hair, add fresh paint to the background so you'll be able to integrate the edges of the hair. This step also allows you to correct drawing errors along the profile of the face.

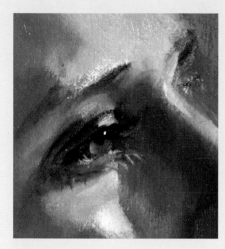

### 12 Paint the Eye

Paint the details in the eye, eyelid and lashes using your smallest cat's tongue brush. Keep all the places where skin touches skin (the crease in the eyelid and the shadow in the left corner where the sclera and lid meet) painted with very dark, warm mixtures of Alizarin Crimson Permanent + Transparent Earth Red + Asphaltum. Hang the iris between 10:00 and 1:00, and light it opposite the catchlight. One tiny stroke of Raw Umber is enough to indicate the upper lashes. Two or three tiny strokes of Foundation Greenish + Flake White are all that is necessary to suggest the lower lashes. You'll want to turn the canvas to accommodate the natural right- or left-handed arc of your stroke.

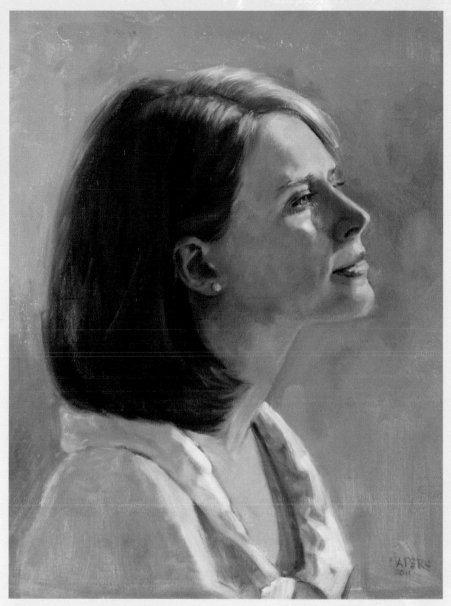

### 13 Complete the Portrait

Paint the blouse, only suggesting the ruffled collar, using the color notes for clothing in light and shadow. Melissa's skin is reflecting warm color into the shadow of the left side of the blouse. The lightest lights on the blouse are painted more thickly with strokes of Brilliant Yellow Light. A very slight bluish gray edge remains where the light of the blouse transitions into the shadow. Note that the underplane of the chin has just the slightest cast of Cadmium Orange, reflecting the warmth of the skin on the chest.

**Melissa from Photograph**
Oil on linen
20" × 16" (51cm × 41cm)
Private collection

# Conclusion

Notwithstanding the title of this book, only nature can really master skin tones. But good training, perfect practice and willingness to reach for something better serve each of us well on our quest. We are fortunate to be engaged in a practice that can continue to grow in its scope and subtlety over a lifetime.

Whether listening to a live instrumental or vocal performance, or creating a portrait from a quick life session, expect that a note will be missed or a lyric sung out of place or a brushstroke placed incorrectly. Be happy to exchange a bit of accuracy for the joy of painting in the moment. Sometimes a life study results in a real keeper, but at least for me, that's the exception rather than the rule. The result, though, has no impact on the value of the experience for the painter. In this book, I've shared both with you.

My hope for you is to enjoy the freshness and immediacy that comes with the challenge of painting from life because there just isn't any substitute. You'll find that the more you observe the individuality of your model, the more beautiful she or he becomes. Enjoy the intoxication that comes with the privilege of painting a living human being and the sheer pleasure that accompanies really seeing color.

Enjoy, as well, the discipline of painting from a photograph, on your own time frame, finding a result that looks as fresh as your life study.

There is certainly no shortage of instructional art books to be had. Thank you for reading mine.

*Chris Saper*

Chris Saper

**Harvey B. Grant**
Oil on linen
30" × 20" (76cm × 51cm)
Collection of the Foundation for the Carolinas

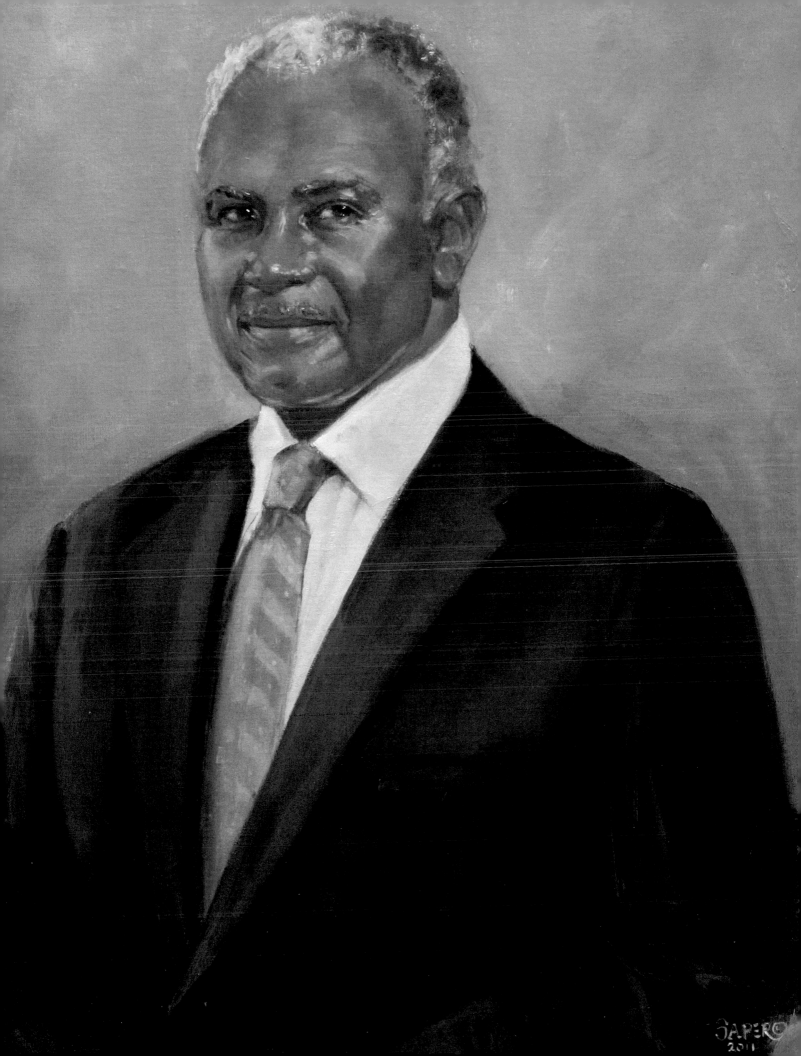

# Index

 Other fine North Light Books are available from your favorite bookstore, art supply store or online supplier. Visit our website at fwmedia.com.

16  15  14  13  12    5  4  3  2  1

DISTRIBUTED IN CANADA BY FRASER DIRECT
100 Armstrong Avenue
Georgetown, ON, Canada  L7G 5S4
Tel: (905) 877-4411

DISTRIBUTED IN THE U.K. AND EUROPE
BY F&W MEDIA INTERNATIONAL
LTD Brunel House, Forde Close, Newton Abbot,
TQ12 4PU, UK
Tel: (+44) 1626 323200, Fax: (+44) 1626 323319
Email: enquiries@fwmedia.com

DISTRIBUTED IN AUSTRALIA BY CAPRICORN LINK
P.O. Box 704, S. Windsor NSW, 2756 Australia
Tel: (02) 4577-3555

Edited by Sarah Laichas
Interior designed by Laura Spencer
Cover designed by Brian Roeth
Production coordinated by Mark Griffin

## About the Author

Chris Saper is a portrait painter, teacher and author of *Painting Beautiful Skin Tones With Color & Light*, as well as four artistsnetwork.tv DVD workshops on painting portraits in oil. As a faculty member of the Portrait Society of America, she has participated in many classes, panels, critiques and countless portfolio reviews, developing a solid insight into the obstacles that keep artists from seeing and painting skin tones well. She has written and self-published two books designed to support workshop courses she's developed, *For Love or Money: A Business Handbook for Portrait Painters* and *Mostly Monochrome: Six Step-by-Step Demonstrations*. Visit her website at **chrissaper.com** or blog at **chrissaper.blogspot.com**.

| METRIC CONVERSION CHART | | |
|---|---|---|
| **To convert** | **to** | **multiply by** |
| Inches | Centimeters | 2.54 |
| Centimeters | Inches | 0.4 |
| Feet | Centimeters | 30.5 |
| Centimeters | Feet | 0.03 |
| Yards | Meters | 0.9 |
| Meters | Yards | 1.1 |

art on title page:
**Candyce and Fiona**
Oil on linen
30" × 24" (76cm × 61cm)

art on facing page:
**Boy in Blue**
Oil on linen
16" × 16" (41cm × 41cm)

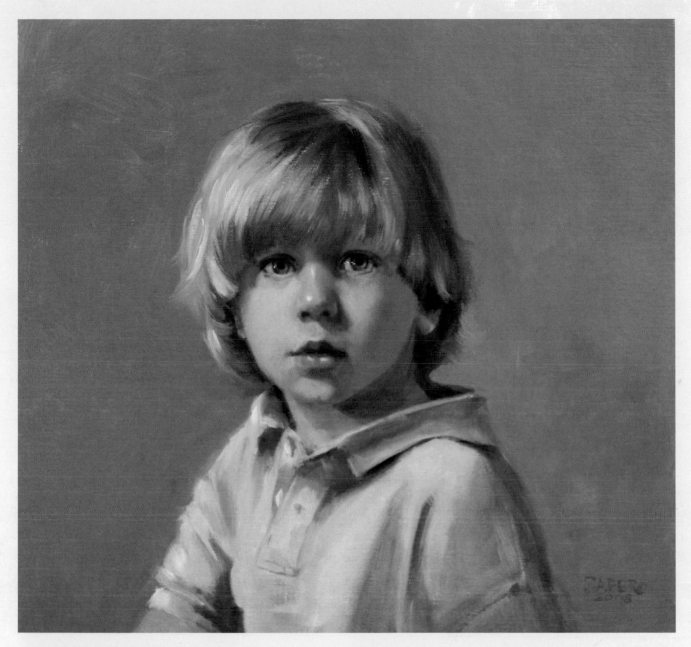

## Acknowledgments

My heartfelt thanks to my family, friends and generous teachers, colleagues and mentors who include William Whitaker, John Howard Sanden, Ann Manry Kenyon, Jamie Lee McMahan, Richard Broderick and so many others who have both supported and inspired me over many years.

Special thanks to the Portrait Society of America, the Scottsdale Artists' School and the Mountain Artists Guild for providing me the opportunity to serve on their respective Faculties. To every one of my students, who teach me as much as I teach them. And to the staff and leadership of North Light Books and F+W Media: Sarah Laichas, Laura Spencer, Jennifer Lepore, Jamie Markle, Maureen Bloomfield and everyone at artistsnetwork.tv.

## Dedication

To Ron, Aaron and Alexandra: thank you for your love and support, every day. I love you.

# Ideas. Instruction. Inspiration.

Receive **FREE** downloadable *bonus materials* when you sign up for our free newsletter at artistsnetwork.com/newsletter_thanks.

These and other fine North Light products are available at your favorite art & craft retailer, bookstore or online supplier. Visit our websites at artistsnetwork.com and artistsnetwork.tv.

Follow us!

Follow North Light Books for the latest news, free wallpapers, free demos and chances to win FREE BOOKS!

Visit **artistsnetwork.com** and get Jen's North Light Picks!
Get free step-by-step demonstrations along with reviews of the latest books, videos and downloads from Jennifer Lepore, Senior Editor and Online Education Manager at North Light Books.